CARVED FROM THE LAND

THE ESKIMO MUSEUM COLLECTION

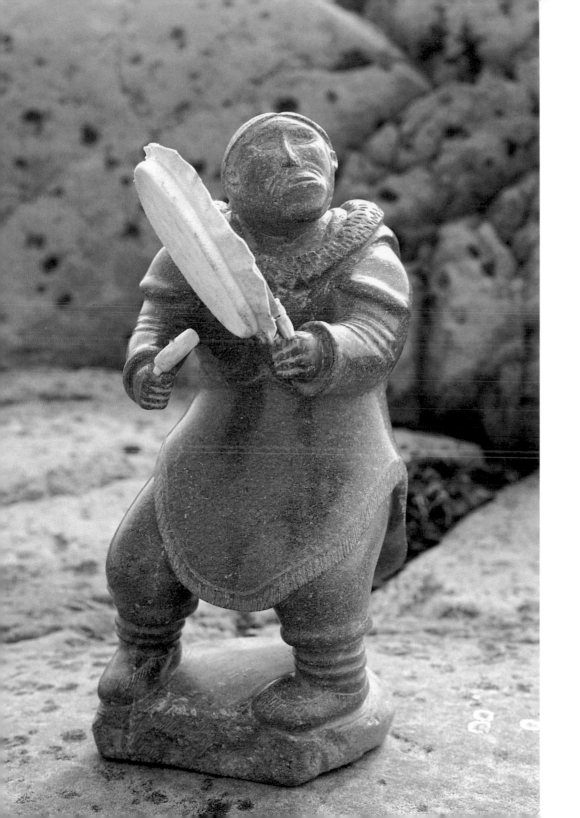

CARVED
FROM THE
LAND

THE ESKIMO MUSEUM COLLECTION

To Earl + Sheil.

Best wishes, Robert R. Taylor

Roma E. Beaudin

by Lorraine E. Brandson

Photographs by

 Robert R. Taylor, R.C.A.

Additional photographs by

 Marcel Bauer p. 12

 Father Etienne Bazin, o.m.i. p. 88

 Father Charles Choque, o.m.i. pp. 64,78

 Father Armand Clabaut, o.m.i. p. 177

 Richard Harrington p. 152

 Gordon Robertson p.14

 Father Guy Mary-Rousselière, o.m.i. pp. 4,22,44,54, 84,100,112,122,126,141,166

 Father Franz Van de Velde, o.m.i. pp. 59,181

Illustrations by

 Ludwina Angmadlok p. 131

 A. Bosch (from a photo by Father F. Van de Velde, o.m.i.) p. 189

 Father Roland Courtemanche, o.m.i. p. 57

 Bernard Fransen pp. 60,103

 Father Georges Lorson, o.m.i. p. 131

 Father Guy Mary-Rousselière, o.m.i. pp. 92,114, 117,125,129,148,153,154,160

 Father André Steinmann, o.m.i. p. 104,173

Front Cover Sculpture:

 Female drummer

 Luke Airut

 Igloolik, 1979

Maps by Susan Plenert, Winnipeg
Cover and book design by Steve Penner

CANADIAN CATALOGUING IN PUBLICATION DATA

Diocese of Churchill Hudson Bay, 1994
Carved from the Land: The Eskimo Museum Collection

Includes bibliographical references and index.
ISBN. 0-9693266-1-0

1. Inuit sculpture--Northwest Territories--Catalogs.
2. Eskimo Museum--Catalogs. 3. Sculpture--Manitoba--Churchill--Catalogs. 4. Inuit--Northwest Territories--Social life and customs. I. Brandson, Lorraine E.
II. Catholic Church. Diocese of Churchill-Hudson Bay.

E99.E7E85 1994 730'.89/97107192 C94-900267-4

Eskimo Museum
Box 10
Churchill, Manitoba
R0B 0E0

Printed and Bound in Canada by
Friesen Printers
Altona, Manitoba
Canada

Financial assistance courtesy of Andreas Züst, Switzerland.

To the people I have met along the journey
who have dedicated their time
and talents to promote respect
and understanding of their
fellow man especially
the late
Bishop Omer Alfred Robidoux, o.m.i.

and

my father
Gestur Gudberg Brandson

"How shall the mighty river
reach the tiny seed?
See it rise silently
to the sun's yearning
sail from a winter's cloud
flake after silent flake
piling up layer upon layer
until the thaw of spring
to meet the seedling's need.

Make tender, Lord, my heart:
release through gentleness
Thine own tremendous power
hid in the snowflake's art."

Antoinette Adam

Uquasiksak Sivullirpaa Foreword

Carved from the Land stands as a witness to a long and patient history of which the collections at the Eskimo Museum at Churchill, Manitoba constitutes a very impressive reflection. The items and works collected and assembled for more than 50 years are in a way a unique monument reflecting its own light and drawing its own life from a much vaster universe.

Sentinel representing a human form that is built with stones.

Carved from the Land bears witness to life, beauty, admiration and faith. It is the fruit of a long and living association with the Inuit of Canada's North. The book demonstrates their creativity and goes far beyond the simple artistic value of the works.

The Inuit were fashioned by the immensity of the territory, a rigorous climate, the enchantment of the sky and its northern lights, long treks and the dangers of wind snow, ice and water. Through a long and energetic patience, a unique symbiosis was created between the inhabitants and the country.

The Inuit marked their presence and their appropriation of the land by numerous **"inuksuit"** that are to be found in every location where they traveled. These are signs of a human presence, of directions and exploration. They evoke a feeling of admiration in a country, the Inuit, the missionaries, and many others who adopted this Northern land and its culture.

Carved from the Land, of which Lorraine Brandson is the author, is more than a work of art. It is rather a Cosmos, inhabited and living, that she translates into words, images and pictures. The approach is global; cultural, social, anthropological and spiritual.

I wish to thank Lorraine for generously sharing her admiration, her fervour and her sincerity.

Carved from the Land, as well as the Eskimo Museum, pays tribute to the living creativity of the Inuit. These creations constitute an invitation for us to deepen our vision of humanity and to enrich our communion with the mysterious and irresistible destiny that creates peoples, cultures and civilizations.

Reynald Rouleau, o.m.i.
Bishop of Churchill Hudson Bay

Ikajuqtiit Qujallijavut Acknowledgments

To the former curator of the museum, the late Brother Jacques Volant, I would like to say thank you, Piku. Brother Volant's dedication to his work at the museum day-in and day-out spoke eloquently to me of his great respect for the Inuit, and his deep appreciation for their art he so passionately promoted and cherished.

Brother Volant's fidelity and love for his chosen vocation became the mirror of what I was to encounter in the Oblates, Grey Nuns, local cathechist families and other personnel I have had the good fortune to meet since I began to work in the Churchill-Hudson Bay Diocese. Their presence and their friendship are an inspiration. Their collaboration in the museum project since its inception has been an integral part of the success that has been achieved.

I have had the good fortune to work under two good Directors, the late Bishop Omer Robidoux, and Bishop Reynald Rouleau. Both have had great empathy with the objectives of the museum and have fully encouraged the development and production of this book.

I have had the friendship, encouragement and support of many professionals in the field. I would especially like to acknowledge Katherine Pettipas, Winnipeg; Diane Skalenda, Winnipeg; George Swinton, Winnipeg; Fabiola Bohemier, Winnipeg; Odette Leroux, Ottawa; Donna Henry, Thompson; Marilyn Walker, Toronto; Bernadette Driscoll, Baltimore; M.J. Patterson, Yellowknife; the late David Owingayak, Arviat; and Mark Kalluak from Arviat who graciously accepted to write a chapter on the importance of maintaining language and culture.

Robert Taylor, R.C.A., Manitoba's foremost naturalist and wildlife photographer enthusiastically accepted to photograph the pieces that are included in the book. I would like to thank the following people for reviewing the text through its many stages, Father Guy Mary Rousselière, o.m.i., Pond Inlet; Father Franz Van de Velde, o.m.i., Landskouter; Father Rogatien Papion, o.m.i., Chesterfield Inlet; Father Georges Lorson, Rankin Inlet; Father Frederick Homann, S.J., Philadelphia; Dr. Donn K. Haglund, Milwaukee, Dr. Jill Oakes, Edmonton, and Dr. Rick Riewe, Winnipeg. For technical assistance and proof reading I would like to thank Patrick Lorand, Edmonton; Anne Kendrick, Montreal and Cathy Brasier, Churchill.

I would like to acknowledge people who in

some way have collaborated in the museum project itself through the years. They include Lillian Zaleski, Winnipeg; Lenore Stoneberg, Grand Prairie; Elaine Gould, Ontario; John Frishholz, Quadra Island; Bryan Ball, Ontario; Mary-Elizabeth Bayer, British Columbia; the "Robidoux construction gang", St. Pierre-Jolys; Anne Gould, Churchill; and students Heather Sarna, Winnipeg, Jean-Pierre Roy, Ste-Pierre Jolys; Anne Gould, Churchill; Marie Dupuis Rocque, Lorette, Denis Daigel, Quebec; Evelyne Dupuis, Churchill and Guy Dubé, Winnipeg.

The present building, a multi-purpose structure was constructed in 1962. Father René Belair, the bursar of the Vicariate was Brother Volant's great ally in the realization of this project. Brothers Maurice Guillemete, Rosaire Turmel and Romeo Goulet came from Montreal to help Brother Jean-Marie Tremblay and Brother Gilles-Marie Paradis in its construction. The Oblate Brothers have always been a great help in many ways especially Brother Jean-Marie Tremblay who constructed most of the display cases. Today Brother Gerard St. Louis assists with the operation of the facility.

Lastly I would like to thank my family in Winnipeg and Brandon for their unfailing support of all my projects.

Lorraine Brandson
Curator

Ilulingit Contents

Sivuniksak Introduction

A small museum on the shores of Hudson Bay officially opened its doors in the Roman Catholic mission in Churchill on May 24, 1944.

The collection exhibited in a room in the mission was mainly composed of a number of ivory boards with scenes of Inuit daily life, some tools, and a few wildlife specimens.

These items had been acquired in recent years by Oblate priests who had lived in the Central Canadian Arctic since 1912, men who recognized the uniqueness of the people they served, and saw this uniqueness expressed in the carvings being made by the Inuit. For some missionaries there was a natural interest to acquire and preserve some items representative of life in the North. In 1944 Bishop Marc Lacroix, o.m.i. and his fellow missionaries agreed that a small museum containing "carvings" representative of the life of the Inuit, made by the people themselves would be one project that would allow

visitors an opportunity to gain an appreciation for Inuit culture. Through the content of these sculptures visitors could recognize the Inuit virtues of courage and adaptability, as well as attain some insight into their society and spiritual view of the world.

While the overall collection is small in comparison to the major Inuit art collections held in southern Canadian institutions today, this historic collection of over 800 pieces kept on permanent exhibit year round overwhelms many of its 10,000 annual visitors. It is unique in its content and focus on Inuit culture.

This catalogue is a significant representation of sculptures from the permanent collection of the Eskimo Museum owned by the Roman Catholic Diocese of Churchill Hudson Bay. While the collection itself contains pieces from the Circumpolar Arctic, the predominant part of the collection comes from the Central and Eastern Canadian Arctic (**Nunavut**), and Northern Quebec (**Nunavik**). It was decided that the pieces selected for the catalogue would come from these areas and that the text would reflect

the lifestyle and history of the Inuit living in the Central and Eastern Canadian Arctic where the Diocese is located. Where two locations are named following the artist's identification the first location represents the community where the artist was residing at the time of the creation of the piece. Texts set in parentheses below the identification of the artist's identification are the artist's interpretation of his/her piece. For the titles of sculpture titles or any other interpretations I take full responsibility for errors or misinterpretations.

I have chosen to add into the text many quotations from the Oblate missionaries, not because they would want to be considered authorities, or because the actual museum displays try to present the Inuit through the Oblates' eyes. I believe rather, that the readers of this book would want the opportunity to read some of their observations of life in the Canadian North.

Today museums that display objects relating to hunting cultures may be stereotypically viewed as being a noble patrimony to cultures that are vanishing or long lost. It remains the challenge of cultural institutions such as ours to affirm that cultures and traditions are not static entities but evolving phenomena with a blend of old and new values and practices.

May the Inuit youth of today recognize with pride the values of their ancestors as portrayed in the museum collection, most importantly those of adaptability, courage and sharing.

Lorraine Brandson
Curator

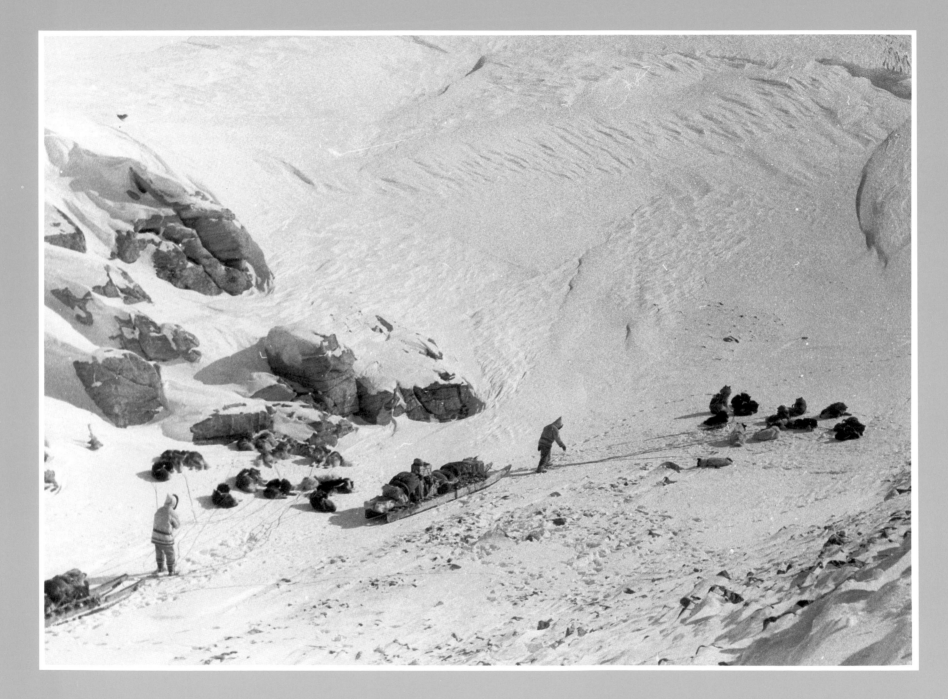

4

Ilitqusituqait Uqausillu Asiutaililugit...

The old ways and language and not losing them...

The Importance of Maintaining Language and Culture

by Mark Kalluak

It is an honour to be privileged with an opportunity to write an article for a museum catalogue prepared by Lorraine Brandson, Curator of the Eskimo Museum in Churchill, Manitoba.

Over the years I have learned to respect Lorraine for her dedication and assistance in providing pertinent photo and text material for a cultural/language publication which I edited for a few years. Along with her I commend the Roman Catholic missionaries for devoting their time and effort in preserving part of our history through the Eskimo Museum. I feel a lot of Inuit owe tribute to them for their premeditation in initiating the fine collection that signifies Inuit culture and tradition. No doubt this publication is surely destined to become a valuable addition.

Back in the "pioneer days" of European civilization, our ancestors were very much at home roaming a vast territory in search of favourable hunting grounds so crucial for their survival. Having maintained themselves from time immemorial, they were able to look into the horizon and determine where to meet up with cross-

Trip from Pond Inlet to Igloolik, 1959.

trails of abundance. Being fully independent, their state of being, manners, taste and intellect were as strong as a young man ready for adventure. Inuit culture was not under threat of being lost with elders leading the way teaching the many things one must know in life. However, the pattern Inuit lived by began to change with time, first with contact with strange people "from across the big sea in big bottoms" followed by missionaries whom Inuit identified as **umiliit** (bearded ones), **iksirarjuit** (priests with writings in their possessions) and **ajuqiqtuijit** (preachers). Of course, with their arrival came others which altered part of the Inuit way of life.

Inuit have always maintained very strong family ties. The establishment of settlements and the arrival of government schools stopped them from living off the land as a family group. At the height of the classroom setting, students were hushed from speaking their native tongue in class. While this was going on, parents and elders found themselves talking to deaf ears with the younger generation taking on a different course.

Although there are many factors in the eventual abandonment of traditional life as we know it, the opening of a nickel mine in 1958 at Rankin Inlet would be one of many examples where families and relatives were displaced, further impacting on Inuit culture. Such was the change that a hunter left behind a team of huskies still tethered to their chains with no one to tend them. A TB epidemic in 1962 also created tremendous burden on families by separating the hunter from his relatives, some for over two years. By the time family members were reunited, the change was so great that it was easier to flow with the course of time and let what come take its pace.

Despite all the circumstances, Inuit have managed to maintain part of their culture. Although they no longer live in iglus, they have found ways to express their culture through arts and crafts, music, education, sports, technology and communication. Each carving is a replica, shape or form of Inuit culture. It speaks of something from the past, an imitation of Inuit tradition created through the mind of an artist. It has always been my belief that culture and language are inseparable. In any civilization language is essential to express culture, and culture is essential to express language. It is said that the Inuktitut language resembles no other language and that scientists can not classify it as belonging to any Indian language group. It is true that Inuit have never developed a writing system, nevertheless, I believe their language was much stronger and sophisticated than today, because they lived and spoke their very own culture and tradition. Inuit were directly involved in teaching orally the proper use of Inuktitut language and grammar.

I am always fascinated by old implements from the past and recall making my first visit to a museum in Winnipeg at the age of six in 1948. I can remember how thrilled I was to see old objects from history relating to my own culture. I have visited many other museums since and each time I took a peek into the past with my curiosity aroused even more. Of course I absorbed new insights and appreciation for the ingenuity of our ancestors despite being one of the poorest living souls on earth.

Identity is something each living person should cherish. Years ago when Inuit were still identified by an Algonquin Indian term "Eskimo" meaning "eaters of raw flesh", we were proud to identify ourselves as such, regardless of the root of the word. It was not until several years later the term "Inuit" was adopted instead to properly identify people who inhabit the Canadian Arctic. In Inuktitut it simply means "People" or human beings, setting them apart from other living creatures, such as animals or other beings.

In Inuit tradition a special gift is something that is cherished for life. I recall during an interview with an elder, seeing an old wooden box beside her with a faded inscription "Benson & Hedges". At the conclusion of the interview, she

picked up the box and said to me, "This small box was given to me by my mother when I was but a little girl", while patting and rubbing it gently. For over 70 years she had kept it, from the time of the iglus till the time wooden houses were provided for Inuit. This small gesture made me appreciate our culture that much more. I'm sure her mind was not only occupied with the small box, but countless memories were racing through her mind, as it did mine as I thought of the past. No doubt words of instruction from her mother were also re-echoing in her mind.

Just as the small box was surrounded by many cherished memories and strengthened an appreciation for culture, I think the same feeling can be said about the accomplishments of people, of whom many are no longer amongst us. They may have considered their endeavours of very little significance, but when they are displayed before the public eye, they bring a very strong message about our culture.

The Arctic has gone through a very swift transition. Many of our leaders have examined the impact of transition and made adjustments in support of language and cultural preservation. Modern technology has become a very useful tool in fulfilling many of our aspirations in relation to preservation of culture and language. Compared to 40 or 50 years ago when the only reading material in Inuktitut for many of the Canadian Inuit were worn out prayer books and biblical texts, we not only have a wider selection

but are involved in publication of more materials, as well as other projects.

In my time of editing publications I liked flipping through old publications dealing with Inuit history. The ESKIMO magazine (published by the Diocese) was one of the publications I visited often since it detailed a lot of things related to our culture, and included photographs that spoke for themselves.

In conclusion I wish to congratulate Lorraine Brandson for her thoughtful initiative, and dedicate this article in memory of the artists and museum staff, past and present.

Keep up the good work.

Mark Kalluak, C.M., Arvial, N.W.T.

(Mark Kalluak is a recipient of the Commissioner's Medal for the Northwest Territories awarded for his involvement in promoting Inuit culture. Mr. Kalluak has edited various publications including the Keewatin Echo newspaper, and the ISUMASI and UQAQTA magazines published by the Inuit Cultural Institute (ICI). He served a number of years as head of the ICI Language Commission and continues to be involved in various endeavours to promote Inuit culture and language.)

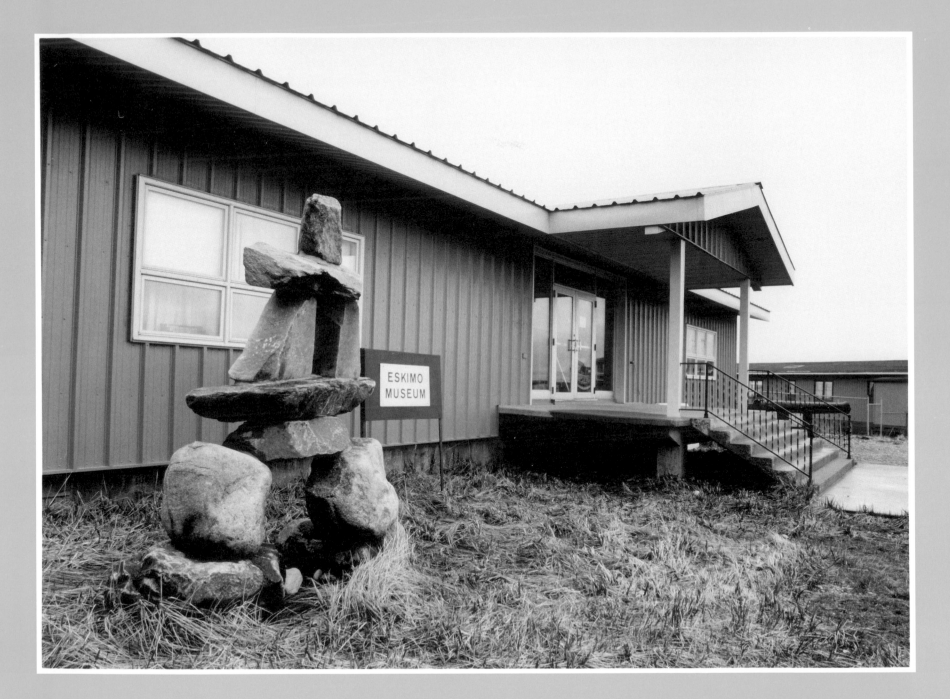

Qaujisarviup Piruqpallialaurninga...
Progressive growth of the museum...
History of the Museum

The Eskimo Museum, owned and operated by the Diocese of Churchill Hudson Bay, is located at Churchill, Manitoba. This small seaport town of 1000 people is located on the southwest side of Hudson Bay, where the Arctic tundra meets the treeline.

One of the most outstanding features of the Churchill region is its Precambrian rock formations along the shores of historic Hudson Bay. It is behind just such a rocky outcrop that the Eskimo Museum is located.

One cannot discuss the museum and its collection of Inuit carvings and artifacts in isolation from the Roman Catholic church, that founded and developed it. The Diocese of Churchill Hudson Bay covers over two million, three hundred thousand square kilometers, extending in the Northwest Territories from Gjoa Haven in the West to Iqaluit on Baffin Island, and in the North from the high Arctic Islands south to Churchill, Manitoba.

The establishment of Inuit missions in the Hudson Bay region began in 1912 when Father Arsène Turquetil laid the foundation for a mission in Chesterfield Inlet. Father Turquetil was a member of the Oblates of Mary Immaculate, a world wide missionary order. The mission at Chesterfield Inlet was to become the foundation and starting point for the first missions; these were established at Cape Eskimo (Arviat) (1924), Coral Harbour (1926), Baker Lake (1927), Pond Inlet (1929) and Igloolik (1931).

The early Oblate missionaries were French speaking and originated mainly from France, Belgium and Quebec. Supply ships and contacts with the outside world were minimal for these men once they reached their mission field. There were few non-native people in the country. English, not French, was the spoken language of the other non-native residents, and the Inuit, of course, spoke their own language, Inuktitut. The missionaries adapted to many challenges of the country with the assistance of the Inuit. These challenges included learning a difficult language, acquiring an adequate supply of food, and enduring difficult winter travel between camps to visit people.

First Roman Catholic mission in the Hudson Bay region Chesterfield Inlet, 1918.

Eskimo Museum with inuksuk, 1992.

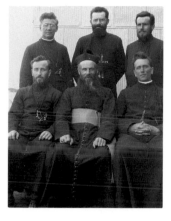

Bishop Arsène Turquetil with his fellow priests.
Back Row:
Fa. P. Girard, Fa. P. Pigeon, Br. J. Volant.
Front Row:
Fa. L. Ducharme, Bishop A. Turquetil, Fa. E. Duplain, Chesterfield Inlet, 1925.

With this new style of life came respect, some insight, and a first hand knowledge of the life of the people indigenous to the North. For some missionaries there was a natural interest to acquire and preserve items representative of life in the North.

In 1944 the missionaries started a museum in a small room at the Bishop's residence at Churchill. The museum would dedicate itself to advancing understanding and appreciation of "Eskimo" (Inuit) culture, mainly through its displays of sculptures carved by the Inuit themselves. Bishop Marc Lacroix placed Father Jean Philippe in charge, and Father Richard Ferron provided assistance. Father Phillipe was at this time also involved in setting up the *Eskimo* magazine, a periodical devoted to recording missionary life and the traditions of the Inuit. Brother Jacques Volant, the cook at the mission, took an interest in the museum from the beginning, and by 1948 was placed in charge of the museum by Bishop Lacroix. Brother Volant dedicated the rest of his working life to this responsibility.

This time period (1948-49) has been acknowledged by historians as the period of "discovery" and promotion of Canadian "Eskimo Art" production following James Houston's visit to the Eastern Arctic. However, approximately twenty-five years elapsed before major public art galleries and museums began to display and promote Inuit art more actively.

By 1948 there had been a military presence in Churchill for six years and many personnel were interested in Arctic survival. They were directed to the mission and museum where they could view "carvings" and artifacts and see films. Tourists and visitors to the town, arriving mostly during the summer and the seaport season were also directed to the museum. In later years, Inuit residents from the Keewatin District passing through Churchill on their way north or south, or utilizing local health services, found their way to the museum. Although there is only a small Inuit population in Churchill today, the number of Inuit resident in the area has varied greatly through the years. Churchill's first inhabitants 3500 years ago belonged to a Palaeo-Eskimo culture, and the Hudson's Bay Company census data in 1881 reported 515 Inuit living in the area.

By 1952 the museum had outgrown its space in the mission. It was relocated to a building, formerly a warehouse, which also contained offices for the administration and bursary of the Vicariate, and the *Eskimo* magazine. Many interesting and magnificent pieces were now in the collection. These pieces included the scenes on single or double walrus tusk ivory boards from Pelly Bay and Repulse Bay collected by Fathers

Logo –
ESKIMO magazine.

Franz Van de Velde and Pierre Henry. They included prehistoric Dorset and Thule culture material from Igloolik collected by Father Etienne Bazin and Father Guy Mary-Rousselière. Some wildlife specimens were also of interest to the visitors. The museum developed at its own pace and Brother Volant made the final selection of pieces to go into the collection.

Neither local or regional in focus, the larger part of the collection comes from the Central and Eastern Canadian Arctic, including Northern Quebec. It falls into three main categories: prehistoric art and artifacts, historical artifacts (19th century, early 20th century), and contemporary objects with ethnographic or mythological content. The contemporary sculptures created after 1930 are the main focus of the display area and their impact as a whole group of carvings is unexpected to viewers more accustomed to the more singular thematic style of display in southern art galleries. Each sculpture brings to life certain facets of Inuit life such as the ingenuity and patience of the hunter or a story relating to the interconnectedness of the Inuit to the land and the animals. As a group of carvings they support the thesis that Inuit art is not a homogeneous entity. Individual styles range from naturalistic detail to more abstract and symbolic representations. While regional styles do exist, and different properties of locally quarried stone can dictate technical limitations, the artists seem to have been inspired by their own visions, and creative

processes. These artists, for the most part have been self-taught.

Soon the need for a larger building for the museum resulted in construction of the present multi-purpose structure in 1962. By the mid 60s, the small museum in Churchill was becoming better known. Some of the exquisite prehistoric pieces from Igloolik and Pelly Bay were requested on loan for an exhibition initiated by the Musée de l'Homme in Paris. This exhibition in 1969 was called "Masterpieces of Indian and Eskimo Art from Canada."

In 1971 the museum participated in another international exposition, a traveling exhibit organized by the Canadian Eskimo Arts Council called Sculpture/Inuit that toured Paris, Copenhagen, London, Moscow, Leningrad, New York, Philadelphia and Ottawa. Requests for loans came in the 1970s and 80s from Gallery 1.1.1 at the University of Manitoba, the Winnipeg Art Gallery, the National Museum of Canada's "Discovery" train, and the Prince of Wales Northern Heritage Centre in Yellowknife.

The museum's collection has grown to contain over 800 contemporary sculptures, and some 3,000 artifacts of prehistoric and historic age. For many years now the main emphasis has been restricted to collecting sculptures, with a small number of pieces still accessioned each year.

Acquisitions have varied from direct purchases by missionary personnel, which form the majority of the pieces accessioned before 1970, to

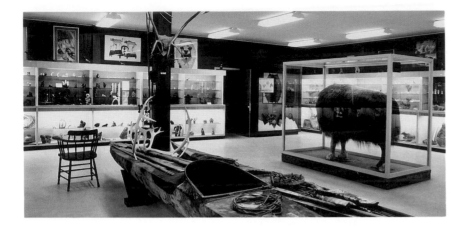

Interior of Eskimo Museum, 1992.

operative movement that became an effective promoter and wholesaler of northern arts and crafts. Since 1959 the co-operatives, today known as Arctic Co-operatives Limited through their marketing arm Canadian Arctic Producers (CAP), the West Baffin Co-operative Ltd., and La Fédération des Co-operatives du Nouveau-Québec (FCNQ) have invested major time, effort and money to develop and maintain a market for northern arts and crafts. Some authorities contend that without these efforts, the "Eskimo Art" phenomena would not have happened.

a small number of donations given to missionaries as personal gifts that were in turn re-donated to the museum, as well as purchases made from the Hudson's Bay Company (now the North West Company) or the co-operative system. A few private donations have been made to the collection by friends of the museum.

Through the years many of the missionaries including Fathers Pierre Henry, Rogatien Papion and Bernard Fransen have been instrumental in encouraging the production and promotion of carvings. Since the 1940s Father Franz Van de Velde worked very closely with the people of Pelly Bay to promote the creation of beautiful small carvings for which this community is famous for today.

Other missionaries (i.e., Father Joannes Rivoire, Father Louis Fournier, Father Josepi Meeus, Father André Steinmann, Father Andrew Goussaert) were involved in the formation of local cooperatives or the evolution of the co-

By the end of the 1960s the importance of recording more detailed information on a growing collection was recognized. Contemporary sculptures were now increasingly promoted and recognized in Canada and abroad, not just as ethnic curiosities, but as art created by individual artists. A project to catalogue the collection was initiated and completed in the early 1970s.

Brother Jacques Volant with a visitor, 1972.

During the late 1970s and early 80s new avenues of endeavour were explored. The collecting and establishment of a resource centre was one such project. A few rare books, mainly explorers' journals, that had been donated to the missions by an American benefactor, Miss Margaret Oldenburg, plus some other books already in Brother Volant's possession, including

the Reports of the famous Fifth Thule Expedition, became the base from which the present collection began. The Diocesan Photograph Archives were later started and housed in the museum resource centre.

The museum's strengths have always been in its commitment to a discerning and modest collecting policy, the conservation and permanent exhibition of a representative example of items portraying Inuit culture, and the reception of a large number of visitors. The collection provides an insight for the visitor into the history of the North expressed through original items produced by the Inuit, with a minimum of "exterior" interpretation. The Resource Centre and Diocesan Photograph Archives have expanded its usefulness to Northern residents. The museum's operation complements the activities of other northern and southern institutions, that take varying approaches to collecting and displaying Inuit art and artifacts.

An outside measure of the success of the museum can be taken from the awards presented to the Oblate community and to Brother Volant for their work to develop and maintain the Eskimo Museum. In 1976, the American Association of State and Local History awarded the Oblate community it's Award of Merit for the activities of the museum. In 1979 Brother Volant received an Honorary Doctorate from the University of Manitoba, and in 1981 he was hon-

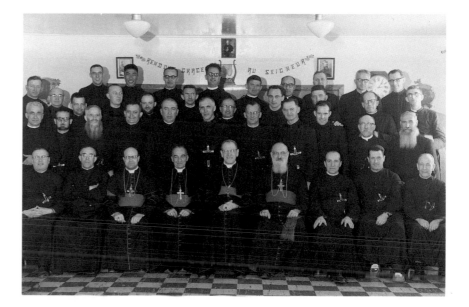

ored with the Canadian Museum Association's Award of Merit.

A small number of new acquisitions to the museum's permanent collection continue to be made each year. This small historic museum remains a symbol of the church's recognition of and respect for the uniqueness of the Inuit culture. As such, it reflects one aspect of a history of commitment by many missionary personnel to promote social and cultural objectives. Other contributions have been made in the fields of linguistics, archaeological and historical research, the collecting of Inuktitut geographic names and in the co-operative movement.

Bishop Marc Lacroix and the Oblate personnel attending the 50th anniversary of the Vicariate of Hudson Bay, Chesterfield Inlet, 1962.

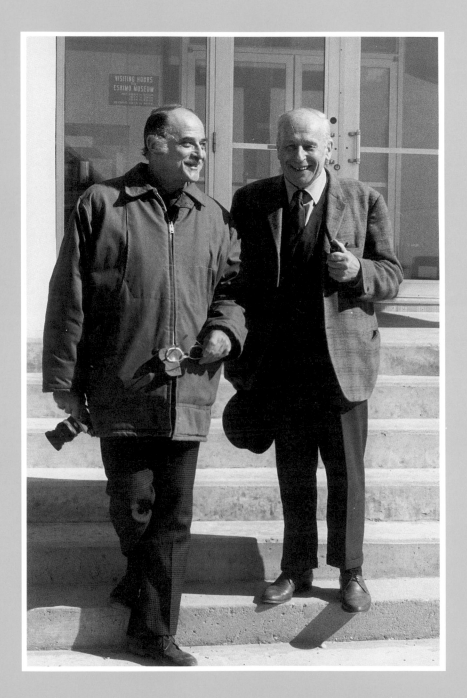

14

Piku Nakurilugu...
Saying thanks to Piku...

A Tribute to Brother Jacques Volant, o.m.i.

by George Swinton

It is with gratitude and delight that I can join in introducing this catalogue. I always have considered the Eskimo Museum in Churchill to be quite special, a real gem, which fills the gap — or rather, creates a true link — between ethnic and aesthetic considerations, also between art as means and art as end in itself. Its former curator, dear Brother Jacques Volant, o.m.i., was a superb skipper who knew how to steer the boat — his boat — along a course hardly, if ever, navigated before. And he knew how to overcome other formidable obstacles, among them lack of space in its early years, absence of government funding, challenges to its autonomy, etc.

Since the museum's history is described by Brother Volant's successor Lorraine Brandson, suffice it to remark solely on its idiosyncratic character that makes it unique. Before doing so, however I wish to add that Lorraine is not merely Brother Volant's titular successor but has been, for many years, his factotum — truly "tres bonne pour tout faire" - the museum's cataloguer, librar-ian, historian, researcher, and silent partner. She is, in fact, a true (effective and accomplished) successor to Brother Volant and his objectives. To wit, this catalogue...

It was Brother Volant's intention to create a storehouse, a testimonial for, but not a mortuary — of Inuit traditions, as well as of Inuit material and intellectual culture; truly a place for Inuit to view and to enjoy, now and in the future. That it has become a great tourist attraction, a remarkable museum, as well as an important research facility, is a by-product of the love and labour Brother Volant invested in it and of his innate sense for quality, aesthetically and ethno-historically.

At practically no time, however, was it Brother Volant's intention to collect "Eskimo Art" (as it was called then) or art as such. As I had written at the occasion of his getting an Honorary Degree at the University of Manitoba, the Museum's great success was essentially due to his ingenuity, humanity and enthusiasm. " He had a

George Swinton and Br. Volant on the steps of the museum, 1972.

great ability to relate to, and to interpret, Inuit life through art rather than merely to illustrate that life or — oh horror! — to exhibit art for its own sake."

"Through his jovial — almost puckish — personality, he was ideally suited to live with the Inuit rather than to study them". His knowledge of them — which he claimed he didn't have — was, however, not based entirely on his rich experiences with them. "I caught him again and again, not only reading, but being able to quote chapter and verse from the large literature on Arctic art, archaeology, ethnography, history, and geography." His reading and his experiences are/were well incorporated into the visual and psychic environment of the Museum. "As a result, art never interferes or competes with life but rather complements and interprets it."

Yet his choices of such art were excellent and sensitive as art itself, that is, the objects are of great aesthetic merit, and witness Brother Volant's sensitivity and "taste" — almost despite themselves. They were chosen not merely for their aesthetic merit but for their power to communicate and convince. Which, after all, is the power of all good art, involving the viewers in direct and sensuous relationships, establishing intimate rapport with them rather than pedantically educating them.

We all are very proud of the Museum, and grateful to its care-takers and to the genial and staunch support it continues to receive from the bishopric of Churchill-Hudson Bay. And grateful also — as will be today's Inuit and generations to come to all who worked for and in the museum — and to the persevering author of this catalogue, which proclaims the guiding spirit and uniqueness of the Museum and its founders.

George Swinton
Winnipeg, July 1992

Interior of the museum, late 1950's.

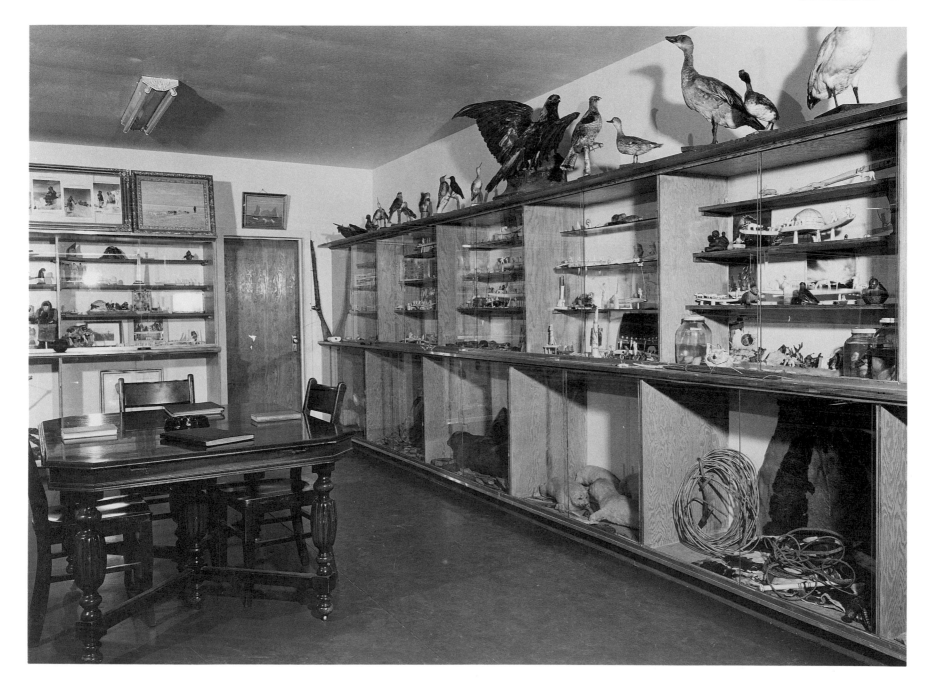

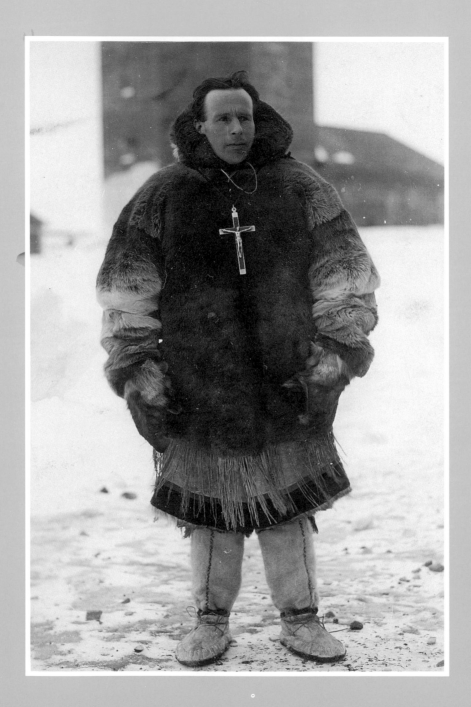

18

Piku...
Man with the hunched back...

Brother Jacques Volant, o.m.i.

Brother Jacques Volant or "Piku" as he was known to the Inuit, was born at the turn of the century in Brittany, France. He entered the Oblate juniorate in 1914 and took his first vows in April of 1919. Following two years of service in the French military in Syria he returned to the scholasticate at Liege, France. In 1925 the young Oblate brother set sail for Canada and more specifically for the northern "Eskimo" missions. Northern Canada became his home, and where he took his perpetual vows as an Oblate of Mary Immaculate. This took place in 1927 in Chesterfield Inlet, site of the first Catholic mission in the Hudson Bay region, founded only 15 years earlier by Fa. Arsène Turquetil.

The following anecdotes gleaned from interviews and Brother Volant's acceptance speech upon receiving an honorary doctorate from the University of Manitoba in 1979 perhaps best explains his life. They are in his own words.

"In April 1925, I received an appointment to the Prefecture Apostolic of Hudson Bay, Canada. I arrived at Montreal on the 18th of May 1925, and then to Chesterfield Inlet, N.W.T. on the sec- ond day of August 1925. In the spring of 1928 I joined Father Rio at Baker Lake for two years, and then back to Chesterfield to help build the new hospital. It took over two summers to build, and many missionaries came to help for a short while at the time. I have worked with Father Ducharme until late in the fall of 1930, and then came back the next spring to finish the job and shiplap the outside walls. A few Eskimos volunteered their services for one day, but the scaffoldings scared them out of sight. They went back home and to their hunting grounds.

"During the summer of 1932, I came to Churchill to stay with Father Duplain and to take care of the new house. During the month of September 1935, Bishop Turquetil requested me to go with two young priests, Father Cochard and Danielo, to the land of the narwhals at Pond Inlet, the most northward mission-post since 1929. As it was in most mission-posts, I was caring for the priests' house, fishing and hunting for food, not only for people but for dogs as well. It's a good past-time during the summer months, especially when it is integrated with ivory carving, and pick-

Brother Jacques Volant, Churchill, 1930.

ing up herb-like vegetation from the plant kingdom of the North, to supply the botanists in the south.

"I came back to Churchill during the month of December 1940 where I lived until August 1942. Then I went to Eskimo Point where I lived until the next spring, when I was requested to reach Duck Lake and build a log house for Father Rousselière. I lived with him for one whole year until I was called back to Churchill in the spring of 1944. There, I became chief-cook at the priests' house, and its caretaker as well. There

were many projects in the making at that time, such as a missionary magazine (ESKIMO) to publish, an airline company (Arctic Wings) to fly, and an Eskimo Museum to develop. My participation to this last project began with Father Jean Philippe as director until 1948, when Bishop Lacroix requested me to take charge of the museum and relieved me of all other responsibilities.

"My aims and objectives at the museum are to show the Eskimo life through carvings. I had spent 19 years working and living with these people, and was able to choose selectively from the many carvings that were sent from various missions by our priests. I now want to mention Father Pierre Henry from Repulse Bay, Father Frans Van de Velde from Pelly Bay, Father Bernard Fransen, and many others. Most Reverend Omer Robidoux, o.m.i., the Bishop in charge of the Diocese of Churchill Hudson Bay is a great supporter of the Eskimo Museum. Everything I have learned I have learned in the North. I lived with the Eskimo for 19 years and my museum has been everything to me, my life."

At the age of 86 Brother Volant became terminally ill in 1986 and retired from his work at the museum. He died the following year on September 14, 1987, at Casa Bonita, the Oblate residence in Winnipeg.

God Bless you. Brother Volant!
"Piku" Tawaovutit aksualuk.

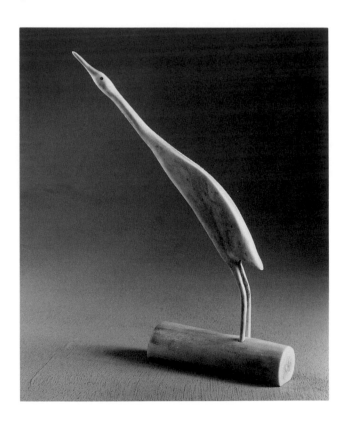

Antler carving of a crane made by Brother Volant (**Piku**) c.1970

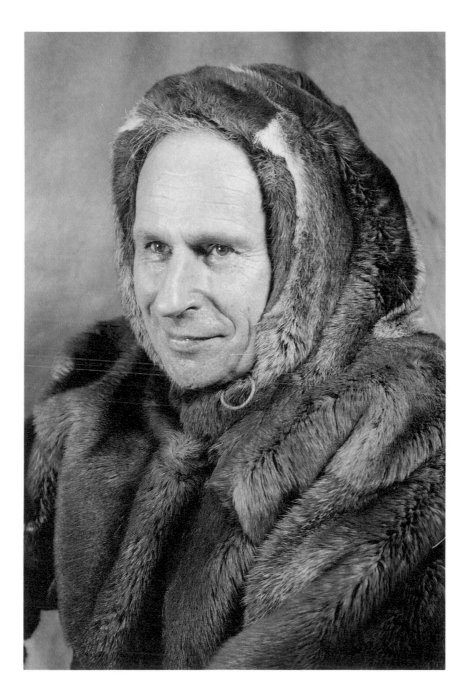

Brother Jacques
Volant, o.m.i.
late 1960's.

22

Ajuritsiarniq...
A good way of adapting...
Environment and Adaptation

WHAT IS THE "ARCTIC"?

The land where the Canadian Inuit dwell is part of the Arctic (**Itjiqarvik**), a region whose name is often taken to mean the far and cold North. There's history here, for the word "Arctic" itself is derived from the Greek word for bear. Ancient skywatchers observed the two northern constellations, the Great Bear, *Ursa Major* (our Big Dipper), and the Little Bear, *Ursa Minor*, whose leading star sailors and travelers took as the (North) Pole Star. They called the uncharted northern parts of the world where these stars appeared directly overhead "Arktikos," the country of the Bear, the Arctic.

Climatologists define the Arctic as a region with an average temperature of no more than 10° C for the warmest month of the year. By this definition, the southern boundary of the Arctic approximates the northernmost occurrence of trees. Biologists use the tree line itself to define the southern boundary of the Arctic. Complete darkness during the winter is often and misleadingly used to characterize the Arctic.

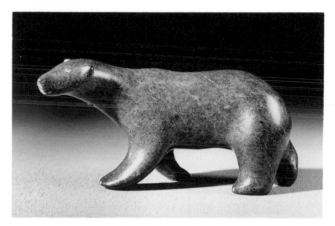

NANUQ
Andy Mamgark,
b. 1930
Arviat 1986
stone
l5 x 13.8 x 4.5 cm.

When this majestic animal emerges from the sea to the ice pack it can easily shake itself free of water before it freezes due to the special nature of its smooth, hollow guard hairs.

One actually has to travel to the Arctic Circle (66° 32') and further poleward to experience the sun missing altogether. In the higher latitudes in midwinter at midday there may only be a twilight glow to the sky. Moonlight is often brighter than day-glow.

The greatest amount of precipitation occurs in summer and early autumn but in general, precipitation decreases northward and the Arctic Archipelago is one of the driest regions in the world.

Snow may cover the ground for at least 8 months of the year. The greatest amount of snow-

R.C. Mission at Pond Inlet on the top of Baffin Island 1958.

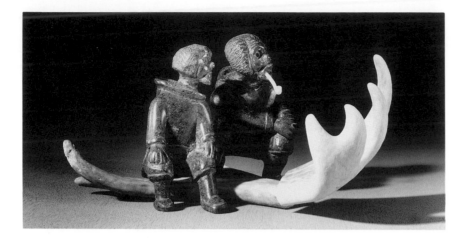

TWO MEN VIEWING
NORTHERN LIGHTS
John Kaunak,
b. 1941
Repulse Bay 1965
stone, antler, ivory
11.5 x 19 x 20 cm.

"Two men watch in
amazement at the
northern lights
(**arsaniq**) as they
shift and sway
across the sky,
almost seeming to
touch the ground."
(The closest the
aurora display
comes to the earth
is 65 kms but
objects of unknown
size in space create
a problem of depth
perception.)

fall occurs in October and November. However, the annual snowfall is less than 75 cm. Snow granules pack tightly if allowed to lie in a hollow or lee of an obstruction. Where the wind blows constantly from one direction the drift pattern of unending, low, fluted ridges provide a navigation guide for the traveler.

Understanding the forces of the wind, particularly what each direction may mean for weather forecasting is an important land skill. Not only can the wind create dangerously cold temperatures but it influences visibility, the movement of the pack ice, and the habits and occurrence of game animals.

The geologic and physiographic core of the North American Arctic is the Canadian Shield, a massive and continuous rock formation mainly granite in composition. Where the Shield stretches from Central Labrador to Baffin Island it forms the glacier-encrusted mountainous eastern wall

of the Canadian North. West of this wall lays the face of the Shield, time-smoothed rocks that remain only as undulating hills, and the lake dotted plains of the Barrens.

When a large continental glacier covered the greater part of Canada as recently as 10,000 years ago, most parts of the Arctic mainland and the Arctic islands were buried under ice. Relic glaciers are still evident today in parts of the Baffin, Devon, Ellesmere and Axel Heiberg Islands. The effects of past glaciation are evident as raised beaches, some 150 to 300 meters above sea level, where the removal of the weight of the glacial ice has allowed the land to rise.

Permafrost or perennially frozen ground underlies most of the surface. This ground has a layer of top soil that annually freezes and thaws. This layer varies in depth from a few inches to several feet and the perennially frozen ground below this layer prevents normal drainage. Surface ponds are common.

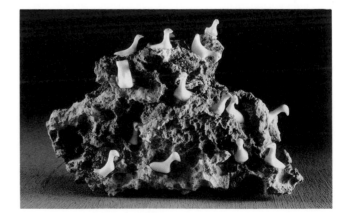

NESTING BIRDS
Dominique Tungilik
b.1920
Pelly Bay (Gjoa
Haven) 1974
ivory, stone
10.1 x 15.4 x 5 cm.

Sea gulls nest on
the ledges of
vertical cliffs out
of the reach of
predators.

Arctic soils are low in nutrients, especially nitrogen, predominantly because bacteria do not fare well in a climate characterized by short summer seasons with low temperatures. The short cool growing season, which lasts but two to three months, affects both plants and animals.

Arctic plants provide food for many animals including lemmings that occupy a central position of the food web for many terrestrial animals, including the herbivorous caribou, in turn the principal food item for wolves and man. Most Arctic plants are perennials — plants that survive more than one growing season. Flowers and vegetative buds are produced in the fall and the plant is then ready to grow in the spring when the short growing season is partially compensat-

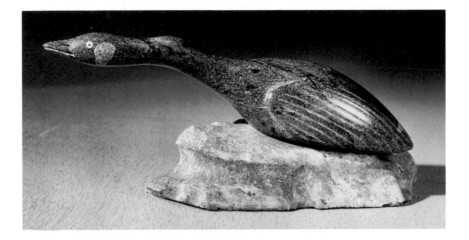

ed by periods of continuous daylight. Due to the severe climate, the deficiency of soil, lack of precipitation, and the short growing season, the rate of growth of Arctic plants is very slow. Many plant species flower and fruit for the first time after a period of many years.

Insects provide food for numerous migratory birds and in their larva stage are an important source of food for small shrews; insectivores who are active year round. Arctic insects, 50 percent of which belong to the Diptera family (flies), are able to remain active at lower temperatures than their southern counterparts. Mosquitoes and midges are well adapted to the short summer season because they have an aquatic larval stage, and water serves to buffer them against environmental temperature changes.

By late October some ice occurs in-shore in all Northern seas where the weather is calm but a more continuous ice cover is slow to develop

ULUAGULIK
Isaac Paningayak
Gjoa Haven,
(Taloyoak) 1986
6.5 x 19.5
x 9.5 cm.

Nesting Canada
goose (**uluagulik**).

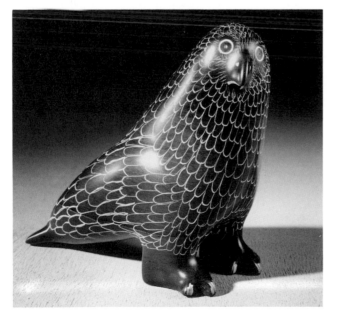

AQIGGIQ
Mina Iqaluq,
b. 1929
Sanikiluaq 1986
stone
11.4 x 13.7
x 6.6 cm.

As the autumn daylight decreases ptarmigan (**aqiggiq**) molt into their winter plumage, produce more body feathers and grow feathers on their feet that act as snowshoes.

due to late fall storms. Between January and early April most open waters to be found exists only as leads where tidal currents are strong, such as in Hudson Strait, or where there are continuous off-shore winds.

Sea ice is composed of land-fast ice, and pack ice, which is drifting and unattached to the land. The land-fast ice floe is the winter highway for the dogteam or snowmobile traveler. It covers

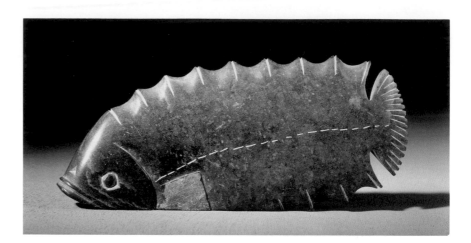

NATARNAQ
Josie Epoo, b. 1956
Inukjuak 1978
stone
7.6 x 18.2 x 2.0 cm.

Greenland halibut
(**natarnaq**), an edible marine fish is commercially fished under the name "Greenland turbot."

WINTER LANDSCAPE - SNOW PATTERNS

"The next day, good weather has really returned, luminous but glacial. It is winter in all its rigour. The snow is hard and deeply striated. The sharp ridges lie side by side one after the other, running from northwest to southeast. Long, rounded mounds trail off behind rocks and stones. Tongues and spurs seem to rise from the ground from the direction of the north winds, as if to brave them, scoffing. It is the tormented northern snow, gullied, chiseled, sculptured.

Now tracks of sled and dogs or men's footprints, or trails of caribou or foxes appear in relief. The wind has eaten away the surrounding softer snow to carry it away. It has thus drained the whole plain and the snow has built up around the edges, filling the hollows and the valleys. And savagely here and there, on some slope or summit, or in front of some kind of obstacle, the ground has been swept naked by the gusts. Winter landscape."

Fa. Lucien Schneider, o.m.i.
(near Tavani-Mistake Bay, c.1943)

the surface of all the inlets, sounds, straits and bays of the Arctic coast and grows out from the open seashore as far out as 8 to 16 km from land, or much closer, depending upon the nature of the currents in the area.

The free-floating pack ice of the open sea is made up of hundreds of ice pieces ranging from huge flat floes to areas of tumbled up ice blocks. Where phytoplankton and zooplankton thrive below the ice pack, higher invertebrate animals and fish follow, which in turn attract seals, walruses, whales and sea birds. On some days the pack ice is separated from the land-fast floe by a wide stretch of open water and on other days it is pressed against the land-fast floe edge by on-shore winds. At these places pressure ridges of jammed ice blocks develop.

New sea ice is the consistency of rubber. Unsafe new ice can be detected usually by its color because the saturated water appears as

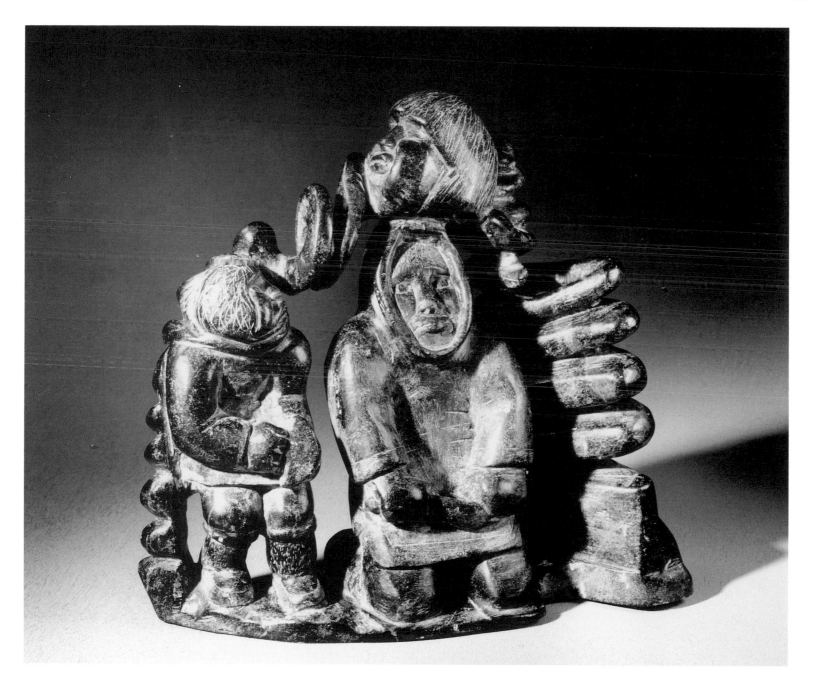

ARSANIQ
Davidealuk Alasua
Amittu, 1910-1976
Povungnituk 1969
stone
25.2 x 27 x 10.8 cm.

Given in memory of
Cecil Stewart, a
veteran H.B.C. man
The aurora borealis
(**arsaniq**) can appear
in many shapes and
colours, but it often
occurs as a thin veil
of pale, whitish
green light swirling
low across the sky.
These lights are
believed by some
Inuit to be the souls
of the recently
departed playing
football in the sky.

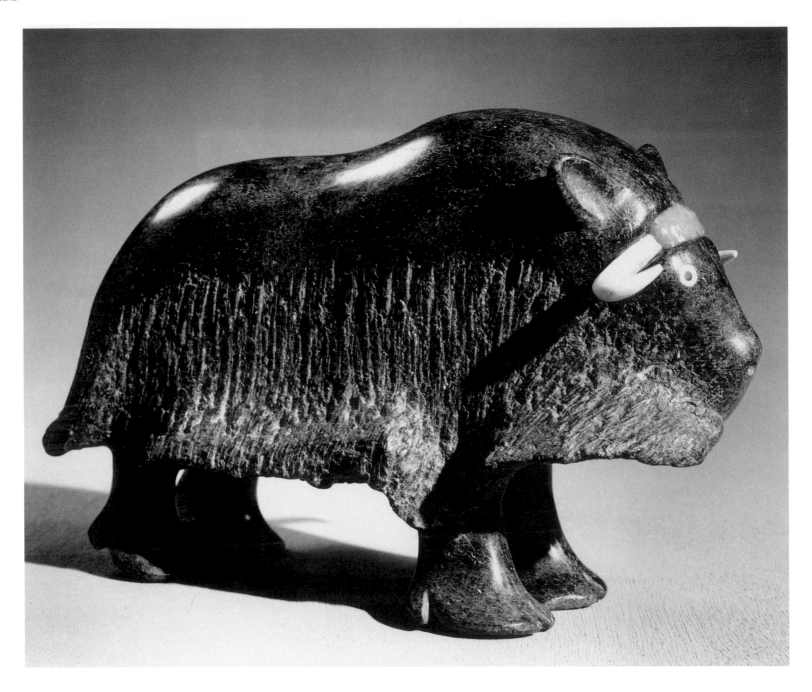

UMINGMAK
Nuveeya Ipellie,
 b. 1920
Iqaluit 1984
stone, ivory
15.4 x 25.8
x 9.7 cm.

A thick undercoat
of fine wool
covered with long
guard hairs helps
the muskox
(**umingmak**) to
withstand -40° C
temperatures.

darker ice. The experienced sea-ice traveler must not only understand the variability of ice conditions, and the forces of the wind, but he must have a keen understanding of the effects of tidal currents, and be able to read the clouds and reflections in the sky.

Dangerous travel conditions exist when "whiteouts" occur under an overcast sky where the light is diffused by the clouds, or in a fog

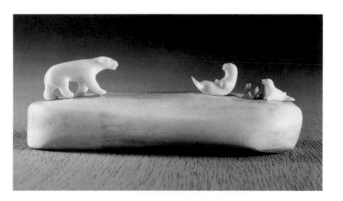

BEAR-SEALS-PUP ESCAPING INTO HOLE
Bernard Irqugaqtuq, 1918-1987
Pelly Bay 1987
ivory, antler
2.5 x 8 x 3.3 cm.

When a polar bear stalks a seal on the ice it moves steadily toward the seal until it gets to about 15 to 30 meters from it. Then it suddenly charges and the frightened seal escapes to its breathing hole. In this carving there are three seals including one pup escaping into the hole.

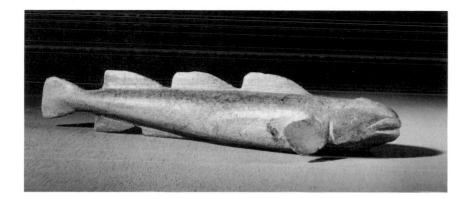

UUGAQ
Repulse Bay 1967
stone
3.8 x 20 x 7.6 cm.

Arctic cod (**uugaq**) occur almost exclusively in the Arctic Ocean and are often found in the layer of water just below the sea ice.

bank. At this time there are no shadows and space has no depth. One can see no horizon between the earth and the sky.

Arctic waters are harsh environments with long periods of low temperatures each year and a low supply of nutrients. The cold temperatures impose a long period of near-dormancy on green plants and algae that are the primary producers of food. The organic debris from which nutrients are derived by bacterial activity tends to sink and remain below the level of light penetration, and there is little nutrient replenishment to upper

water layers from these deeper waters.

Arctic fish have slow growth and reproductive rates. A 10 year old lake trout (*Salvelinus namaycush*) might weight 1 kg in the Northwest Territories compared to 5 kg in temperate southern waters. The dominant freshwater fish species contained in lakes and streams are the anadromous arctic char (*Salvelinus alpinus*), the land locked arctic char, lake trout, whitefish and arctic grayling (*Thymallus arcticus*). The most dominant fish of the Arctic coast region are the arctic cod (Boreogadus saida) and the arctic char, a member of the salmon family. Most char travel in large schools to the sea for a few weeks in summer soon after their fifth year of life.

The dominant life forms in the sea are the marine mammals. The principal species are the seal, walrus and whales. The five commonly occurring seals: the ringed seal (*Phoca hispida*), the bearded seal (*Erignathus barbatus*), the harbour seal (*Phoca vitulina*), the harp or saddle-back seal (*Phoca groenlandica*) and hooded seal

AIVIQ
Timothy Jar, b. 1934
Coral Harbour 1985
whale bone
18 x 33.5 x 19.5 cm.

With its expansive
jowls, luxurious
whiskers and
wrinkled skin the
walrus (**aiviq**) has
an almost human
like appearance.
The female has tusks
that are shorter and
thinner than those of
most males.

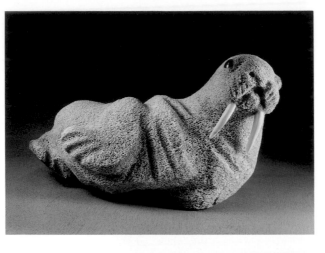

QILALUGAQ
Napatchie Noah
b.1926
Iqaluit 1991
stone
7.5 x 8.5 x 18.2 cm.

The beluga or white
whale (**qilalugaq**) is
the smallest whale
in the Arctic.

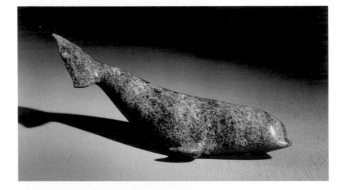

POLAR BEARS
FIGHTING OVER
SEAL MEAT
Prime Okalik, b. 1923
Rankin Inlet,
(Whale Cove) 1969
stone
8.4 x 29.5 x 11.7 cm.

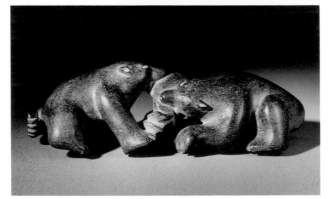

(Cystophora cristata) belong to the Pinnipedia family of mammals that also includes the Atlantic subspecies of walrus. Ringed seals are the most abundant and widely distributed of the five seal species. While the three species of whales — the bowhead *(Balaena mysticetus)*, beluga *(Delphinapterus leucas)* and narwhal *(Monodon monoceros)*, the "one toothed animal that's like a unicorn" are full time arctic residents, they all migrate seasonally to stay clear of the pack ice.

Several animal species are adapted to life in both marine and terrestrial environments. Walruses *(Odobenus rosmarus)* live nearly all their lives in the sea, feeding on starfish, shellfish and crustaceans, but give birth to their young on land. Polar bears *(Ursus maritimus)* are large carnivores that spend most of their time on pack ice hunting the ringed seal, their staple food. They are forced onto land when the ice melts and must either await freeze-up or move to regions where ice remains. Maternity denning sites are usually located in coastal areas in thick snowbanks on the leeward side of hills and valleys. Both arctic terns *(Sterna paradisea)* and oldsquaws *(Clangula nyemalis)* are birds that feed largely on animal life in water, but do nest on land. The Arctic loon *(Gava arctica)* also nests on land, but keeps close to the water edge because it is so awkward on land.

In Canada over 520 species of birds can be found, 75 of which spend part of the year north of the tree limit. Only 8 spend their entire lives in the North — the raven *(Corvux corax)*, the snowy owl *(Nuyctea scandiaca)*, the gyrafalcon *(Falco rusticolus)*, the willow ptarmigan *(Lagopus lagopus)*, the rock ptarmigan *(Lagopus mutus)*, the black guillemot *(Cepphus grylle)*, the dovekie *(Alle alle)*, the thick-billed murre *(Uria lomvia)*, and 3 members of the Auk family.

Most of the migrating species are principally insect eaters and ground feeders. In spring the birds return en masse to begin nesting, and quickly raise their young before heading south.

The Arctic supports only six major indigenous species of terrestrial mammals: barren ground caribou *(R.T. groenlandicus)*, polar bear, barren ground grizzly bear *(Ursus arctos)*, muskox *(Ovibos moschatus)*, arctic fox *(Alopex lagopus)*, and wolf *(Canis lupus)*. Other animals commonly associated with the Arctic are the

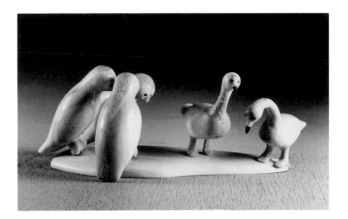

OWLS AND GEESE
Helen Qarqmatsiaq
Qirngnuq, 1913-1985
Pelly Bay 1959
antler, plastic
4.3 x 11.6 x 6.2 cm.

LOON CAPTURING
FISH
Repulse Bay 1960
ivory
11 x 27.3 x 3.8 cm.

A loon dives for its prey and can remain submerged for several minutes if necessary.

Arctic hare *(Lepus arcticus)*, short tailed weasel *(Mustela erminea)*, red fox *(Vulpes vulpes)*, wolverine *(Gulo gulo)*, Arctic ground squirrel *(Spermophilus parryti)*, Greenland collared lemming *(Dicrostonyx groenlandicus)*, brown lemming *(Lemmus trimveronatus)*, tundra redback vole *(Clethrionomys rutilus)*, meadow vole *(Microtus pennsylvanicus)*, and the masked shrew *(Sorex cinereus)*.

Although barren-ground caribou engage in

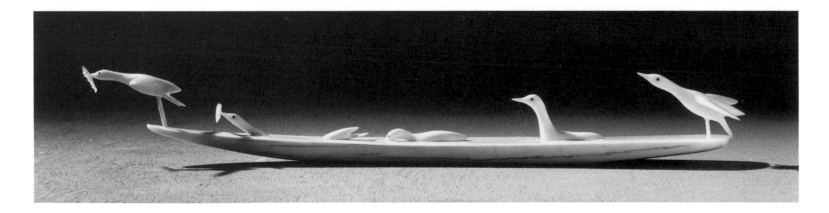

semi-annual migrations north and south between regions of tundra and taiga, there are always subgroups of animals wintering on the tundra. Here they keep to exposed ridges and slopes of hillsides where little snow accumulates and lichen and woody growth can be found.

Arctic foxes have a holarctic distribution. Known to occur throughout the whole Canadian Arctic these sturdy little animals weighing 3 kg on the average, seek shelter only in the coldest and stormiest of weather.

The Arctic fox is one of a host of Arctic carnivores that live on lemmings, the animal that constitutes the main food supply of many arctic fur bearers. Raptorial birds including the snowy owl, the short-eared owl *(Asio flammeus)*, the gyrafalcon, the rough-legged hawk *(Buteo lagopus)*, the parasitic *(Stercorarius parasiticus)* and long-tailed jaegers *(Stercorarius longicaudsu)*, and the ravens are other intense predators of lemmings. Lemmings are known for their extreme cyclical population fluctuations.

The arctic ground squirrel or siksik is the only arctic animal that hibernates. During its nearly eight month hibernation its normal heart rate of 200 to 400 beats a minute drops to 5 or 10 beats.

THREE CARIBOU
Cape Dorset 1965
stone
8.4 x 18.5 x 6.4 cm.
3.4 x 6.6 x 1.1. cm.
9.6 x 13 x 6.3 cm.

Antlers are grown by both male and female caribou (**tuktu**). They shed them annually at different times of the year according to their age, sex, and condition of pregnancy.

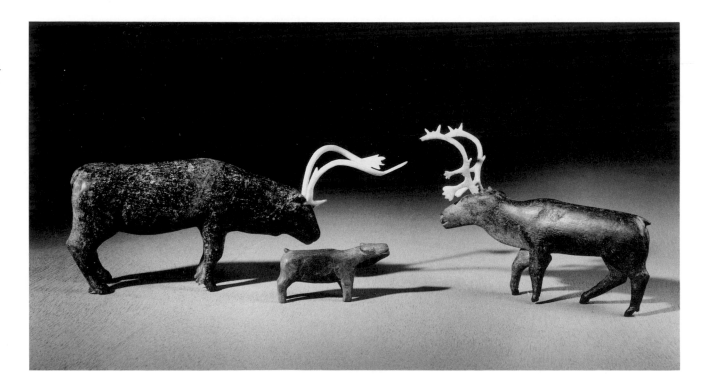

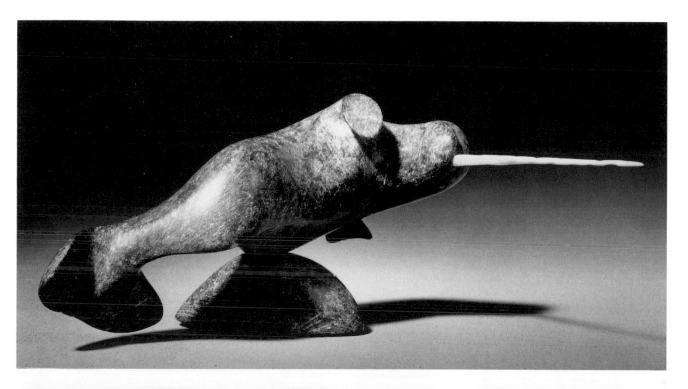

ALLANGUAQ
Thomas Saumik,
b. 1942
Repulse Bay,
(Rankin Inlet) 1965
stone, ivory
7.5 x 14.8 x 4.1 cm.

When a pod of narwhals (**allanuguaq**) is spotted, the gleaming ivory tusks of the males are seen surging through the water as they swim and dive in unison. The evolution of the tusk that spirals counter-clockwise is still a mystery.

QILALUGAQ
Lucie Angalakte
Mapsalak, b. 1931
Repulse Bay 1980
whale bone
4.4 x 18.4 x 7.1 cm.

The beluga whale (**qilalugaq**) possesses one of the most sophisticated underwater communication and guidance systems in the mammalian world.

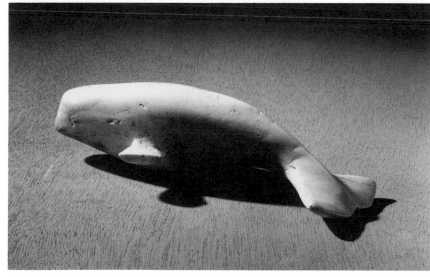

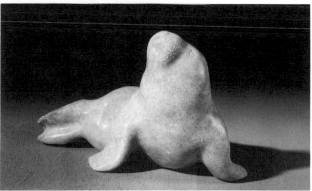

AIVIQ
Isaac Killikte, b. 1948
Pond Inlet 1990
stone 10 x 11.3 x 16.5 cm.

The temperature of the body drops close to freezing and its respiration rate slows almost to a stop.

The arctic ecosystem, the youngest ecosystem on earth, has been frequently described as "sensitive" due to its extreme vulnerability to disturbance. Disruption of protective permafrost layers creates melting and erosion. In the event of oil spills, the decomposition of such a foreign substance would be restricted, with wave action and dispersion effects absent for most of the year. Plant and animal species are slow to regenerate. There is a small number of species, and a consequent simplicity of food chains.

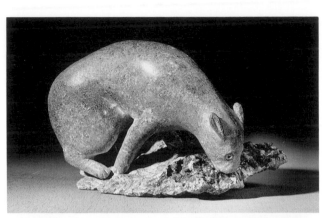

UKALIQ
John Kaunak,
b. 1941
Repulse Bay 1959
stone
9.1 x 15.6
x 12.5 cm.

The Arctic hare (**ukaliq**) is the biggest member of the hare family. It may congregate in small family units or in large herds of 100 or more as they do in the High Arctic.

OWL, SNOWBIRD,
AND LEMMING
Peter Ahlooloo,
b. 1908
Arctic Bay 1967
whale bone, antler
17.8 x 17 x 5.5 cm.

"The owl teases the snowbird outside the lemming hole to draw the lemming out. The owl then feeds on the lemming."

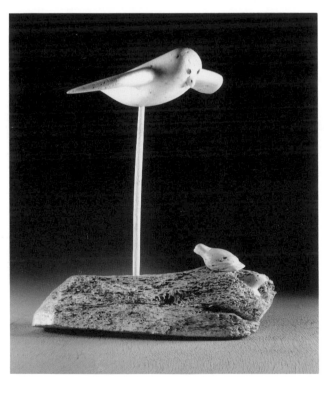

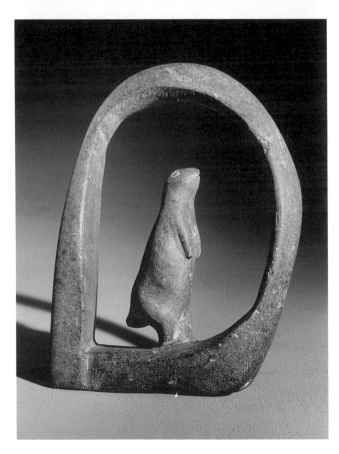

SIKSIK
Simon Kolit,
b. 1914
Arviat (Rankin Inlet)
1975
stone 21 x 16.3 x
8.5 cm.

The only true Arctic hibernator, the arctic ground squirrel (**siksik**) follows a fairly rigid summer schedule, foraging from about 4 a.m. to about 9:30 p.m., then heading to its underground nest to sleep for 7 or 8 hours.

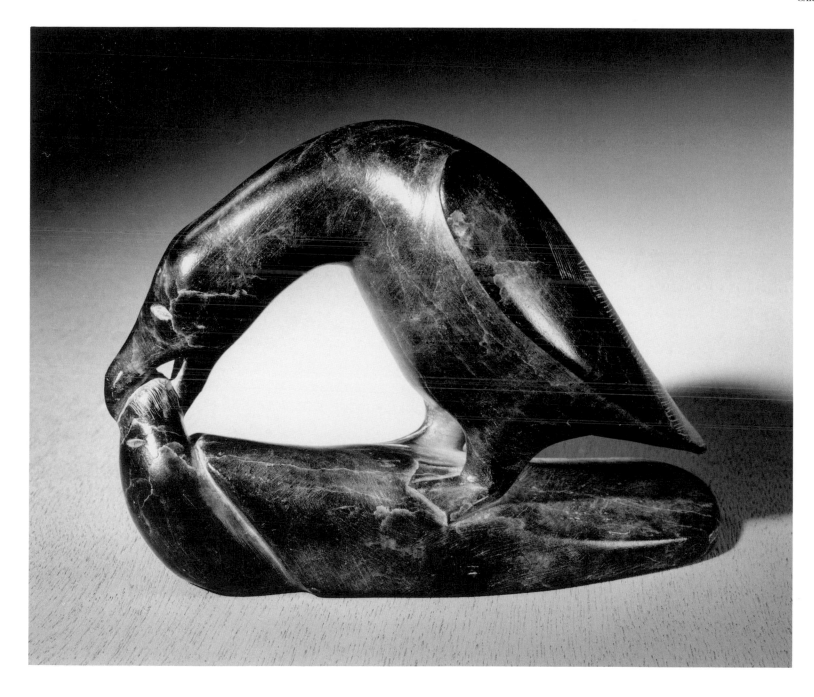

GULL EATING FISH
Adamie Aupalurta
Putugu, b. 1934
Povungnituk 1953
stone
11 x 5.8 x 8.3 cm.

Gulls arrive early
in the spring and
hunt for fish or
crustaceans in the
leads among the
ice.

TWO SEALS ON
THE ICE
Mariano
Aupillardjuk,
 b. 1923
Arviat, (Rankin Inlet)
1975
ivory (sperm whale
tooth), stone
5 x 8.2 x 7.5 cm.

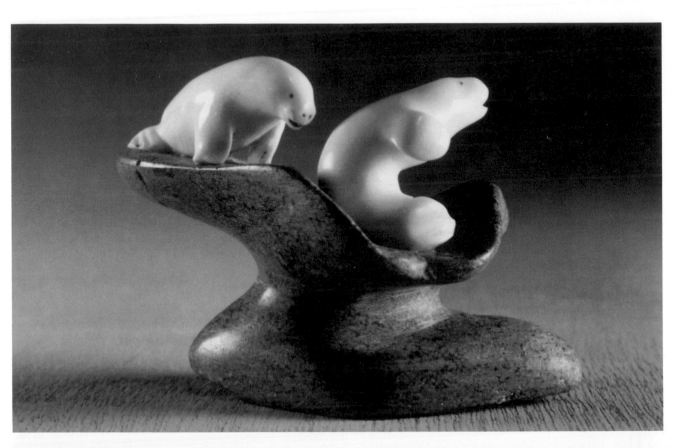

COURTING LOONS
Pie Unalerjuar
Sanertanut,
b. 1949
Repulse Bay 1976
ivory, stone
5.5 x 3.4 x 3.3 cm.
3.7 x 4.6 x 3 cm.
3.3 x 8.8 x 1.7 cm.
4.7 x 4.9 x 2.5 cm.
1.9 x 5 x 3 cm.
Courting loons
(**kaglulik**).

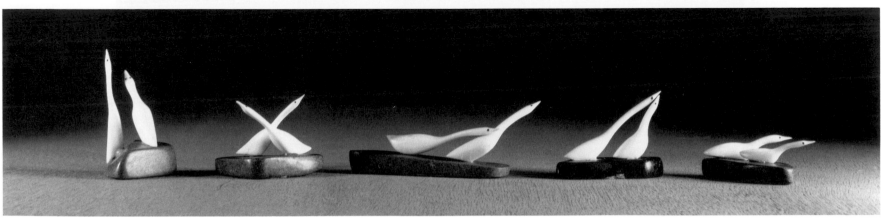

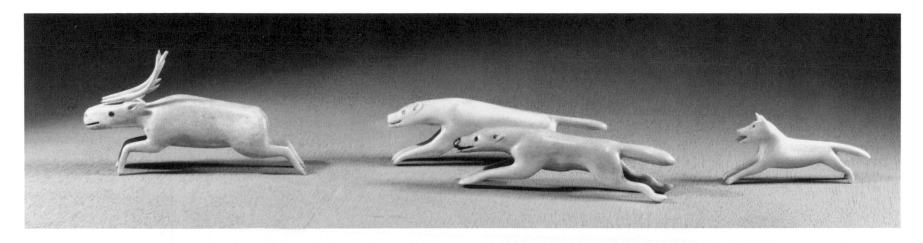

WOLF CHASING
CARIBOU -
FOLLOWED BY FOX
Simon Inuksaq,
b. 1923
Pelly Bay 1950
antler
caribou
6.7 x 10.7 x 2.1 cm.
wolf
2.8 x 10.6 x 1.9 cm.
wolf
3.2 x 11.1 x 1.7 cm.
fox
4 x 7.5 x 1 cm.

It is said that when
a wolf (**amaruq**)
hunts a caribou it
jumps up and seizes
the anus. The
caribou turns to
defend itself and the
wolf grabs the throat
with his teeth. The
arctic fox (tiriganiaq)
scavenges on the
remains of the kill.

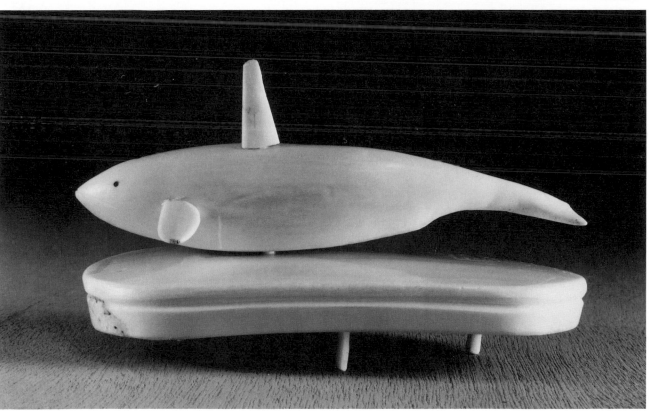

AARLUQ
Repulse Bay 1964
ivory
7.9 x 13.8 x 5.7 cm

Killer whales
(**aarluq**) often drive
the beluga whales,
narwhals, and seals
close to shore
where they can be
more easily killed
by hunters.

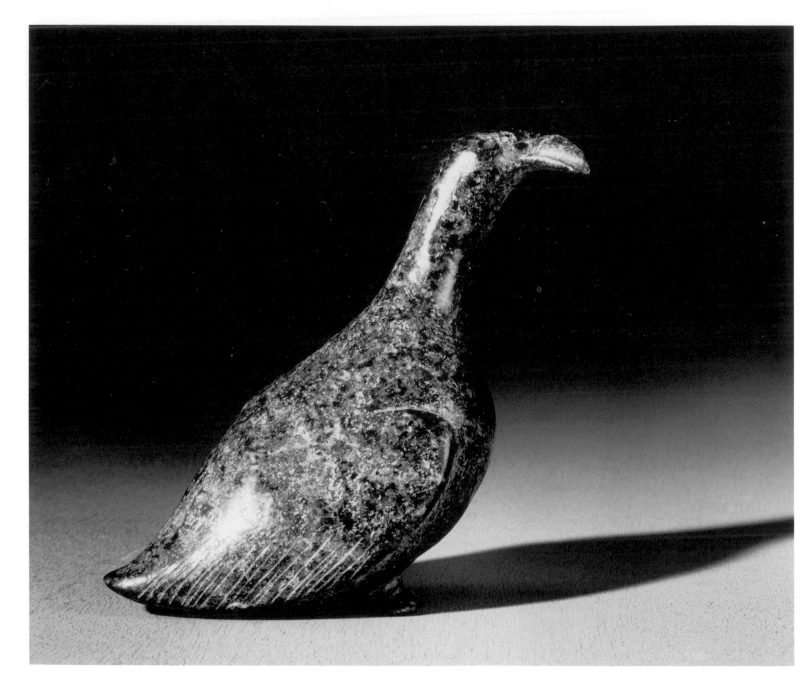

SEAGULL
Madeleine Isserkrut
Kringayark,
I928-1984
Repulse Bay 1964
stone
13.7 x 18.3
x 7.5 cm.

The increased
circulation of blood
specifically directed
to the legs and feet
of the gulls is an
asset to a bird
spending extensive
amounts of time on
the ice watching for
food.

TULUGAQ
Anrnarinaaq
Hatkaittuqi
Sanikiluaq 1964
stone
10 x 37.5 x 16 cm.

In flight, the raven (**tulugaq**) alternate- ly flaps and soars like a hawk.

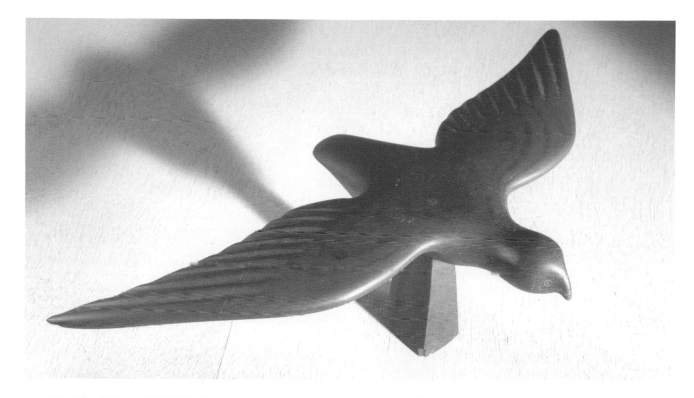

SNOWY OWLS
HUNTING
Bibiane Ittimangnaq,
1912-1979
Pelly Bay 1962
antler, bear skull,
ivory, plastic
8.6 x 11.2 x 11.7 cm.

Snowy owls (**uppik**) have completely feathered legs and toes to withstand the long, cold winter.

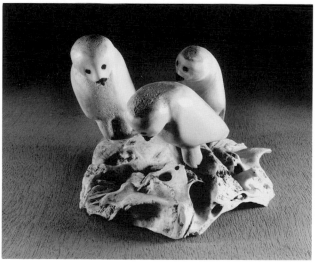

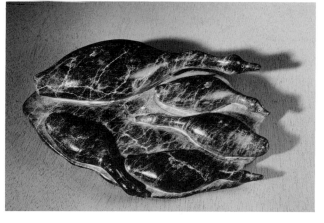

MOTHER GOOSE
AND YOUNG
Povungnituk 1953
stone
4.4 x 19.1
x 13.8 cm.

Flocks of migratory geese come and leave the Arctic quickly, laying their eggs, molting and getting their young into the air in five or six weeks.

QUGJUK
James Kukkik,
b. 1949
Hall Beach 1975
ivory, antler
5.3 x 16.1 x 8.5 cm.

Tundra swans
(**qugjuk**) arrive in the
Arctic by mid May.
Courtship begins in
late winter and
continues through the
spring migration.

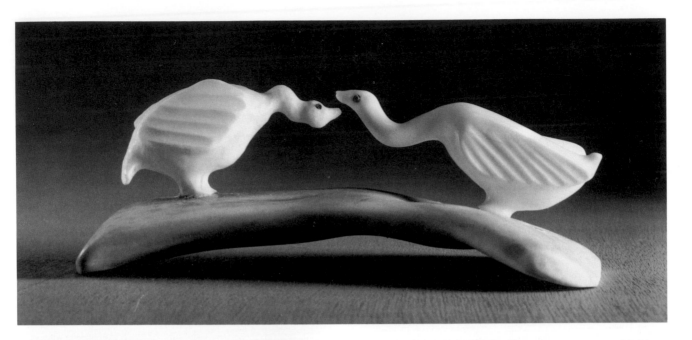

IMIQQUTAILAQ
Repulse Bay 1959
ivory, plastic
8.5 x 10.3 x 5.5 cm.

These graceful little
birds carved with
coral red feet in
plastic will angrily
dive bomb any
intruder. Arctic terns
(**imiqqutailaq**) fly to
the Antarctic Ocean
at the end of the
summer. By the time
they return to the
Arctic they will have
traveled at least
25,000 km.

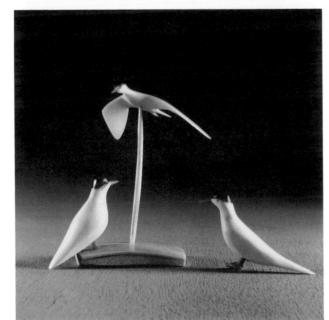

TIRIGANIAQ
Pond Inlet 1960
stone
2.5 x 6.3 x 2.5 cm.

Normally solitary
animals arctic fox
(**tiriganiaq**) can be
seen together
during the mating
season, or when
they are attracted
to the remains of
an animal killed by
a wolf or bear, or
the carcass of a
stranded whale.

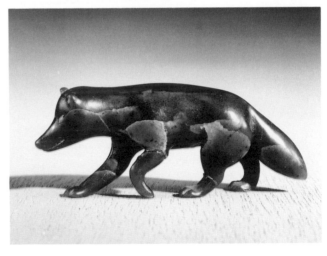

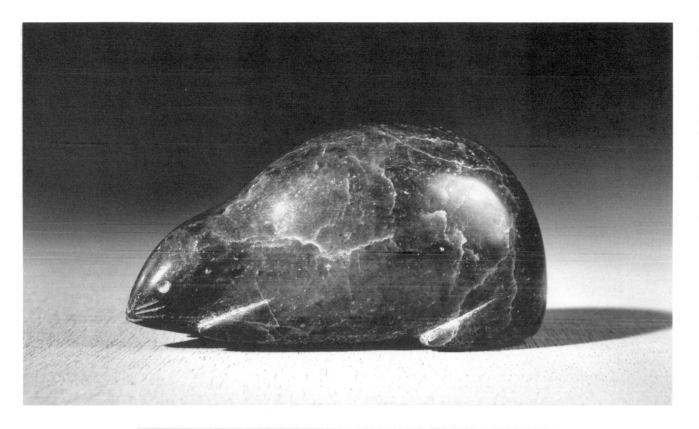

AVINNGAQ
Louise Sarpinak
Hall Beach 1974
stone
4.5 x 10.1 x 5.3 cm.

Lemmings
(**avinngaq**) can
tunnel through the
snow to a warmer
environment aided
by elongated third
and fourth toes that
serve as powerful
digging claws.

KULLUQ
Repulse Bay 1968
stone
11 x 6.3 x 2.7 cm.
Louse (kulluq).

OWL WITH YOUNG
IN AMAUT
Theresa Totalik
Taloyoak 1992
duffel, wool, cotton
32.8 x 25
x 18.4 cm.

Taloyoak is famous
for the "Spence
Bay packing dolls."

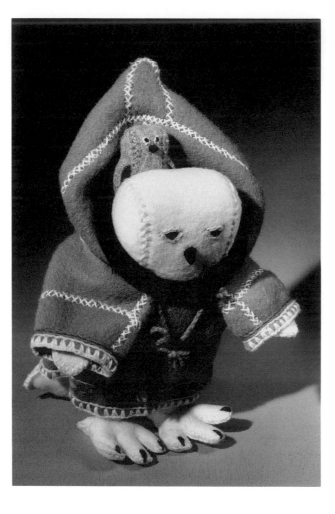

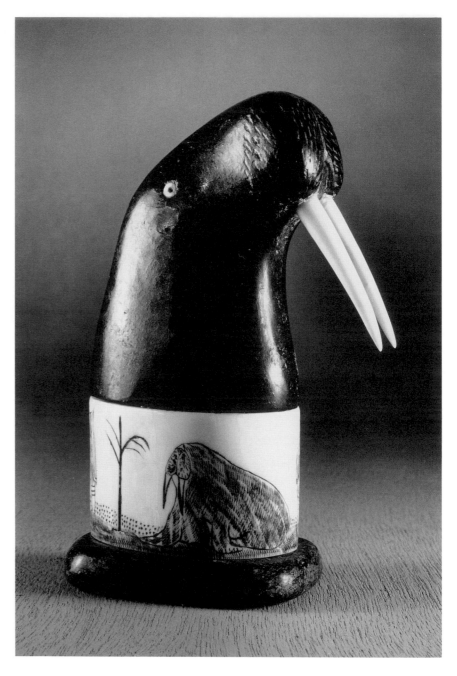

AIVIQ
Cape Dorset 1944
stone, ivory
13.6 x 4.8 x 8.7 cm.

TWO WEASELS
Mark Tungilik,
1913-1986
Repulse Bay 1975
ivory, stone
2 x 5.7 x 3.4 cm.

The short tailed
weasel or ermine
(**tiriaq**) seems to
constantly seek
food, its primary
diet consisting of
small rodents. This
ferocious little
carnivore can
pounce with
lightning speed on
its victim's shoulder
and bite through its
prey's neck.

FREEZE - UP

"The first cold has arrived; it is already freezing at night. The equinox is approaching and the winds are getting worse. The wind will soon have solidified the lakes. It would only take one night and this first freezing could be it, with no going back whatsoever.

Then this land so soft, so slippery and spongy becomes hard and resonant, and the thin ice that covers all the indentations, cracks under foot. At the southern end of the lakes from which the wind projects a dusting of water, it is strange to see blades of grass which yesterday quivered, today encased in their girdles of ice thicker than the thumb, and curled over like crosiers. The waters, though agitated by the furious winds, little by little stiffen their waves and the ice follows the path of the north wind.

No more birds. All have fled towards more hospitable skies. Only here and there, swimming on some patch of lake left liquid, one or another of those big ducks, - eiders - that spend the winter in the country, on the seas, around the edges of the ice.

One day the sky closes in, cloudy, overcast, almost black and low, retaining the cold fogs and, from the north-east, the wind which has risen obliquely throws its compact, hard flakes of blinding snow. The next day the wind turns to the north-west, hardens this snow and packs it into the hollows of the terrain."

Fa. Lucien Schneider, o.m.i.
(Arviat, 1939)

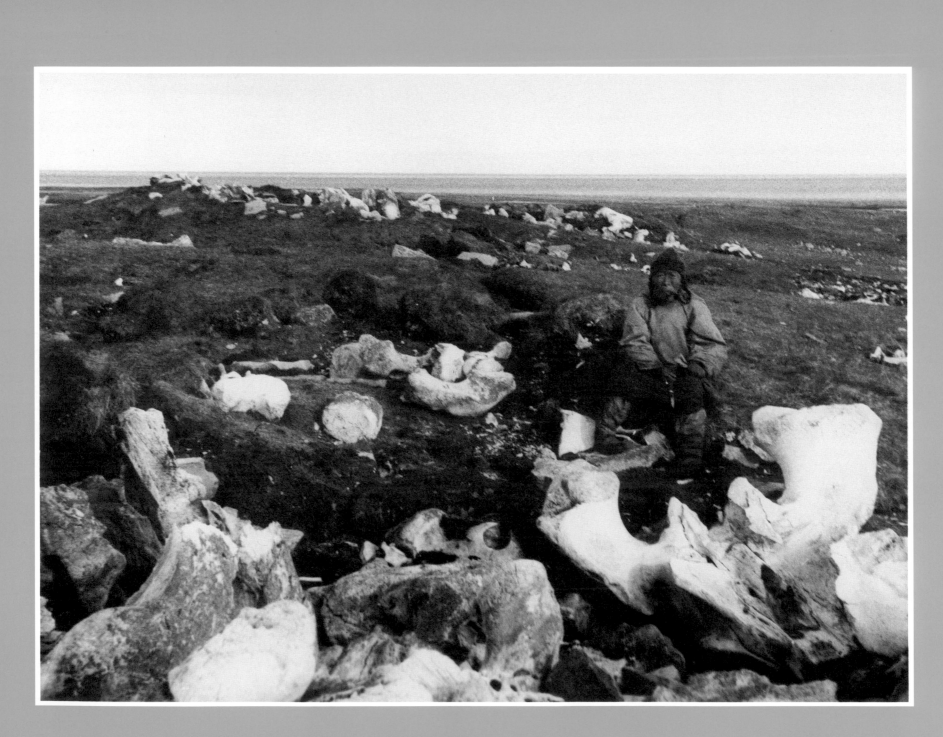

44

Itsarnitait...
Things of the past...
Arctic Archaeology

The first systematic archaeological excavations in the Canadian Arctic were made in 1927 by Therkel Mathiassen (**Tikilik**), a member of the famed Fifth Thule expedition. Arctic archaeologists have been facilitated in their research because the area's remains are relatively well preserved, more visible in comparison with artifacts in southern regions, and located in relative isolation from other cultural traditions.

While the permafrost helps to preserve the artifacts it also makes excavating a difficult task as the ground thaws to only a few feet in depth in some places. Once the permafrost has been reached, excavation may only proceed at a few inches per day as the exposed soil thaws further.

In the search for Eskimo origins and ancestry, archaeologists have recorded the existence of various hypothetical prehistoric cultures that populated the area. In Arctic Canada we refer to these cultures as the Palaeo-Eskimos (they include the Independence I and II cultures of the High Arctic, Pre-Dorset and Dorset cultures in the Low Arctic, and Groswater Dorset culture in

Monica Aaguuttaluk "Queen of Igloolik" at Thule archaeological ruins at Pingerkalik, 1954.

Labrador) and the Thule people, a second cultural tradition distinct from the Palaeo-Eskimos.

PALAEO-ESKIMOS (2000 B.C.)

Palaeo-Eskimo camps appeared in the western regions of the North American Arctic 4000 years ago and spread from Alaska to Greenland. A point of origin for these people is yet unknown, although the prevailing choice of Alaska, and ultimately Siberian origins with Bering Strait as the avenue of entry, has not been definitively challenged. The first known skeletons indicate that they were Arctic Mongoloids, as are the Aleuts, Eskimos, and people of Siberia. Apart from Indian occupations in the Barren Grounds, these people were the earliest occupants of Arctic Canada.

The Pre-Dorset Period
(2000 B.C. - 800 B.C.)

The Pre-Dorset culture of the low Arctic islands and mainland area centered on the region of northern Hudson Bay, Hudson Strait and Foxe

Basin. The resources utilized by this culture included caribou, fish, ringed and bearded seals, migratory harp seals, walrus, whales and birds.

Pre-Dorset bands would seasonally camp at traditional hunting locations where caribou crossed a river, at sealing grounds or at fishing spots. They also split into smaller groups to travel and exploit all the various resources available.

The Dorset Period
(800 B.C. - A.D. 1000)

Although there is general agreement among archaeologists that the Dorset culture emerged from the Pre-Dorset culture, there is no agreement about the causes or nature of this transition dated between approximately 800 and 500 B.C.

At one time the Dorset people occupied much of Arctic Canada east of Dolphin and Union Strait, south to Newfoundland, and north to Greenland. They may have spent the spring and summer months on the coast, living on the rich mammal resources of the sea, and moving in late summer to gather at fishing spots and caribou hunting areas. In the fall the Dorset people may have dwelled in semi-subterranean houses, and in the winter on coastal sites in snowhouses.

The Dorset adaptation appears to have been more successful than the Pre-Dorset one. Tools such as ivory sled shoes, presumably made for small man-drawn sleds, snowknives, and ice creepers, apparently not known in Pre-Dorset times, appear in Dorset culture sites.

The Dorset people left a vivid impression on the Inuit, for there exists a rich oral tradition about an earlier people the Inuit call the Tunit. This oral tradition is spread among most of the Inuit living east of Coronation Gulf to Greenland, except for the Caribou Inuit. According to this tradition, when the ancestral Inuit first came to the Canadian Arctic they found the country occupied by the Tunit.

According to Fr. Guy Mary-Rousselière's research among the Inuit of Igloolik, "the **Tunit** were extremely well built... their extraordinary strength enabled them, to lift huge rocks and carry heavy loads. A good number of the tales of which they are the heroes stress this unusual strength... their habitats probably skin tents were rectangular or square, and comprised a wall of stone which was sometimes quite high but most often no more than a foot and a half. The Tunit placed their feet on this wall while they were sleeping to prevent the blood from running down their legs... the **Tunit** had no dogs and it was by walking that they shifted from one place to another. They were very swift runners and hunted caribou on foot, racing after them killing them with spears.

In winter, when they (the **Tunit**) hunted seals at the **'aglus'** (seal breathing holes in the ice), they often had to spend the entire night outside watching and waiting for the seal to appear. To warm themselves, they had a small stone lamp, oval in shape, which they placed in front of them

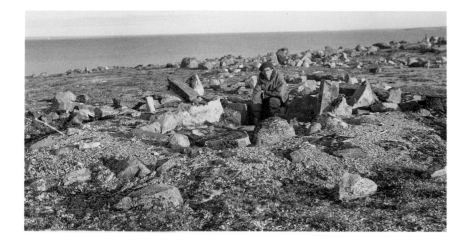

Fa. Guy Mary-Rousselière at a Dorset house at the Jens Munk site, Igloolik, 1954.

on a low stand. Stooping, they placed the front of their **"atigi"** or inner caribou shirt over this lamp, thus creating a sort of tiny tent where the temperature rose rapidly, warming the hunter's body. This practice naturally had several drawbacks, as when a seal came up in the hole to breathe, in his haste to harpoon the animal, the hunter often knocked over the lamp and burned himself. They say the **Tunit** often had numerous burn scars on their stomachs and chests.

"They also hunted walrus and square flippers and it is said a **Tunerk** (**Tunit**) could, without help, drag a bearded seal or even a walrus on the ice. In this line, William Okkomaluk (from Igloolik) tells us the following anecdote: one day, on the ice, an Eskimo met a **Tunerk** (**Tunit**) who had just killed an **"ugjuk"** or square flipper. Seeing the stranger, the **Tunerk** lifted the animal (average weight 270 kg) on his back and started off for home.

"In spite of their strength, the **Tunit** were finally forced to leave the country by the invasion of the Eskimos. For some, there were bloody battles : Our ancestors, like the white men, loved to fight," Anangoar told me (Fr. Mary-Rousselière) one day. It was following these battles that the **Tunit** fled from Repulse Bay towards Igloolik.

"However, it is generally thought at Igloolik that the penetration of the new arrivals was made in a more peaceful way and that the **Tunit** withdrew of their own accord by timidity. The following is often heard: The Tunit were very strong but they were not ill-natured and did not like to fight. This does not mean that they were happy to leave their own land. On the contrary, they were much attached to their country as is proved by the following story."

WHY STUDY ANTHROPOLOGY AND ARCHAEOLOGY ?

"Perhaps I should answer right away a question that has sometimes been put to me : Why did I, as a priest, study anthropology and archaeology ? My answer is that I don't see any contradiction between the study of God, in theology, and the study of man, created by God. Moreover I think that anything that helps me to better understand the culture of the people among whom I live is justified."

Fa. Guy Mary-Rousselière, o.m.i.
(Pond Inlet, 1987)

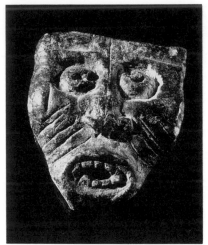

MASK
Dorset Culture
Igloolik
soapstone
4.5 x 3.7 x .9 cm.

This small face is one of a small number of Dorset culture "art" objects carved from soapstone that have been found in the Canadian Arctic. It is a reworked fragment of a soapstone lamp. Since its upper margin is perforated as if for suspension, this mask might have been worn around the neck, or sewn to a garment as an amulet. The incised lines, if they are meant to depict tattoo marks, might well suggest a woman's face.

"One of the last spots the **Tunit** occupied in the Igloolik region was the island of Uglit, about forty miles south of Igloolik. Little by little, they had been "made land-less" (**nunaerti-taulaurmatta**) and forced to abandon their best hunting camps : Igloolik, Alarnerk and Pingerk'alik. Finally, the Eskimos had come and installed themselves at Uglit. Because of this, the **Tunit** left for K'immertorvik, south of Uglit. However, one of them hesitated a long while before deciding to depart. At last, sick at heart, he made up his mind, but just before leaving his beloved island he set up a howl, grimacing with rage at the Eskimos, and struck the ground repeatedly with his harpoon. And such was his strength that splinters of rock flew in the air. The deep marks made by his harpoon are still to be seen near the shore."

Dorset culture achieved its greatest expansion in its later period, reaching from southeastern Hudson Bay to northwestern Greenland and west to Victoria and Melville Islands. It was at this time that artistic expression on carved items becomes evident.

Any attempt to determine the function of prehistoric art can only be speculative at best. Nonetheless, most archaeologists and art historians generally agree that the small engraved "art pieces" found at Dorset sites were not meant primarily as decorative items, but could have been related to magico-religious rituals. Some historians speculate that some crisis or combination of crises such as the appearance of the superior-equipped Thule Inuit and a warming climate that resulted in changed hunting patterns, turned the people increasingly toward their shamans and religious beliefs for guidance and protection.

Around A.D. l000 the northern hemisphere, including the Canadian Arctic, experienced a warming trend, probably causing change in sea-ice conditions and animal distributions. The tree line in central Canada advanced north about 100 km.

Shortly after this time, a migration from the West (Alaska today) brought the Thule people to the Canadian Arctic. The Thule are the ancestors of today's Canadian Inuit of the Central and Eastern Canadian Arctic and of the Inuvialuit of the Western Canadian Arctic. Both Thule and Dorset cultures overlap in some areas. Except for what is presented in the oral traditions of the Inuit, the nature of Dorset and Thule contacts remains a mystery. The Dorset culture disappeared by the fifteenth century A.D.

MAN
Dorset Culture
Igloolik (Alarnerk)
ivory
3.8 x 1.4 x .6 cm

In the Boothia Peninsula west of Igloolik during an incantation a shaman (**angakkuq**) spit into a miniature sealskin kayak he had made earlier. After the kayak was filled with spit he spit again and a small man similar to this figure appeared in the kayak.

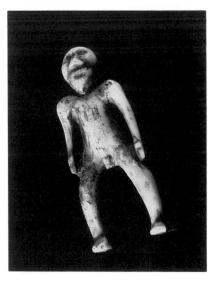

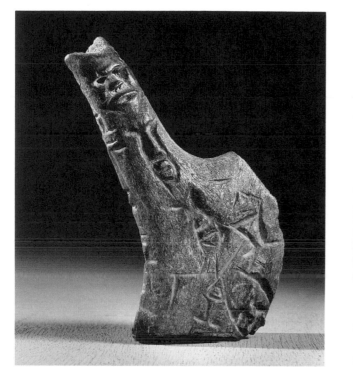

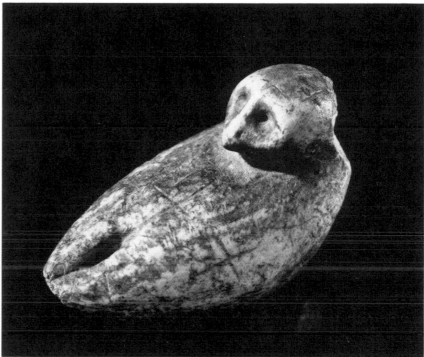

OWL
Dorset Culture
Igloolik
antler or
walrus bone
2.5 x 3.8 x 2.1 cm.

This gently rounded
little bird has three
crosses (+)
engraved on the
body and four on
the head. It also
has a gouged out
suspension hole in
the tail and may
have been used as
an amulet.

MULTI-FACED
FIGURE
Dorset Culture
Igloolik
antler
11 x 7.3 x 2.0 cm.

Clusters of low relief carvings of faces have
been recorded from Dorset sites in Canada and
Greenland. This antler carving has 17 human
faces. We are left to wonder if they are por-
traits, caricatures, or themselves, significant
magical or religious objects representative of a
pantheon of spirits or the patients whom a
shaman has cured.

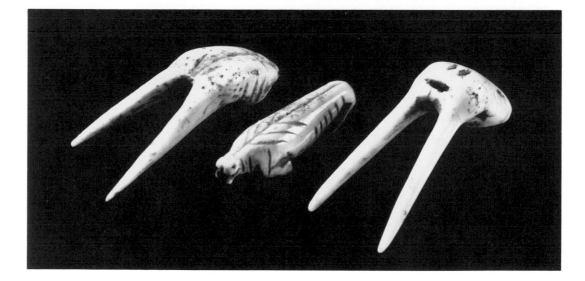

WALRUS FIGURES
Dorset Culture
Igloolik
ivory
4.5 x 1.4 x .9 cm.
3.5 x 1.0 x .8 cm.
4.7 x 1.7 x .9 cm.

COMB
Thule Culture
Pelly Bay (Isortuk)
Found by Levi Iluitok
ivory
10.9 x 3.9 x 0.7 cm.

The beautiful incised designs on this ivory comb are nearly identical on both sides of the comb.

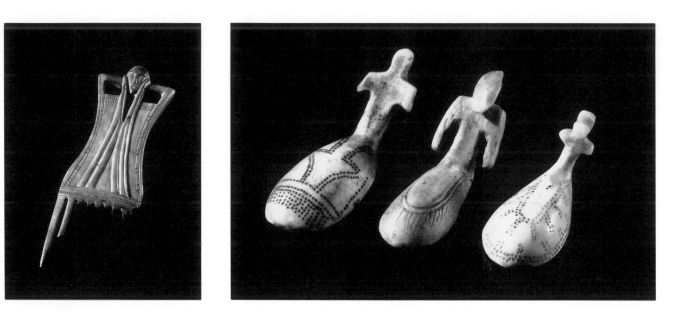

THULE HUMAN FIGURES
Thule culture
ivory
Igloolik, N.W.T.
4.7 x 1.7 x 2 cm.
4.4 x 1.3 x 2.2 cm.
3.4 x 1.5 x 2 cm.

These small birds with human upper torsos sometimes have patterns incised on their backs. The "knob" on the top of the head may represent a woman's hairstyle.

THE THULE PERIOD (A.D. 1000 - 1600)

The origins of the Thule culture, the direct ancestors of the contemporary Canadian Inuit are found in the Birnirk culture of North Alaska.

After A.D. 900 a warming climatic trend known as the "Medieval Warm Period" reduced the seasonal and regional extent of summer pack ice in Arctic seas. This permitted larger numbers of bowhead whales to summer in the feeding grounds of the Beaufort Sea, Amundsen Gulf and adjacent seas. Moving from Amundsen Gulf north to Peary Channel, Thule hunters may have come in contact with migrating Greenland whales heading east for Baffin Bay and the North Atlantic. Improved whale hunting opportunities,

an efficient hunting tradition, as well as other factors such as social pressures arising from an increasing population or a search for metals may have provided the impetus for this initial rapid Thule expansion to the East. Later expansions brought Thule people into more ecologically diverse areas; the southern Arctic Archipelago, the coasts of Hudson Bay, the coastal mainland to the West, and lastly down the coast of Labrador as far as Hamilton Inlet.

Whales may have been chased in the open sea using an **umiaq** that is a skin-covered boat 10 meters or more in length, and a small number of kayaks. No other Arctic marine or terrestrial mammal can rival the bowhead whale *(Balaena mysticetus Linnaeus)* for the amount of raw resources it yields for use as food, fuel, implements, trans-

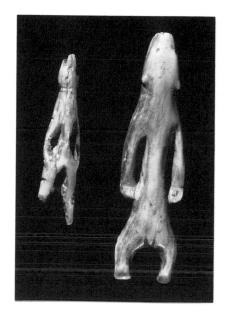

POLAR BEARS
Dorset Culture
Igloolik
ivory
3.1 x .7 x .2 cm.; 4.5 x 1.3 x .7 cm.

It has been suggested that many of the animal carvings, especially those of bears, represent the spirit-helpers of the shaman (**angakkuq**) embodied in small carvings that the shaman dangled from his belt or other clothing parts, or kept in special bags or containers. These bears may have been part of a shaman's magical equipment to help him embark on "spirit flights" to visit the prinicipal spirits or powers to consult with them, to seek information about offenses against them or the breaking of taboos, to appease them, and to invoke their help to overcome adverse conditions.

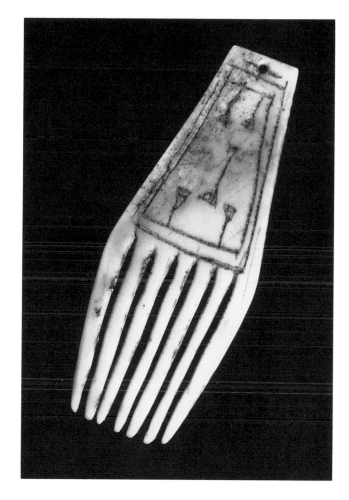

COMB
Thule Culture
Igloolik
ivory 4.8 x 1.8 x .2 cm.

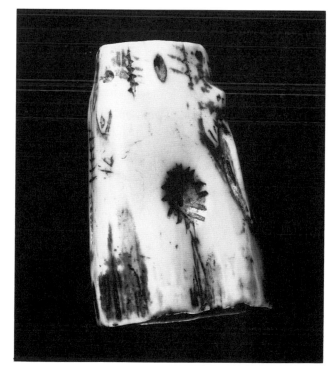

SUCKING TUBE
Dorset Culture
Igloolik
ivory
4.2 x 2.8 x 1.9 cm.

Engravings to represent the ears and eyes of both the polar bear and the caribou can be found on this delicate carving that may have been used by a shaman as a tube to suck the illness caused by bad spirits out of a patient's body.

portation and shelter. If utilized in combination with local resources perhaps only one large whale captured at a single locality was necessary to sustain a winter camp.

Therkel Mathiassen, whose work resulted in the definition of the Thule culture, summarized a description of the Thule house: "The type of house that is connected with the Thule culture is the circular, semi-subterranean house with the walls built of whale bones (particularly whale skulls), stone and turf, the roof supported by whale jaw bones (mandibles) and ribs, with an elevated platform in the rear part of the house and a stone-built doorway which debouches into the house below or at the level of the floor." The frame would then have been covered with heavy skins and a layer of sod.

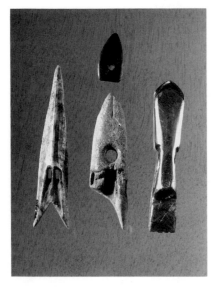

HARPOON HEADS
FROM IGLOOLIK
Dorset Culture
ivory
9 x 2 x .8 cm.

Thule Culture
ivory
7.4 x 2.l x l.0 cm.

Blade -
slate
Thule Culture
Igloolik
2.8 x 1.5 x .3 cm.

Historic
brass, steel
8.5 x 1.7 x 1.4 cm.

Alongside artifacts for marine mammal hunting, the Thule culture sites contain bow and arrows, multiple pronged bird darts and antler or bone bola balls for bird hunting, trident and three pronged fish spears, gorges, composite fishhooks, and a wide variety of ice picks, scoops and three legged stools for seal hunting. Household related items include crescentic stone lamps, cooking pots, snowknives and snow probes. Other implements include the bow drill to make holes, whale bone mattocks, adzes with ground stone blades, ground slate bladed knives, lulus, scrapers, needle cases, thimble holders and snow goggles. Decorated combs, pendants, female figurines and swimming figures of birds and "humans" are to be found in many sites.

THE LITTLE ICE AGE

The cooling trend in the North after A.D. 1200 that resulted in the Little Ice Age (approximately 1650 - 1850) would have increased the extent of the sea-ice and restricted the movements of all whales and walrus. With the increased ice cover, the small ringed seal that lives and breeds beneath winter-ice, increased in population and range.

In the southern Arctic islands and mainland coast the people adapted to the environmental changes and diversified their subsistence practices. The semi-subterranean whale bone winter houses were abandoned and replaced by **qarmaqs** (snowhouses with skin roofs or stone and sod houses) and more predominantly by snowhouses (igloos). In regions where the whaling economy had never established itself as part of the Thule tradition, adaptation to a diversified resource base continued within the existing deteriorating climatic conditions.

A series of local cultures evolved with each group adopting a more mobile hunting and settlement pattern than their Thule predecessors. The Arctic was now inhabited by a series of small

bands named after the local areas, each with a slightly different dialect and way of life. It was these Inuit and Inuvialuit groups, biological and cultural descendants from the Thule people, whom the European explorers met in their treks through the Arctic. Anthropologists later arbitrarily gave "tribal" names of no particular importance to the Inuit themselves to these local groups such as Mackenzie Eskimo, Copper Eskimo, Netsilik Eskimo, Caribou Eskimo, Iglulik Eskimo, Southampton Eskimo, Baffinland Eskimo, and Labrador Eskimo.

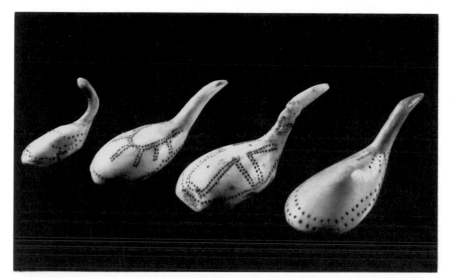

THULE BIRD
FIGURES
Thule culture
Igloolik
ivory
4.1 x 1.4 x 1.3 cm.
4.2 x 1.6 x 1.5 cm.
4.1 x 1.6 x 1.5 cm.
(Repulse Bay)
4.2 x 1.6 x 1.5 cm.

These small bird figures are carved with a flat base so they resemble the animal sitting in the water, with the lower part of the body submerged. Many of these birds found in Thule sites in the Canadian Arctic have holes in the tail and may have been suspended or worn on the clothing of their owner.

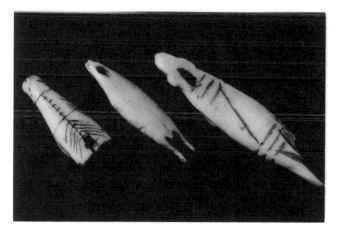

SEAL AMULETS
Dorset Culture
Igloolik
ivory
4.8 x 1.0 x .8 cm., 2.5 x .9 x .6 cm., 32.5 x .8 x .6 cm.

Amulets (**arnguaq**) were personal and private magical objects that might protect the wearer from harm, endow him with special qualities, and enable him to propitiate the necessary spirits who enabled him to live successfully. These seal amulets may have attracted the seals to the hunter to be killed (sympathetic magic).

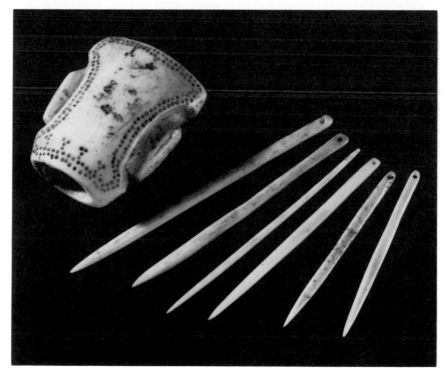

THULE THIMBLE
AND NEEDLES
Thule Culture
Igloolik
ivory
thimble
2.6 x 2.1 x 1.1 cm.
needles
(3.0 cm. x 1-2 mm)

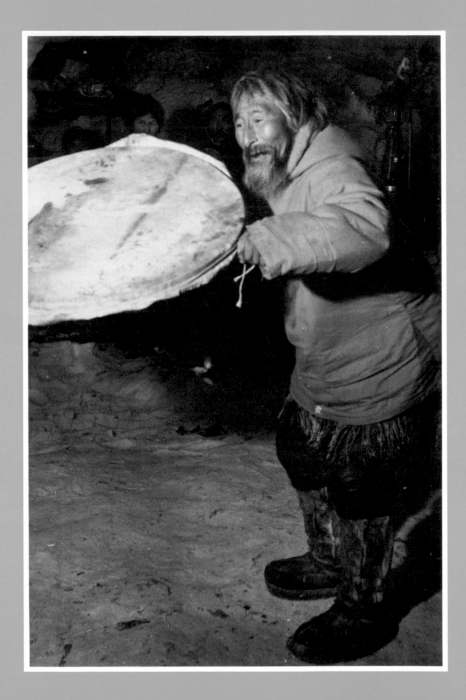

Ukkiusiurniq...
Around the year...
Yearly Cycle of the Central Inuit

The Central Inuit have been divided by anthropologists into five sub-groups mainly on the basis of geographical location and the sharing of dialects and genealogical history. These sub-groups are the Copper Inuit of Victoria Island and Coronation Gulf, the Netsilik Inuit of King William Island, the Boothia Peninsula and Back River, the Caribou Inuit of the Keewatin coast and interior, the Iglulik Inuit of Melville Peninsula and Northern Baffin Island, and the Baffinland Inuit of the rest of Baffin Island.

ANNUAL CYCLE

Summer *(Upirngaaq)*

Summer was the time of greatest dispersal for Central Inuit groups. Small groups, perhaps only ten to twenty people, migrated to locations where game which at this time of the year was scattered could be found. Inland travel was difficult at this time. Lakes that dotted the landscape had to be detoured. The ground could be boggy or wearisome to walk on due to the soft cushion of plants covering the surface. Insects could make life a torment. Caribou were now in smaller groups

after their spring migration and calving. Fish, small game and migratory birds could be caught at this time. The Inuit who harvested the resources of the sea stored seal blubber in seal skins for later use. Meat and fish were dried by cutting the flesh into strips and setting them up to be exposed to the sun and wind.

At the end of the summer larger groups came together for more communal activities, such as fishing for char in stone weirs, and hunting caribou at the time they were best-suited for use as clothing and food. This was a crucial time because it was necessary to ensure that enough hides were taken to provide a complete new set of winter clothing for the family.

Autumn *(Ukiaq)*

Autumn was the time to head back to traditional gathering places. It was the season of squalls and biting winds. Snow began to cover the land, and the small lakes and creeks began to

Willie Niptayok in a drum dance, Pelly Bay, 1956.

MAN AND WILDLIFE
Pierre Karlik,
b. 1931
Rankin Inlet 1989
ivory, stone
61.8 x 18.5
x 10 cm.

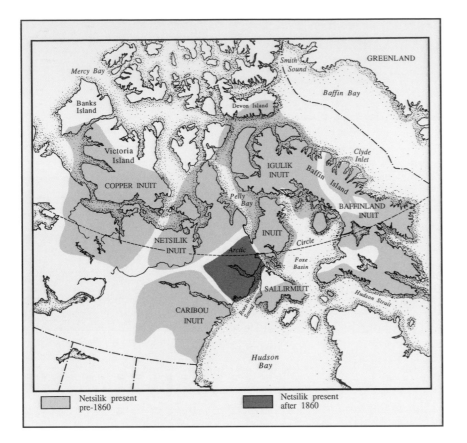

Figure 1
Distribution of
Central Inuit groups
around 1900
(adapted from
Damas 1984:391)

Due to certain taboos, activities relating to contact with sea and land animals had to be kept distinct or else Nuliayuk, the Mother of the Sea Animals, would withhold game from the hunters. This affected many spheres of life including the urgency to prepare skin clothing for the winter.

Winter *(Ukiuq)*

After the clothing was prepared, the Central Inuit except for the Caribou Inuit sub-group headed to the sea. Here they spent the majority of the winter in pursuit of marine mammals, especially seals and walrus. The Caribou Inuit continued to hunt whatever caribou still remained on the tundra, but relied heavily on the kill they had made in the late summer and fall, and on the fish they could catch in the lakes. A part of this sub-group went to the sea for short periods of time.

At this time the groupings were much larger, especially where the sea dwellers were located. Social interaction was at its peak.

Kinship ties based on blood relationships or established through marriage were recognized. Extended families might consist of husbands, wives, adult siblings, in-laws, aged parents, and children. Through their ties certain obligations were recognized, such as the care of aged or orphaned persons,

MAN AND THE SEA
ANIMALS
Joseph Oqallak,
b. 1940
Arctic Bay 1989
narwhal tusk,
muskox horn, stone
26.2 x 4.2 8 cm.

freeze. As the groups moved towards their destinations, intensive hunting took place. Southern bound caribou herds were intercepted, and many caches of food were stored. Groups united and the women joined together to sew their winter attire. Muskoxen might be encountered, and fishing in the lakes was carried on all along the travel route. The transition from tents to snow houses took place.

Jacqueline and Victor Tartok Chesterfield Inlet, 1950's.

and the sharing of food and possessions. During certain seasons of the year the extended families acted as discrete economic units working together in the communal caribou hunts and taking of fish at the stone weirs. Extended families tended to exist as a residential unit occupying a group of attached or separate snow houses or tents. It was the Inuit ideal to have an extensive kinship network, and it was not rare to see families undertake long trips with their wives and children to spend one or several years with relatives. Kinship ties were invaluable as they widened the area of social security of the individual family.

Partnership relationships varied from one region to another. There were partners for numerous activities including boxing, wrestling, singing, dancing, exchange of wives, hunting, and the sharing of food. These alliances demonstrated a fundamental value of the Inuit to share. They also served to more closely relate generally unrelated persons thereby increasing social cohesion within a camp or between distant groups.

Leadership existed mainly within the family unit where a leader (**isumataaq**) for each extended family unit, was normally the oldest male. Informal consultation also took place among the hunters with the opinions of the most experienced and highly respected elder regarded

most seriously. Among the Iglulik Inuit there was a leader of the winter sea-ice camp who emerged from the largest tightly knit kinship group. His judgment was followed concerning the hunt, the division of food, the settlement of disputes, and the arrangements of marriages or adoptions.

Traditionally, there existed no external organizations to establish or enforce laws of conduct. Trouble-makers were discouraged from carrying on their behaviour through shunning or ridicule, sometimes exercised in the form of song duels. In these song duels, each party ridiculed each other publicly until one or the other person lost control by becoming angry, or breaking down into tears, thereby ending the dispute. Public boxing contests or fist fights might be used to settle disputes. Where conflicts were more serious and could not

Geneology of Jacqueline and Victor Tartok compiled by Fa. Roland Courtemanche, o.m.i.

be settled, such as in the case of murders that precipitated vengeance blood feuds, suspicion of witchcraft, or unauthorized adultery, the individual, family or other larger grouping might move off to another area or join another band.

Execution, the ultimate check on inappropriate social behaviour, was performed when a person such as a murderer considered insane was a threat to the safety of the whole village. This was done by common consent of the men.

The suicide rate varied in each area. It is believed that suicide was connected to incidents such as disasters that affected a close relative,

marital discord, an illness, or the burden of old age.

Spring *(Upinngaksaaq)*

By the end of March the days became longer and warmer. On the frozen sea new born baby seals could be found above the breathing holes of their mothers in their birth lairs. Intensive breathing hole (**aglu**) hunting continued. Seal hunting on the spring ice that involved the stalking of seals napping on the ice began.

In the higher latitudes the sun returned after its absence in the dead of winter. Small puffs of

RAISING A
COOKING POT IN
SPRING
Kangiqsujuaq
1956
stone
6 x 31 x 8 cm.

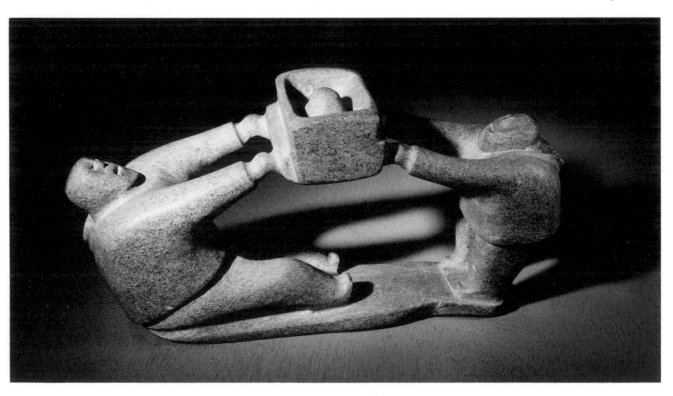

clouds tinged with orange and crimson foretold the arrival of the sun, a ball of fire that ascended above the earth. In the lower latitudes the sun's rays became stronger creating a danger for travelers not protecting their eyes with special snow-goggles.

By May **aglu** hunting activities slowed down and the snow houses required skins to be placed on their roofs. For some people it was time to move back inland. This became the time of great travel throughout the Central Inuit territory. Fishing through the lake ice again became a more important activity. Migratory birds, especially ducks and geese, arrived in the millions. Some Inuit journeyed long distances to favourite walrus feeding areas.

These long spring journeys made possible many social interactions whereby marriages could be arranged, partnerships could be solidified, intra-tribal trade might take place, but more importantly relatives were visited.

Song and dance feasts held in specially constructed enlarged snowhouses were common at times when provisions were abundant.

In one common form the men formed a circle. The singer, a man or woman, held the drum

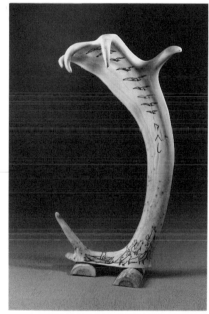

SPRING TRAVEL BY DOGTEAM AND BOAT
Bernard Fransen, b. 1925
(Missionary in Diocese 1953-75)
Baker Lake 1959
antler
36.2 x 12.7 x 19.1 cm.

in their hand, slowly rocking it from side to side on its own axis, and beating the drum with the drumstick, alternating on each side of the frame. The single headed frame drum was 50 to 90 cm in diameter, depending on the wood and hide available. Traditionally skin drums with a wooden frame had a notched handle and were secured with sinew. Today the drum is more often nailed together and covered with a removable sail cloth or lightweight rubber sheet.

Each dancer moved to his own beat singing his own personal song or one he composed on the spot to the accompaniment of the women's chorus. A wife might sing her husband's song while the latter danced and beat the drum. The audience swayed back and forth and joined in after each verse with the refrain ayayaya — ayaya.

Songs told of daily life with many recurring themes, the joy of a successful hunt or the disappointment of a failure, difficult journeys, the land, etc. Many songs about the weather were considered to be magic songs, incantations to the spirits. Songs might be derisive or a self deprecation of the singer's inability to obtain enough food for his family. The more brave or successful a hunter was in life the more modest he presented his abilities in his song.

When the singer was finished his turn another person took his or her place. If a man had a

Rosa Kangatalark - The Grand Lady who helped Fa. F. Van de Velde begin his geneology studies of the people from Pelly Bay.

song partner he handed the drum to his partner. Sometimes social conflict was resolved through song duels held between two conflicting persons, each one telling his story with a high degree of satire and insults.

Yet, songs were mainly a form of profound poetry and narrative. They repeatedly referred to "being on the land." The land's central importance was expressed in poetic descriptions, expounding great admiration and joy for its vastness and beauty. Fear and humble respect for the land's harshness and the necessity to live in harmony with it were also recurring themes.

MAN WITH DRUM
George Tataniq, 1910-1991
Baker Lake 1974
stone, antler 18.9 x 11 x 3.8 cm.

THE DRUMMER
Illustration by
Bernard Fransen

ANIMALS ON
THE EARTH
Peter Katokra,
b. 1934
Repulse Bay 1973
whale bone
45 x 62 x 34 cm.

"From the beginning of time the walrus, the polar bear and man have been the most powerful animals in the North, and not afraid of other animals. They may be afraid of each other, as they can kill among themselves. They may be the most powerful animals but they are not the fastest in speed. Because of their strength they are not the fastest. The polar bear is on top because it can do most things. It can travel very easily on rough terrain where the walrus can not travel at all. It can travel on any surface in the North. It is also the strongest. This is the reason for it being on the top."

Through songs, poetry and mythology the Inuit world view was reaffirmed again and again, where no individual could own land or the animals, and where people must share and help one another to survive. Many Inuit singers today such as Charlie Panigoniak of Rankin Inlet are guitar playing balladeers. Affinity with the land and the old camp life is found in many of these ballads sung in a Nashville-Western-Country music style by contemporary Inuit artists. A more recent music video called "Searching," composed and sung by Susan Aglukark from Arviat, is a moving audio and visual portrayal of the identity crisis young Inuit face today. The young composer's sensitivity to and respect for her elders and the old camp life is evident.

BEAR
APPROACHES
IGLOO
Nicholas
Kringayark, b. 1921
Repulse Bay
1945
ivory, metal, string
16 x 61.6 x 16 cm.

LATE SPRING OR EARLY SUMMER SCENE
Antonin Attark, 1909-1960
Pelly Bay 1956
ivory, sealskin thong
8.4 x 46.1 x 6.1 cm.

Caribou pass on the farther side of the lake
while the woman fishes. A man approaches
some ducks with a gun while two men hunt
muskoxen with dogs.

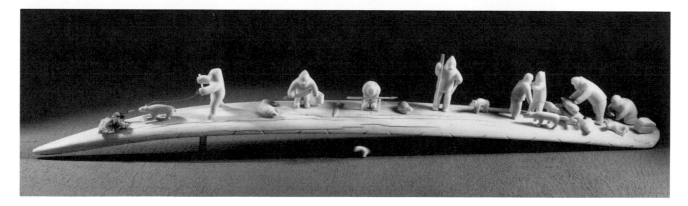

SPRING HUNTING
AT THE AGLU
Antonin Attark,
1909-1960
Pelly Bay 1949
ivory
17.4 x 48.2
x 5.3 cm.

FROM MEMORY SHE TRACED...

"From memory, she (Rosa Kangatalark) helped me trace back nearly 100 years," says Father Van de Velde. "Then I used the notes and journals made by Captain James Ross, an explorer who was at Pelly Bay in 1830, and another explorer called Franklin, who was looking of the Northwest Passage there in 1845."

"Ross' notes were especially helpful because he wrote down the names of everyone living in the community when he was there. The people he listed as infants are the old women remembered by my walking library when she was a child"

Father Franz Van de Velde (Pelly Bay, 1974)

TOTEM
Irene Kataq
Angutitok,
1914-1971
Repulse Bay 1955
stone
30.4 x 9.6
x 8.7 cm.

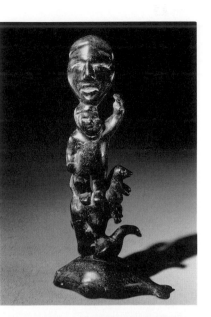

MAN WITH DRUM
John Kaunak,
b. 1941
Repulse Bay 1971
stone, antler, ivory
10.9 x 7.4
x 8.7 cm

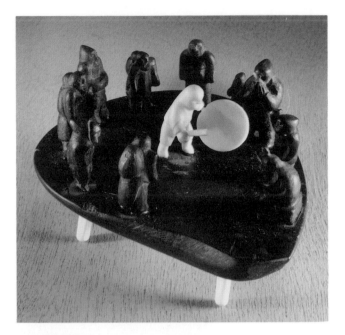

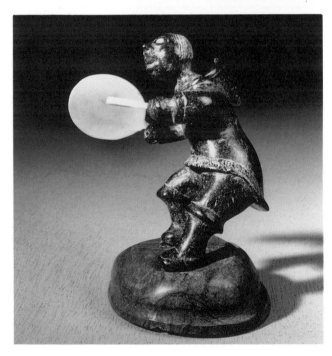

DRUM SCENE
Antonin Attark,
1909-1960
Pelly Bay 1944.
stone, ivory
7 x 12.6 x 10.6 cm.

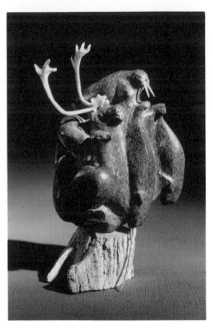

VISIONS OF
PLENTY
Louis Oksokiktok,
b. 1926
Repulse Bay 1967
stone, whale bone,
antler
16.8 x 11.1
x 8.5 cm.

TRAVEL - YESTERDAY AND TODAY

"Those who travel in the Arctic in the summer time are sometimes surprised to find almost everywhere on the seashore traces of old encampments. Were the Eskimos more numerous then? or did they travel more extensively?

According to native traditions, according also to the evidence gathered by the first explorers, both conjectures are correct. Captain Ross (to quote him among many others) was greatly surprised, around 1833, to meet at Thom Bay a family which was formerly living at Iglulik. A Netsilik Eskimo stated to me positively that, in olden times, Padlermiut used often to come in the spring and trade caribou skins for seal skins and ropes. This was confirmed to me by an old Padlermiut. All the other older natives assure me that, formerly, there was much more traveling than now. According to them, it did not create serious problems in many cases because, despite the small number of dogs at the disposal of the travelers, hardly a day or two went by without encountering igloos while, at the present time, on an identical trip, a week or more will elapse without meeting a living soul."

Father Rogatien Papion, o.m.i.
(1966)

FEMALE DRUMMER
Luke Airut, b. 1942
Igloolik 1979
stone, wood,
intestine
33.5 x 15.8
x 23.5 cm.

Inuillu Qallunallu...
Inuit and the qallunaaq...
Central Inuit Contact History

FIRST CONTACTS

The presence of a commercial fur trade establishment on Hudson Bay at Fort Churchill resulted in some of the first Inuit-white contacts in the Central Inuit territories. This Hudson's Bay Company post established in 1717 conducted trade at Fort Churchill, and from 1750 to 1790 the traders of the H.B.C traveled with sloops that were sent north along the west coast of the Bay to trade skins, whale bone and meat for metal tools such as ice chisels, knives, and awl blades.

The search for a Northwest Passage through North America to the riches of the Orient brought the first Europeans into Arctic Canada during the 17th century, but it was not until the early 19th century that these expeditions came into more intimate contact with the Central Canadian Inuit. Both male and female Inuit assisted the explorers by producing highly accurate maps where distortions were only indications of areas intensively hunted. In fact, Sir William Parry in his Second Passage in 1824 would have missed a crucial opening at Fury and Hecla Strait had it not been for the "astonishing precision" of his Inuit maps.

Marguerite Kralalak, born 1877, the first baptized Roman Catholic in the Hudson Bay region in 1917, Rankin Inlet 1964.

Some of the more interesting records of Inuit life arise from the journals of expeditions by Captain John Ross (1818), Lieutenant Edward Parry (**Pari**) (1819-20, 1824-25), Lieutenant Edward Parry and Commander George F. Lyon (1824) and, Captain John Ross (1829-33) and Lieutenant Schwatka (Henry Klutschak) (1878-80).

These early contacts had little impact on the life-styles of the country's inhabitants; however abandoned ships, in particular Ross's *Victory* (1832) as well as McClure's *Investigator* (1853) provided valued iron and wood for tools, and treasured objects to trade with other tribes.

From 1860 to 1915 a new breed of men, the whalers, came to the North, establishing themselves in three main areas, the Roes-Welcome Sound-Repulse Bay region, Cumberland Sound and Pond Inlet. European whaling was to make more of an impact on the economic life of the Inuit than European expeditions in search of a

SOAPSTONE MUG
Jens Munk Island,
Igloolik
stone
7.8 x 11.5 x 8.1 cm

This soapstone mug may have been carved after contact with British sailors - perhaps after Sir William Edward Parry's overwintering at Igloolik 1822-23.

> ## LETTER FROM MEMBERS OF THE FIFTH THULE EXPEDITION TO FATHER ARSENE TURQUETIL, O.M.I.
>
> Repulse Bay
> August 28, 1922
>
> Reverend Father,
>
> I am very sorry that it was impossible for me to pay a last visit to the mission and bid farewell. The schooner started so suddenly that I was not able to get a-shore again, once I was out there. I regret it so much the more, because I had promised to do so, and the hospitality and kindness all of you showed to us at Chesterfield both in the spring and now also in the summer has put the whole Expedition in your debt. I believe that we, who are always on the move, are doubly thankful for any kind of friendliness.
>
> Mr. Rasmussen has given me the letters of introduction, you kindly wrote for me, and I scarcely need to tell you, how obliged I feel to you for that reason. Please, remember me to Father Duplain and Brother Gerard.
>
> I remain, Reverend Father,
> Yours respectfully,
>
> Kaj Birket-Smith
>
> My best greetings!
> Knud Rasmussen
>
> My best regards!
> Helge Bangstad

people expedition members met and lived with through their travels.

The Hudson Bay Company (H.B.C.) was the largest mercantile operation in the North but other trading operations existed as well, such as the Canalaska Company in the West from 1927-38, the Revillon Frères mainly in the Northern Keewatin from 1924-36 and the Sabellum Company in the East from 1911 to 1920. Before 1940 free traders and white trappers flourished in the Southern Keewatin district. The great era of trade, mainly for Arctic fox pelts, extended into the 1950s although there were intermittent periods of low returns and prices. Staples acquired at the post were firearms, ammunition, tools, boats and food including tea, lard, molasses and tobacco. The supply of trade goods arrived annually by ship. What feelings of joy and anticipation were felt when the Nascopie, the most well remembered H.B.C. vessel arrived at the post. This ship (**Omiakchuk** - The Great Boat) a 1500 ton vessel echoed its whistle when it reached near the shore, and a loud splash could be heard as it dropped its anchor to the accompanying sounds of the movement of the steam winches. Many willing hands were waiting on the beach ready to haul crates and cases of all kinds and sizes.

Trapping required more dogs which in turn allowed the hunters to range more widely and travel quickly. Firearms, ammunition and nets were issued on credit from the H.B.C. posts in the off-season to encourage trappers to store suffi-

THE HUDSON'S BAY COMPANY

Winnipeg
October 29, 1912

The Right Revd. Bishop Charlebois,
The Pas, Manitoba.

My Lord,
I returned from Hudson's Bay by canoe from York Factory,
where I left our steamer on the 17th September.
We landed Fathers Turquetil and Le Blanc at Chesterfield
Inlet on the 3rd September.
We had a very tedious voyage, owing to incessant fog, and,
as all our supplies were in one vessel, we had to be extremely
careful. Safety had to be studied, rather than speed.
We enjoyed the company of the two Fathers very much, and
before we left they were hard at work getting their material sort-
ed out, so as to start building their houses.
I enclose account ($1,296.00) certified to by Father
Turquetil, and I will be glad to receive your Lordship's cheque
for the amount, so that we may, at once, settle up with our part-
ners in the ship (Messrs. job Brothers of St. Johns,
NewFoundland) for this season's work.
We have just received a message by wireless that the
"Nascopie" is approaching the NewFoundland Coast on her
return voyage.

I am, My Lord
Your obedient Servant.

R.H. Hall

cient supplies of food for use during the trapping season. All of these items, including the whale-boats inherited from the old whaling days, served to increase the productivity of the hunter, and to change or adjust the economic cycles of the region. Caribou could now be hunted throughout the year. Sea mammal hunting at the floe edge and by boat in the summer increased in some areas. This is not to say that there were not peri-ods of famine and sickness, times when the cari-bou herd did not follow known migrations routes, or situations where game was less plentiful.

Christian missionaries, mainly from the

TRADE BY BARTER

"Trading was carried on by barter as no money was used at the posts. The main fur catch was white (Arctic) fox and if the pelts were valued that year at $20.00, a native would receive a small stick for every fox skin. As he traded, he would hand back one stick and be given forty smaller ones in return. These were known as "Made Beaver," valued at 50 cents each, and after they were traded off the process would resume all over again until only one stick was left. This stick was given to the wife to do with as she saw fit and was usually expended on needles, thimbles, and cloth. The Company's barter system was simple but effective."

Archie Hunter
(H.B.C. trader in the Keewatin 1924-33)

Anglican and Roman Catholic denominations, came to the land spreading their Gospel message of a single God, and a Saviour Jesus Christ.

The Roman Catholic priests were mainly French and members of the Oblates of Mary Immaculate, a world wide missionary order. Fa. Alphonse Gasté, the first Catholic priest to visit the Inuit in the Central Arctic, undertook a seven month voyage in l868 to visit the Ahiarmiut in the region of Lake Ennadai. Forty-five years later two Catholic priests, Fathers Rouvière and LeRoux

THE INUIT GUIDE A NEW MISSIONARY

"With Easter just around the corner, numerous sleds laden with furs begin to trickle in (to Repulse Bay) from Igloolik and Pelly Bay: all the while Father Henry (Kajualuk) intensifies his preparations for departure. He has acquired dogs; old Takrauvak has made him a fish net, Charley Ussuligaardjuk, his Nitjilik traveling companion, is overhauling his sleigh... On April 26th, 1935, at the close of a windswept day of light swirling snow, he kneels on the icy sea to implore his superior's blessing. The day has arrived for Kajualuk to adventure off into the unknown of the Magnetic Pole. With Charley and William Niptaujuk as guides, he will make the most of the long hours of daylight....from the top of the hill, Father Clabaut (his superior) trains his binoculars in the direction of the Arviligdjuar: loaded sleds slowly and painstakingly grow smaller and smaller. Bon voyage, Kajualuk!"

Fa. Charles Choque, o.m.i.

THE MISSION AND THE HUDSON'S BAY COMPANY

"The white community consisted of the Crawfords, the Fathers from the mission, and myself. Long before my arrival at Repulse the social life pattern was well established. I found myself inserted into the spot reserved for the Hudson's Bay Company apprentice. Every Sunday night was bridge night with Tom and I forming a partnership against two of the Fathers. Only one slight deviation ever occurred in the fixed format of these card gatherings. We met at the mission one week and at the Hudson's Bay Company the next. Regardless of the score, eleven thirty meant game over to allow sufficient time for a social snack before the Fathers celebrated their midnight mass."

*William Robinson
(H.B.C trader in the Keewatin, N. Manitoba - late 1930s, 1940s)*

who had been sent by the Church from the Western Arctic to the East, were murdered in the Coronation Gulf region. In 1912, Fa. Arsène Turquetil who had previously made two exploratory trips to the Keewatin, arrived at Chesterfield Inlet with his confrère Fa. Armand LeBlanc to successfully establish the first Catholic mission in the Central Inuit territory.

In l823 Rev. John West, a minister for the Church of England (Anglican church) visited Fort Churchill where he spoke to a number of Inuit through an interpreter named Augustus. On his

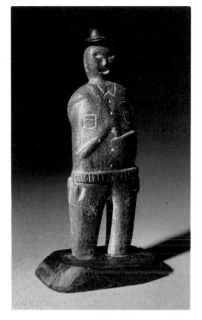

ROYAL CANADIAN
MOUNTED POLICE
Rankin Inlet 1962
stone
15.8 x 8.4 x 4.3 cm.

The carver of this
caricature was in jail
for three months.

return to England he pleaded the cause of Eskimo missions to the Church Missionary Society, but it was not until 1882 that a permanent mission was established by Rev. J. Lofthouse at Churchill. Rev. Lofthouse ministered to a mixed transient population of Indian, Inuit, and white folk. Rev. E. J. Peck was generally recognized as the first missionary to minister in the Central Inuit territory after he moved to Blacklead Island on Baffin Island in 1894. A noted linguist with previous experience at Great Whale River and Little Whale River, he published a valuable and widely used grammar in 1883.

Catholic and Anglican missionaries traveled from camp to camp, and Christianity was relatively quickly accepted by the Inuit. Although as in other regions of the world, syncretism characterized the religious realm during the contact-traditional period.

The Royal Canadian Mounted Police first arrived at Cape Fullerton on Hudson Bay in 1903 to control the shooting of muskoxen. Eventually the RCMP established posts alongside most major trading posts where Christian missions were also located. The policemen's duties were to take census, to make reports about the people in the area, and to enforce laws for both human interactions and the taking of game. The issuing of

> ## PUKIRTALIK - THE ROYAL CANADIAN MOUNTED POLICE
>
> *"No doubt after traveling the entire night, a night only partially dark, an officer of the Royal Canadian Mounted Police arrives from Chesterfield in the company of Rene Naituk, his guide. Bearers of glad tidings, they bring stacks of mail that have been piling up for months; good news coming from countless localities. In between the comings and goings of the Inuit, the missionaries are hard at work answering letters, for the police officer returns south on the 8th; he does double duty acting both as policeman and government administrator; he registers births and deaths, spelling the strange sounding names more or less correctly, enquiries about the ailing, and the state of the economy, visits the White people, telling everyone how the rest of the world is faring. "Pukirtalik" the Inuit call him; the yellow stripe along his navy trousers remind them of the white stripe that runs up and down the women's pants, a strip cut from the "pukirk," the white part of the caribou hide."*
>
> *Father Pierre Henry, o.m.i.*
> *(Repulse Bay, May 3, 1934)*
> *As written by Father Charles Choque, o.m.i.*

medical supplies and the care of the sick were adopted as responsibilities by the R.C.M.P. as well as by the missionaries. In later years, government relief provisions were distributed by the R.C.M.P.

Despite the presence of the so-called "Big Three," the H.B.C. men, the missionaries, and the R.C.M.P., the native hunting camps retained a high degree of autonomy. The hunt or decisions

SIGHTING OF HIS
FIRST AIRPLANE
Antonin Attark,
1909-1960
Pelly Bay 1955
ivory
19 x 50 x 5.1 cm.

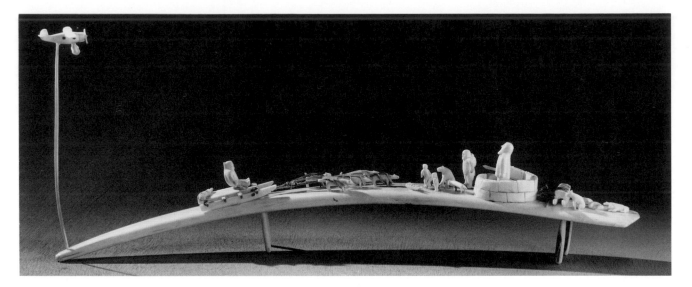

to shift camp locations were still organized by whatever local leadership pattern existed, including in some areas a new *isumataaq*, the whaleboat captain. This new concept of a whale boat captain as leader was probably introduced by the American and Scottish whaling captains who hired an Inuk to hire and direct a local Inuit crew. Marriages were arranged by parents and grandparents. These were the days of the old camp life that extended into the late 1950s, remembered at the Elders' Conferences held in the North during the last 15 years.

CENTRALIZATION

While the whaling days are seen by many as a transition stage, and the trapping era as a time of great change in economic orientation, neither period could rival the economic, social, and cultural changes brought about by the centralization of the Inuit into settlements in the last half of the 20th century.

In 1947 the Canadian government began issuing Family Allowance cheques in the North, followed by Old Age Pension cheques in 1948. In 1953 the establishment of the Department of Northern Affairs and National Resources heralded a more concentrated effort to implement a 1939 ruling of the Supreme Court that entrenched the legal rights of the Inuit to the same education, and health and welfare benefits as those accorded to Canadian Indians. The Inuit were encouraged to move into centralized settlements next to existing trading posts, to receive both existing and new government services. By the late 50s' welfare payments were being distributed on a case-by-case basis.

In the 1950s' representatives of the Department of National Health and Welfare arrived by boat annually to administer medical surveys and to test for tuberculosis and other serious diseases. A deep tragedy struck in the mid 50s when 5 - 10 % of the Canadian Inuit required evacuation to the South for active tuberculosis treatment. At that time there were only two small church operated hospitals in the Central and Eastern Arctic. Both hospitals, St. Luke's, run by the Anglican church at Pangnirtung, and Ste. Theresa's, run by the Vicariate of Hudson Bay with the help of the Grey Nuns at Chesterfield Inlet, had been established in 1931.

During and after World War II it was recognized that Northern Canada was of strategic military importance to the defense of North America from a manned Soviet bomber attack over the Northern polar region. Weather stations, new air strips, military bases (many temporary) and what is more important the Distant Early Warning System (DEW Line) were constructed in the mid

CHANGES IN THE NORTH

"No one can deny the transformation of the North which is going on from day to day. No one would object either to the Eskimo's gradual adaptation to the new conditions of life. But to conclude that now and forever and everywhere he should give up his dog team for a tractor and replace seal by a tin of canned goods, is a big jump. This is not opposition to progress but a careful look to see if progress is real and, especially on the spot, if it is real for this or that Eskimo....

The Canadian public frequently turns its eyes northward and it was natural to seek to impress this spectator with impressive achievements. Model villages and camps were built for the Eskimos.

Very much effort has been devoted to the utilitarian, and when human problems have been studied, it has been taken for granted that which is good for the white is good for the Eskimo.

The latter has been invested with the needs, the reactions, the mentality of the white - in other words, under pretext of the evident technical superiority of the white, a superiority which is rarely of a moral nature, the white's mode of life, culture and even defects, have been set up as an ideal for the Eskimo to follow.

The aggressiveness and competitive spirit of our ways have been presented as virtues. Money is to be the basic motivation of all activity and the value of a man is to be measured in dollars. Few realize that this teaching strikes at the very root of the Eskimo personality.

An imbalance is bound to result since the Eskimo is brought to the point where he gives up his traditional values and finds nothing in the atmosphere of materialism to make up the loss. Talk of integration abounds but disintegration is the end product."

Bishop Marc Lacroix, o.m.i (1959)

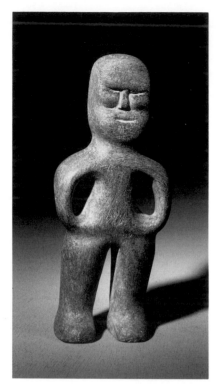

1950s. Peak incidence of respiratory tract infections was recorded in the North when Inuit families moved near DEW line sites where they lived in crowded tents and shacks. The construction of the original DEW Line from 1955 to 1957 that consisted of 61 sites stretching from Cape Dyer on Baffin Island to Point Barrow, Alaska was considered the greatest feat of logistics and construction the Arctic had ever seen. There was no "turning back the clock" in the North.

In 1956 the Federal Government introduced the Low Cost Housing Program that was succeeded by the Northern Rental Housing Program in 1965.

Federal day schools began appearing across the North in 1959. Before this, whatever formal education the Inuit received, was due to the diligence of the priests and ministers at their respective missions. In 1955 some families agreed to send their children to a federal day school and hostel at Chesterfield Inlet. The hostel continued operation until 1968. Many contemporary Inuit leaders were taught by the Grey Nuns at the federal day school.

The 1960s saw more and more Inuit introduced to wage labour. Beginning in 1959 co-operative stores owned and directed by the local people evolved in the Arctic. In time the Arctic co-operatives organized into two regional federations - now known as La Fédération des Co-operative du Nouveau-Québec (FCNQ) in Northern Quebec and the Arctic Co-operatives Limited (ACL) in the Northwest Territories (formerly known as The Canadian Arctic Co-operatives Federation Limited). These federations and the West Baffin Eskimo Co-operative in Cape Dorset, N.W.T. (a former member of ACL) provide a wide variety of producer-consumer- service operations including arts and crafts development and marketing. The production and sale of arts and handicrafts have emerged as a good supplementary source of income for many Inuit, and for some artists a primary source of income. World-class artists have been acknowledged on an international level, and Inuit art is considered to be one of Canada's unofficial national symbols. The continuing efforts of the Federal Government, in particular the Department of Indian Affairs and Northern Development Inuit Art Section, and more recently the Government of the Northwest Territories, in promoting arts and handicrafts has been significant.

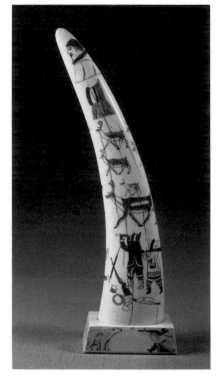

The sealskin trade that had its origins in the whaling period and had been important for many years on Baffin Island increased in importance in the rest of the Central Inuit territory when there was a boom in prices in the early 1960s. This increased value in the pelts was the result of a Norwegian innovation in tanning which created new markets. The Inuit now had a commodity, a by-product of their hunt that could be turned into cash to reinvest in equipment necessary to facilitate all kinds of food harvesting. In the early 1980s this trade of sealskin products collapsed. Anti-harp seal harvest protests against commercial hunts in eastern Canada triggered a chain of events. They ultimately resulted in a two year ban of the sale of all seal skins in the European Economic Community in 1983 and an indefinite boycott of sealskins by the EEC in 1989. A vital income for many Inuit was destroyed by the lobbying efforts of the animal rights movement with no consideration of their culture. Reductions in the availability of money for hunting have affected the presence of country foods in communities and undermined the sharing networks and cultural frameworks of settlements. Proponents of the animal rights movement had now determined that Inuit harvesting with its new technology was neither essential nor linked to cultural traditions and only motivated by market demands and economic wants.

The populations of northern communities rapidly increased due to the improved health care services provided by the Dept. of Health and Welfare and more recently through Regional Health Boards. At the same time the occurrence of dental caries, nutritional anemia in children, myopia in adolescents, metabolic and cardiovascular diseases, amd changes in cancer patterns in adults appear to be related to nutritional and lifestyle changes. Other technology and southern influences were rapidly advancing North. Snowmobiles that came North in 1962-63 meant

THE EFFECT OF THE SEAL BAN

Seal hunting is part of our cultural heritage. It is a way our men pass on important technical skills and social knowledge to their children. By hunting, butchering and distributing the seals and their meat, we teach our children how to share, work co-operatively, be patient, and be responsible to the community.

Seal hunting is central to our well-being - it is a part of our everyday life - but it is not an opportunity for us to get rich. Banning the seal trade in Europe will not put an end to our seal harvest - as the sale of the sealskins is a secondary reason for our hunt - but it will increase the already high levels of unemployment, economic dependence, social and cultural hardships, and poverty in our communities. In addition, a poor market for sealskins means that we will be unable to fully utilize all the products of the seals we do harvest."

Nunasi Corporation
(Economic Devlopment Corporation
for the Inuit in Nunavut) (1986)

ATANIIVIK
Lazarus Tausiruapik,
b. 1919
Hall Beach 1973
ivory, stone
15.4 x 43.5
x 43.7 cm.

One of the last
people in his region
to move into a
settlement this carver
portrays in this chess
set (**ataniivik**) the
Bishops as Catholic
Bishops, his King as
the Inuit hunter with
a snowknife, his
Queen as the Mother
and child, the Castles
as Igloos, the Knights
as Bear heads and
the Pawns as Polar
bears.

Canada's first aboriginal broadcast network (TVNC).

Scheduled and chartered airline service ensured the flow of people, goods and information. New forms of leadership emerged in village structures, territorial political structures and in the proliferation of Inuit social and political organizations. The Inuit Tapirisat of Canada was formed in 1971 as the main national organization representing the concerns of the Canadian Inuit.

Under a 1985 agreement signed between Canada and the United States the old DEW Line that has become technologically obsolete is being replaced by a new North Warning System (NWS) which will provide improved radar coverage and the upgrading of four northern air fields.

Since the 1980s many federal government responsibilities in the North have been devolved

easier and more efficient hunting in the winter, although this new equipment as well as other items, including motorized boats, progressively has become an economic burden for hunters without significant sources of income.

Contact with the outside world and between far flung settlements was brought about by the introduction of radio in the mid 1950s, telephone service in the 1970s and television through the Anik satellite transmission system in 1972. An Inuit owned and operated broadcasting corporation, the Inuit Broadcasting Corporation (I.B.C.) began its service in 1981. In 1992 the I.B.C. joined five other aboriginal broadcast groups, the Government of the Northwest Territories, Yukon College and the National Aboriginal Communications Society to form Northern

MONKEY SITS
ON A BRANCH
May Kailik Hikoalok,
b. 1933
Coppermine 1965
stone
7.5 x 9.1 x 4.3 cm.

to the Northwest Territories government. Aboriginal people in the N.W.T. including the Inuit of the Central and Eastern Canadian Arctic hold the majority of seats in the Legislative Assembly. This process of devolution of government responsibilities is also proceeding from the territorial to the hamlet level of administration.

In 1992 the Inuit of the Central and Eastern Canadian Arctic ratified a Land Claims Agreement to collectively take more control and responsibility for their home lands, an area that they call **Nunavut**. On July 9, 1993, the federal Minister of Indian Affairs and Northern Development presented the Governor General's Order-in-Council to the people of **Nunavut**, bringing the **Nunavut** Land Claims Agreement into effect. A political division of the N.W.T. will take place in 1999 that delineates the same boundary as the Inuit Land Claim and includes 28 widely scattered communities. The average density of Inuit occupying the **Nunavut** region is approximately 0.005 Inuit/km². Land claims research indicates that the Inuit in Nunavut have prehistorically and historically used and occupied roughly 1,780,000 km² of land and 920,000 km² of sea.

MINIATURE KAMIKS
Bertha Sinisiak Aggak, b. 1926-
Chesterfield Inlet 1991
seal skin, duffle, acrylic, cotton

TWO MEN
John Kavik,
1897- 1993
Rankin Inlet
1969
stone
12.7 x 6.3 x 7 cm.
11.2 x 8 x 4 cm.

John Kavik was born in Gjoa Haven in 1897 and lived inland until starvation resulted in his relocation to Baker Lake and then to Rankin Inlet (1959).

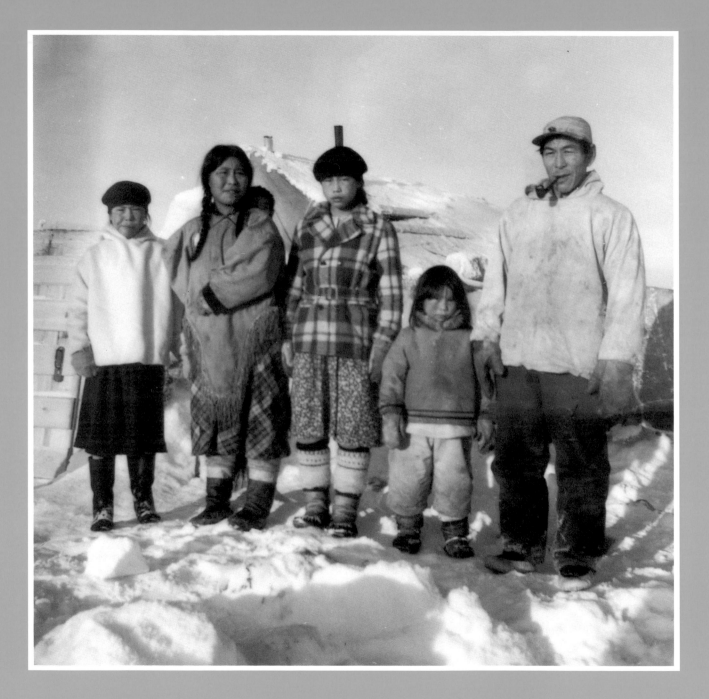

Uqausiit...
Words...
Language

Inuktitut is the language traditionally spoken by Canadian Inuit. Its roots lie in the Eskimo-Aleut linguistic family that consists of two branches, the Aleut and the Eskimo. Each branch may have developed independently from a common ancestor.

The Eskimo branch has two subgroups, the Yupik and the Inuit-Inupiaq. Yupik is spoken in the U.S.S.R. on the coasts of the Chukchi Peninsula in Siberia, and in Alaska from Norton Sound south to the Alaska Peninsula, and east along the Pacific Ocean to Prince William Sound.

The Canadian Inuit belong to the Inuit-Inupiaq subgroup that, as a continuum of closely related dialects extends from Northern Alaska, the Northwest Territories, and Labrador to Greenland.

In the Northwest Territories two written forms of language are used. In the Central and Eastern Arctic, syllabics are the common form, and in communities east from Cambridge Bay a Roman orthography is in use. In Labrador the first detailed grammar based on a Greenlandic writing system was written by Theodor Bourqin, a German Moravian. Today the people in Labrador still use a Roman orthography system of writing.

Inuktitut syllabics were adapted from a system developed for Indian languages in Canada. The Reverend James Evans, a Wesleyan missionary first devised this syllabic character system, a simple way of writing syllabics with signs. John Horden and E.A. Watkins, two English missionaries from the Anglican Diocese of Moosonee, were the first to adapt Evans' Cree syllabics for **Inuktitut**. As both Horden and Watkins were primarily working with Indian populations, neither had much time to devote to the spread of the **Inuktitut** syllabic system.

In 1876 Edmund James Peck, the man usually credited with the adaptation of Cree syllabics to **Inuktitut**, began to study the **Inuktitut** language at Great Whale River. There he began to translate biblical material, and to promote and teach the syllabic system to the local people. This system spread throughout the Eastern Arctic, initially through the printing of religious materials. It was quickly accepted by the Inuit and learned by rote from missionaries, parents, and other friends.

Jean Ayaruar, author of the first non-religious publication in syllabics, with his family.

Communities in Nunavut

1. Arviat
 (Cape Eskimo,
 Eskimo Point)
2. Whale Cove
3. Rankin Inlet
4. Chesterfield Inlet
5. Baker Lake
6. Coral Harbour
7. Repulse Bay
8. Hall Beach
9. Igloolik
10. Pelly Bay
11. Taloyoak
 (Spence Bay)
12. Gjoa Haven
13. Cambridge Bay
14. Umingmaktok
15. Bathurst Inlet
16. Coppermine
17. Resolute Bay
18. Grise Fiord
19. Nanisivik
20. Arctic Bay
21. Pond Inlet
22. Clyde River
23. Broughton Island
24. Pangnirtung
25. Iqaluit
 (Frobisher Bay)
26. Lake Harbour
27. Cape Dorset
28. Sanikuluaq
 (Belcher Islands)
29. Kangiqsualujjuaq
 (George River / Port
 Nouveau - Quebec)
30. Kuujjuaq
 (Fort Chimo)

Figure 3. Inuit and Inuvialuit Communities.

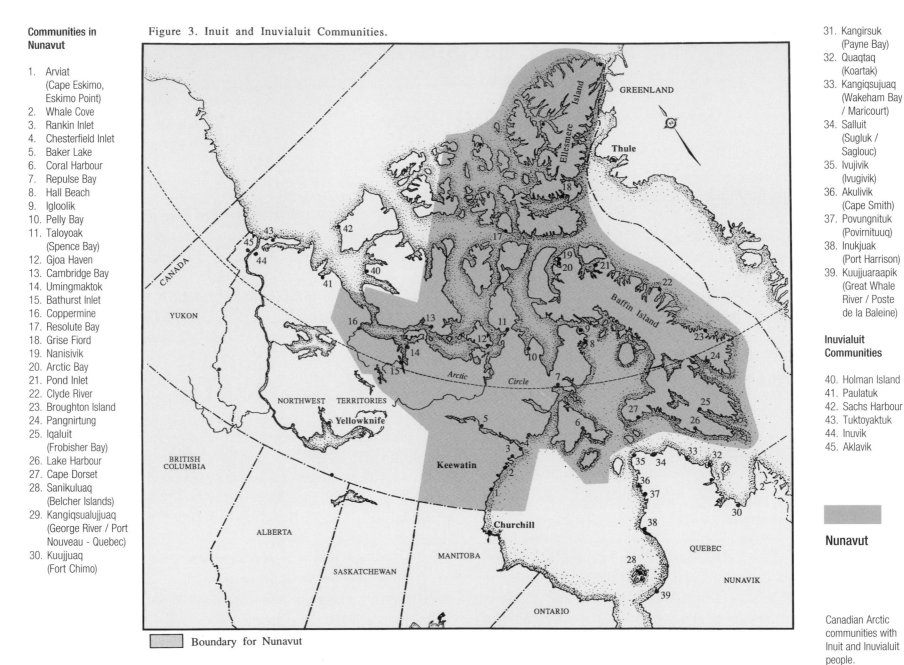

31. Kangirsuk
 (Payne Bay)
32. Quaqtaq
 (Koartak)
33. Kangiqsujuaq
 (Wakeham Bay
 / Maricourt)
34. Salluit
 (Sugluk /
 Saglouc)
35. Ivujivik
 (Ivugivik)
36. Akulivik
 (Cape Smith)
37. Povungnituk
 (Povirnituuq)
38. Inukjuak
 (Port Harrison)
39. Kuujjuaraapik
 (Great Whale
 River / Poste
 de la Baleine)

Inuvialuit Communities

40. Holman Island
41. Paulatuk
42. Sachs Harbour
43. Tuktoyaktuk
44. Inuvik
45. Aklavik

Nunavut

Canadian Arctic
communities with
Inuit and Inuvialuit
people.

Boundary for Nunavut

Dictionary of Fa. Arthur Thibert that was first published in French in 1954.

Most early N.W.T. syllabic materials were printed for religious purposes by the Roman Catholic and Anglican churches.

The first non-religious publication by an Inuk that was printed in syllabics was written many years later by John Ayaruaq, of Chesterfield Inlet, a great helper to the Catholic missionaries working in the Keewatin District. *The Autobiography of John Ayaruaq* was published by the Federal government in 1968.

In the 1970s the Inuit began the process of revising and improving their writing systems. The Inuit Language Commission, sponsored by the Inuit Tapirisat of Canada under the auspices of the Inuit Cultural Institute, met with representatives of Inuit associations, the Roman Catholic and Anglican churches, and the federal and territorial governments. In 1976, the Commission ratified a dual orthography built on an analysis of the language and use of scientific principles. The two orthographies, the Roman and the syllabic, became compatible and interchangeable, and

the syllabic system was standardized. For his extensive work in promoting the Inuktitut language one participant, Fa. Theophile Didier was

Inuktitut, the two forms of the dual orthography, "qaliujaaqpait" to describe the Roman orthography, and "qaniujaaqpait" to describe syllabics. The term "qaliujaaqpait" to describe the Roman orthography was suggested by Abe Okpik; it derived from "qalit," a word describing the markings or the grain in rocks, reminiscent of the appearance of Roman letters.

Titirausiit nutaunngittut. Old syllabic system.

	ai/e ā	i ē	o/u o	a u	
	▽	△	▷	◁	
p	∨	∧	>	<	
t	∪	∩	⊃	⊂	ᶜ
k	ᖅ	ᕆ	ᑯ	ᖯ	
q	ᐁ	ᕇ	ᒍ	ᒡ	
m	ᖕ	ᖓ	ᒪ	ᒷ	
n	ᖤ	ᖦ	ᒧ	ᒣ	
s	ᖢ	ᖣ	ᒥ	ᒦ	
l	ᖱ	ᖲ	ᒦ	ᒧ	
y	◁	▷	▷	◁	
v	▽	△	▷	◁	
r	ᖴ	ᖵ	P	ᖅ	

ᐃᕐᖃᕐᑯᑦ naaniit finals

Titirausiq nutaaq. New writing system.

△ i	▷ u	◁ a	H	
∧ pi	> pu	< pa	‹	
∩ ti	⊃ tu	⊂ ta	ᶜ	
P ki	ᑯ ku	ᑲ ka	ᖯ	
ᕆ gi	J gu	L ga	ᐦ	
ᒥ mi	ᒧ mu	ᒪ ma	ᖫ	
ᓂ ni	ᓄ nu	ᓇ na	ᖕ	
ᓯ si	ᓱ su	ᓴ sa	ᔆ	
ᓕ li	ᓗ lu	ᓚ la	ᓪ	
ᔨ ji	ᔪ ju	ᔭ ja	ᔾ	
ᐱ vi	ᐳ vu	ᐸ va	ᖵ	
ᕆ ri	ᕈ ru	ᕋ ra	ᖟ	
ᖅ qi	ᖁ qu	ᖃ qa	ᖅ	
ᖏ ngi	ᖑ ngu	ᖓ nga	ᖕ	
ᖠ ɫi	ᖢ ɫu	ᖣ ɫa	ᖤ	

ᐃᕐᖃᕐᔪᑦ NAANIIT Finals

Chart of the Old Syllabic System. Chart of the New Writing System.

Syllabic translation of the New Testament compiled by Fa. Theophile Didier, o.m.i.

selected as a recipient of the Commissioner's Award in 1982.

The new dual orthography has not gained complete acceptance across Canada. In Labrador the Moravian Roman orthography is still in use, and many older Inuit in the Eastern Arctic remain attached to the old 4 column syllabic system. Technological advances have contributed to the

new dual orthography's increased use and computerized systems have been developed to transliterate from syllabic orthography into Roman and from the Roman orthography into syllabics.

In the Canadian Arctic the most commonly used dictionaries and grammars have been compiled by Oblate missionaries. Father Arthur

Thibert's English-Eskimo/Eskimo-English dictionary published in 1954 is still extensively used. Fr. Lucien Schneider, a missionary active in the Hudson Bay area both in the Keewatin and Northern Quebec regions, wrote a series of dictionaries and grammars based mainly on his Northern Quebec experiences. In 1979, a conference of Inuit translators from across Canada made a request to the Department of Indian Affairs and Northern Development to support a translation and publication of an English version of Schneider's 1970 Inuktitut-French dictionary. In 1985, Laval University published this dictionary translated from the French and transcribed into the standardized dual orthography by Dr. Dermot Collis. While most of the vocabulary for Schneider's book was collected in Arctic Quebec, it also contains many words collected from other Canadian Arctic areas.

Another monumental work, **Uqausillar-migit**, was published in 1991 by the Avataq Cultural Institute and the Association Inuksiutiit Katimajiit. For 12 years Tamusi Qumaq of Povungnituk wrote and collected **Inuktitut** syllabic words and definitions from **Nunavik** (Arctic Quebec) which were compiled into the first comprehensive **Inuktitut** dictionary.

Since 1979 Interpreter/Translator terminology conferences have been held. Inuit representatives from across the Canadian Arctic create and formalize Inuktitut words and spelling for modern-day terms that previously did not exist in the traditional language. The Inuit Cultural Institute published a glossary of these terms in 1987, and continues to promote **Inuktitut** language development and usage.

Most Inuit under the age of 35 are bilingual, and in **Nunavik** (Northern Quebec) some young Inuit are trilingual, speaking French as well.

Ulirnaisigutiit: an Inuktitut - English Dictionary of Northern Quebec, Labrador and Eastern Arctic Dialects based on the work of Fa. Lucien Schneider.

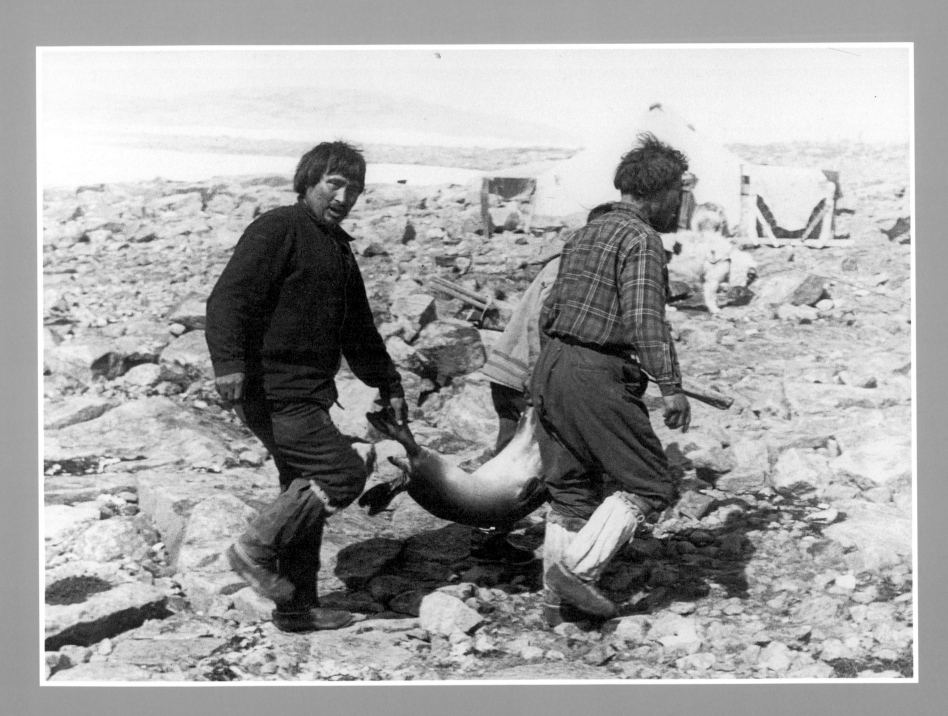

Tariurmiutaniaqtiit...
They look for animals of the sea...

Hunters of the Sea

SEAL HUNTING

In a culture that spent most of its time on the coast and frozen sea, the hunt for seals (**natsiq**) was a major occupation and a significant part of the diet. The ringed seal (**natsiq**) and bearded seals (**ugjuk**) were the most common species encountered.

In the winter seals could be captured as they emerged from the breathing holes they kept open in the ice during the winter. These holes are located in leads of open water near land-fast ice, or in regions of pressure cracks in areas of unstable ice.

In late March or April ringed seal pups are born in birth lairs constructed on the sea ice and connected to the sea with breathing holes through the ice. The young pup was particularly vulnerable to the hunter during its first few weeks of life when it could not swim.

If the snow was not too thick and dense, the hunter could quickly break through the roof and catch the young pup. Some hunters might try to attract the mother who had escaped down the breathing hole by tying a thong to the pup's hind

Athanase Ollikattark and Emmanuel Pudjuk hauling a seal, Repulse Bay c.early 50s.

flipper and throwing the pup into the hole. The mother would seize it between its fore flippers and bring it up and out of the breathing hole regardless of the noise above. The adult seal could then be easily harpooned. The white sealskin pelt from the baby seal provided a nice soft skin useful to make a hat for the hunter's baby.

In the spring seals emerged from their breathing holes in order to fast and bask nearby on the sea ice. They lie sleeping on the ice, but every minute or so raise their heads. With their heads directed away from the wind, they keep a constant look to the leeward. The ringed seals' sight is poor, but their sense of hearing is good. **Ugjuk** are of the opposite nature, with keen eyesight and poor hearing. Various stalking techniques were employed to approach close enough to strike the animal. One stalking technique was based on the idea that the hunter be hidden from the view of the seal. He would utilize a white

MAN WITH
HARPOON
Henry Evaluardjuk,
b. 1923
Pond Inlet (Iqaluit)
1958
stone
13 x 11.6 x 9 cm.

85

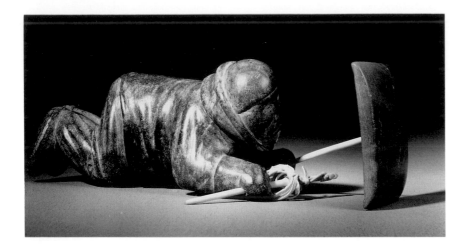

SPRING SEAL
HUNTING WITH
A SCREEN
Arpalaska
Povungnituk 1953
stone
16.7 x 25.6 x 12 cm.

On a bright day a
large white screen
(**tarraq**) might be
held in front of the
advancing hunter.
The approach had to
be made facing into
the wind. In this tech-
nique the hunter did
not want the seal to
observe him. At the
beginning of the stalk
the hunter kept the
screen at leg level.
When he got closer
he would
crawl or walk bent
over and when the
seal raised its head
the hunter would lie
still, kneeling down.

screen (**tarraq**) held in front of his body to hide himself, begin crawling, and then lie motionless when the seal looked up. Other stalking techniques were based on the fact that the seal had poor eyesight, and that the slowly advancing hunter imitating a seal was thought to be another seal by the seal itself. A stalk might take several hours to complete, and the animal might decide to return to the water just before the man approached close enough for the kill. With a firearm the hunter didn't need to approach so close, but if the seal was not killed by an accurate shot to the head it could escape to the **aglu**.

Spring seal hunting from the ice with the use of a small boat to recover the animal or open water hunting in the summer required a keen sense of observation and understanding of the habits of the animal by the hunter. In the open water the seals became less fearful and more curious, diving under the water and bobbing their heads up to look around, swimming closer to the hunter, especially if they were attracted by an unusual noise. In spring and early summer, the surface water has a low density due to the fresh melt water from the sea ice and the fresh water flowing in from the rivers. Seals have less blubber at this time of the year. This factor, in combination with the effect of low density surface water resulted in high hunting losses at this time of the year.

In some areas a small outstretched screen on the bow of the kayak was used to hide the hunter from the view of the seal. With the advent of firearms seals hunted from boats or from the floe edge would first be shot, then harpooned. When a ringed seal surfaces to breathe only the snout and a small portion of the head protrudes above the water. The hunter needed a high degree of alertness and expertise to spot and hit an animal. If the hunter aimed at the seal's chest and his aim was low, the bullet could ricochet off the water and hit the seal's head, and if his aim was a bit high the bullet could possibly hit the seal's head.

MEN GOING TO
THE FLOE EDGE
Antonin Attark,
1090-1960
Pelly Bay 1949
ivory
6.4 x 38.8
x 5.5 cm.

The practice of floe
edge hunting in the
winter increased in
popularity with the
advent of the rifle.
Seals harpooned or
shot from the floe
edge were quickly
retrieved by means
of a small boat.

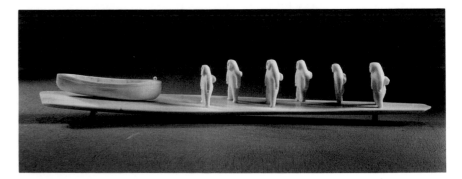

The harpoon (**unaaq**) has become a symbol synonymous with the sea mammal hunt. The basic elements of a harpoon are a spear designed so that a detachable point or harpoon head can be secured to it by friction, and a line attached to the harpoon head. This allowed the hunter to retrieve the animal after the harpoon was thrust directly into the animal, or thrown from a short distance. When the harpoon head was driven into the animal, one or more spurs at the base of the head dug into the flesh, and the tension from the harpoon line pulled by the hunter caused the harpoon head to rotate 90 degrees, and imbed itself under the skin of the animal.

The harpoon itself has many other devices attached to it to help make it function efficiently. Depending on whether the harpoon was directly thrust into the animal or whether it was thrown at the animal, the foreshaft between the harpoon head and shaft was attached fixed or loose. All parts of the harpoon were recoverable. Open water hunting conducted from a boat or at the floe edge involved the use of a sealskin bladder (**nakasuk**) or skin blown up with air. This float was attached to the end of the line to slow the wounded animal, preventing its escape.

The harpoon has changed very little through the years. Today's foreshafts may have a steel or iron rod, and the harpoon head made from brass or steel. The difference between the first prehistoric harpoon equipment and today's harpoon is found in the style of the harpoon head. This

RESCUE AT A SEAL HUNT

"One day Father Mascaret went on a seal hunt with Iktokotak. While the Father, holding his screen, tried to get near the seal, Iktoktak stayed by the sleigh holding the dogs and keeping them quiet. Once within range my companion brought his gun to his shoulder, aimed carefully andBang! Father and seal disappeared under the ice as if they had vanished into thin air by some diabolical trick. Well, the Father had chosen to stand right over a crack in the ice which was covered with a layer of hard snow, and when he fired, it had given way under his weight. The seal, of course, was safe and sound. On hearing the shot he had dived and was probably laughing himself sick. In a flash Iktokotak rushed to the poor hunter's rescue and helped him back on to the ice, fortunately more scared than hurt."

Fa. André Steinmann (1977)

includes the shape and location of the spurs, the position of the line hole, the nature of the socket, the presence or absence of side barbs or top blades, as well as other minor attributes.

BREATHING HOLE (AGLU) HUNTING

During the winter Ringed seals and Bearded seals overwinter in the Arctic seas. Each seal maintains a series of breathing holes (**aglu**) through the ice with the use of its sharp claws on the front flippers.

Pacome Qulaut hunting at the breathing hole Igoolik c. early 1930s.

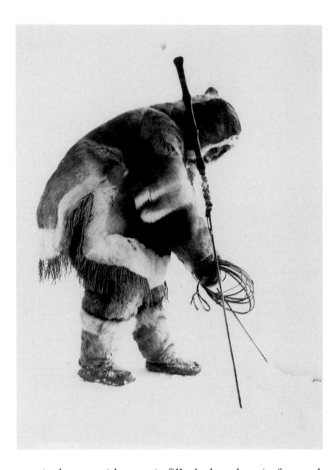

A dome with an air-filled chamber is formed between the water, ice and snow above the ice. At ice level the hole freezes over after the seal leaves but because the snow above the ice acts as an insulating layer the ice does not become too thick before the seal returns for a repeat visit and re-opens the hole. When the seal returns, it will breathe for approximately ten minutes before leaving in search of food or another breathing hole.

Each hunter brought along a leashed dog to search and smell out the location of a hole that was covered with snow and difficult to see even with the most trained eye. A greater number of hunters working together in one area increased the chances a seal would be killed at one of its breathing holes. This activity was therefore, commonly a more communal hunting activity.

There was a defined technology and methodology associated with this hunt that enhanced one's chances of success.

When setting out from camp, each hunter carried his harpoon, a snow probe to locate a

IKPIK SUMMER - NETTING AND CACHING SEALS

"July 26 - The net, one hundred and thirty yards long and twenty yards deep, yields twenty-five seal, when we raise it for the first time. The catch is snarled in the netting like kittens in a ball of yarn.. Three hours of drudgery. The weight of the net gives us kinks in the back, the icy water reddens our arms, the ropes bites into our hands. Now the game has to be stored beneath piles of rocks: twelve seals to the cache. A small one is reserved to feed us and our dogs. In turn, the mosquitoes eat us. Nobody cares because the fishing season looks so promising. This coming winter the dogs will have enough to eat and the house will be warm."

Father Rogatien Papion, o.m.i.
(Ikpik, 1951)

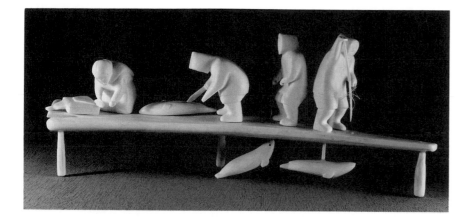

HUNTING AT THE
AGLU
Repulse Bay 1962
ivory
13.4 x 34 x 5.9 cm.

breathing hole, a searcher to determine the contours of the hole, and a hunting bag with the rest of his tools that was attached to the back of the hunter's outer parka or by a thong over the shoulders.

Once a hole was found the hunter's dog was removed a distance away and sometimes tied to a block of snow. The snow probe (**sabgut**), a long bone stick with a handle at one end was then used to find the exact location of the narrow breathing hole.

The hunter used his snowknife (**pannak**) to cut away the upper layer of snow covering the aglu in order to see and smell whether the hole was still in use. If the hole was good the ice pick (**tuuq**) on the end of the hunter's harpoon was used to break the hard ice-like snow covering the hole. The resultant pieces of snow were then removed with a scoop or spoon (**ilaut**).

Next, a breathing hole searcher (**sabgutaojark**), a long bone stick with a handle at one end

and carved lengthwise in a curved form, was utilized to determine the center and general contours of the hole, the water's consistency, and the height difference between the water and the snow dome. Some breathing holes have irregular shapes and some seals scratch one side of the wall of the dome more than the other walls. The knowledge gained by using this tool was therefore vital to the hunter so he thrust the harpoon in the proper direction at the right time.

The hunter then covered the breathing hole with snow and held the snow probe upright in the middle of the snow in the proper striking direction. The probe was then removed leaving behind a small dark hole.

In order to determine the approach of a seal coming up the hole different alert devices were available. They were based on the idea that as the seal rose, the agitation of the water or the upward

MAN STALKING A
SEAL
Salomonie Alayco,
b. 1906
Akulivik 1988
stone
2.8 x 15.5
x 10.4 cm.

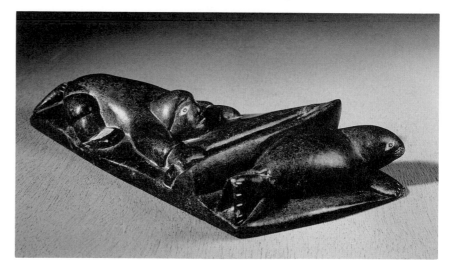

pressure of the air above forced the movement of the device, which could be detected by the hunter. A hunter could detect the seal's approach when it was two or three meters away when the ice was thick.

One alert device was a down indicator (**kreviutservik**). At one end of the device was a small bone piece shaped in the general form of a lying seal holding itself on tip-toes. At the end of this "seal" piece was a line that was tied to a tuft of swan's down or another substitute. The line was then threaded down between the "flippers" of the seal piece by freezing a small looped hair of swan down or fox qiviut. This end was hung

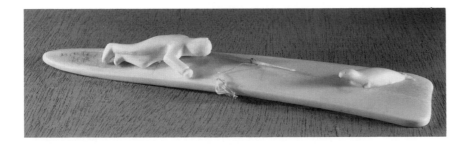

MAN STALKING A SEAL ON THE ICE
Mark Tungilik, 1913-1986
Repulse Bay 1948
ivory
1.3 x 15.3 x 3.8 cm.

While the seal was dozing, the hunter began to crawl along the ice perhaps using a bear or seal skin under his shoulders and buttock to glide more easily, and to protect himself from the frigid surface water on the spring ice. He tried to keep his legs and arms close to his body. When the seal looked towards him the hunter would stop, and either lie motionless or imitate the antics of the seal such as imitating the movement of the flippers with his feet. At first the animal would become scared, and then it became lulled into the false belief that the hunter was a fellow seal. The hunter had to be careful not to allow his weapons to project beyond his silhouette. When he was about fifteen to twenty feet from the seal he would jump up and run quickly to the seal to thrust the harpoon at the animal.

on it's two arms on the chimney. Upon the seal's approach the air movement in the hole created a vibration in the tuft of down. If it was too windy a windbreak funnel (**anorsleorepkut**) made out of sealskin was placed over the chimney to prevent the hole from being choked up with snow.

Another device, the bone indicator had two rods, a short one and a longer one, with each one connected by a plaited caribou sinew line. The longer rod, (**idlanuark**) which was sharpened at the end to hold a small removable disc, (**nakkarepkut**) was hung in the aglu with the disc resting on the partly frozen surface of the water. The shorter rod, (**sennertark**) pointed at one end and forked at the other, was stuck horizontally in a snow block placed near the hole with the holding back lash or line passing over the fork. When the seal arrived the longer rod in the aglu would move upward. When there was no slush or ice the disc on the end of the longer rod was not used, and the seal actually touched the rod, making the operation much more risky.

After setting an alert device the hunter placed himself and the rest of his equipment in the most strategic position possible. Sometimes when there was a keen wind, a wall of snow was built as a protection.

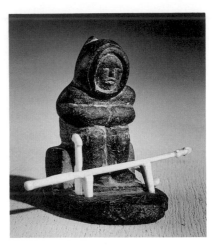

MAN SITTING NEXT TO AGLU
Bernard Irqugaqtuq, 1918-1987
Pelly Bay 1955
stone
5.1 x 6 x 4 cm.

The hunter is set and waiting for the seal's approach to its breathing hole. The man has already learned the art of enduring patience. He has time to merge his thoughts with the physical and spiritual world surrounding him. If he is not successful or lucky that day, hopefully his partner(s) will capture a seal to be shared by the whole camp.

Next, a support (**nakmaktat**) to lie the harpoon across was set up. Two sharpened wooden or antler sticks with a skin-lined notch at the wider end were stuck in the snow. The sticks were placed far enough apart to act as a support for the harpoon which was placed horizontally in front of the hunter. The hunter placed his fur hunter's bag (**tutereark**) under his feet and stood bent over from the waist with his hands across his chest and tucked into his sleeves for warmth. It was essential not to make any noise for any sound could be easily heard by the animal through the ice. The hunting bag helped keep the hunter's feet warm and muffled the sound of his moving feet.

The harpoon (**unaaq**) consisted basically of five components - the harpoon head, the foreshaft, the main shaft, the ice chisel and the lines. The foreshaft and shaft were generally constructed to be the length of the height of the hunter where sufficient material permitted such a practice. Previously made from pieces of spliced wood or caribou antlers, the more contemporary harpoon has an iron foreshaft about 1 cm in diameter and a wooden handle. The removable harpoon head (**senmijark**) had a socket at its end where it was held on the foreshaft by friction. This pointed harpoon head with or without a blade had two slightly flared barbs (**pameark**). A hole to hold the thong was positioned exactly in the middle of the harpoon head so that when the harpoon was in the seal's body it would

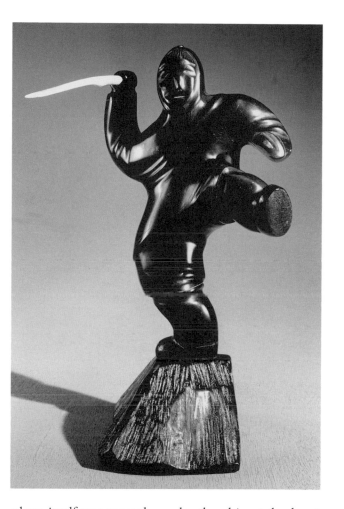

MAN WITH SPEAR
Joachim Kavik, b. 1945
Rankin Inlet 1986
stone, antler
21.6 x 14.9 x 7.6 cm.

place itself transversely under the skin at the least traction. The holding thong (**tukarsiark**) was tied in such a way that the eye formed would not obstruct the barbs. This holding thong would then be passed by free insertion without knots to the spear.

A hard disc (**piglertaut**) with two holes was inserted in the eye of the holding back cord just

below the harpoon head. Because the disc was a little higher than the head of the harpoon it would act as a stopper when the harpoon head went into the seal's body preventing too deep a penetration into the flesh.

A separate length of cord (**kereark**) was attached to the spear, one end often attached near the middle, passing through a hole in the shaft and held by a knot on the opposite side. The other end would be tied tighter in a circular notch around the harpoon near the loop. The holding back thong would be placed by free insert between the parallel cord and harpoon, allowing it to slide freely. A loop (**norluk**) fixed to the spear allowed the holding back thong to pass freely and this loop retained the harpoon shaft to the holding thong when the harpoon head was detached. Plaited caribou sinew lines were preferable for lines because they did not freeze stiff when wet.

The hunter required a good grip on the shaft. This was attained by tying a length of cord (**tikaagut**) around the shaft a couple times at the correct spot.

When the alerting device moved, the bare-handed hunter seized his harpoon with one hand while holding the end of the coiled line in his other hand. He thrust the harpoon down, quick-

Nicholas Niartok, Baker Lake 1951.

TWO MEN HAULING A BEARDED SEAL
Lucassie Tookalak, b. 1917
Povungnituk 1953
stone
13.5 x 38 x 25.7 cm.

A bearded seal weighs 270 kg on the average. It exerted tremendous strength to try to get away after it was harpooned. The hunter usually lay the harpoon line across his knee and arm for pulling the animal out of the hole. This often resulted in swollen and seared fore-arms or thighs.

ly withdrawing the shaft and letting a little line go. The strike was made after the hunter heard the second breathing of the animal, following the expiration. He then firmly held the line. The hunter enlarged the ceiling of the breathing hole with his ice pick, and removed the ice chips with the spoon.

When the seal's head was pulled up through the hole a pointed bone needle with a thong (**orsersitark**) was threaded through a hole made above the teeth of the seal's lip and coming out under the skin between the skin and the eyeball, taking care not to injure the eyeball. This knotted leather thong (**orsiutark**) in the form of a closed circle was used to haul the body out of the hole. A rope was attached to the thong to pull the seal, or it was put on the sled. The animal was completely limp and flexible, blood freezing in thick layers around the wound. After the catch, the

NIKPARTI
Tommy Tattatuapik,
b. 1937
Arctic Bay 1970
whale bone
13 x 31.6
x 12.3 cm.

A new technique of hunting seals in their breathing holes (**nikparti**) was introduced to the Baffin Island region by Corporal F. McInnes (**Uqarajuittuq**) in the early 1920s. A harpoon rifle made with an old discarded rifle that had the barrel sawed off would be set up on a tripod over the seal's breathing hole (**aglu**). To replace the cartridge, a harpoon with a thin rod shaft was inserted. The harpoon line was attached to a piece of wood anchored outside the aglu in the snow. Many times the force of the blast blew the tripod and firearm four or five meters away, but the seal would remain anchored, hanging in the aglu.

MAN SPEARING
SEAL
John Kaunak,
b. 1941
Repulse Bay 1971
stone, antler, ivory
12.2 x 17.2
x 10.5 cm.

man who had made the catch cut an incision in the belly, removing the liver and a piece of blubber that was cut up and shared with the hunting party. Then the animal was re stitched. Needles or wound plugs (**tuputark**) were used to stitch the opening or to block wounds to prevent excessive loss of blood at the site.

The hunter's total concentration and endless patience had paid off that day. His good fortune was shared with the rest of the camp.

(Compiled with information from Father F. Van de Velde, o.m.i.)

WHALE HUNTING

The white whale or beluga (**qilalugaq**), the narwhal (**allanguaq**), and the bowhead whale (**arviq**) traditionally provided large quantities of edible skin, meat, and oil that could sustain the local population.

Qilalugaq were commonly hunted in or near shallow river estuaries, and along the coast during their spring and autumn migrations. In places where the whales entered river estuaries with the tide, the hunters allowed the animals to enter the estuary and then hunted the whales when the tides turned and the animals headed back to the sea. **Allanguaq** were taken at the floe edge during the spring, in deep fjords during the summer, and along the coast during the autumn migration. Both types of whales sink almost immediately when shot, and will only appear on the surface of the water for a short time.

In open water whales would be pursued by a group of hunters and driven into shallow water where they could be harpooned and shot. Whales could also be netted with a larger mesh net at points and at entrances to bays.

To harpoon an animal it was necessary to aim at the back of the neck when the animal was above the surface of the water which only lasted a brief moment. This had to be done when the animal was on the way up because if it had already turned and was on the way down it would exhale the spent air and not having a chance to inhale, continue downwards and sink. Sealskin bladders (**nakasuk**) and in more contemporary times, ten gallon steel barrel drums were attached to the harpoon line. If shots were fired in the vicinity of the surfacing animal, it would have no time to breathe and it would head down right away. After a while the animal would get tired and stay on top of the water longer. Then the hunter could get closer.

When the ice breaks up in the spring **allanguaq** appear along the ice edge in the cracks and holes. Hunters await the appearance of narwhals in these small holes and ice cracks where they can be pursued and killed, first by being shot, and then harpooned. A few camps might be situated along the ice edge where the hunters patrol on snowmobile along the ice-edge until the narwhals are spotted within 50 meters. From such a distance an animal was shot with a 30-30 or 30-06 rifle. It would then be retrieved with a harpoon and boat.

The fall hunt during the animals' migration period was important because the whales traveled closer to land. Areas of narrow straits and peninsulas are favourite hunting spots.

WALRUS HUNTING

HARPOONING
A WALRUS
Tommy
Angutitauruq,
b. 1945
Gjoa Haven 1981
muskox horn, stone
5.8 x 15 x 8.1 cm.

Floe-Edge

Walruses (**aiviq**) hunted from the ice were hunted communally with several hunters taking up position on the ice edge. Often they would try to decoy the walrus by imitating the grunting noises of the animal, as walrus will call when on the ice or on shore to attract others.

When the animal approached close enough it was harpooned and the shaft of the ice-hunting harpoon was stuck in the ice through the end-loop of the line. If the line could not be held fast this way, the hunter might try to hold the walrus by bracing himself against a previously prepared block of ice frozen to the ice's surface.

The other hunters were armed and ready to lance the animal when it slackened its line. In

more contemporary times, canoes 5 to 6 meters in length powered by outboard motors would be sledged to the floe edge, and the canoes with three or four hunters in each fanned out from the floe edge on to the water. An animal would be shot with a high powered rifle and then harpooned. Nearby canoes came to assist in the hunt when they heard the shooting.

On Winter Ice

Igloolik

Where there was thin winter ice the walrus could thrust his head though holes to come up to breathe. The hunt was dangerous because the walrus sometimes broke through the ice under the hunter's feet. Even if the hunters were not close enough to harpoon the animal, by scaring and exhausting it, the animal would finally surface long enough to be harpooned.

Open Water Hunt

Hunts could be conducted by traveling to walrus feeding or haul-out sites in late summer and early autumn. Walrus could be driven into shallow water near the shore where they were harpooned. The animals could be recovered later from the sea bottom with a special retrieving hook, and towed ashore, or collected at low tide.

When the walrus lay sleeping on drifting ice pans or on land the hunters would paddle their kayaks toward the animal as quietly as possible and then discharge their firearms. A wounded or

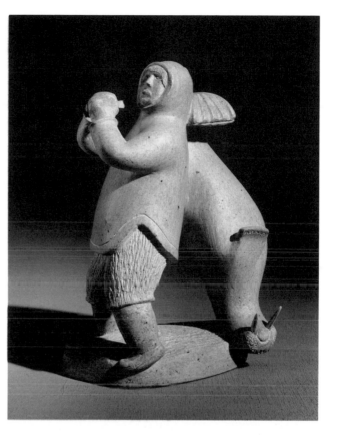

MAN HAULING A WALRUS
Silas Qayaqtuaq
Hall Beach 1986
stone
 21.6 x 9.7
x 13.3 cm.

This fanciful carving could not depict a real walrus that reaches a maximum average weight of 550 kg.

dead animal sank in the water unless it was harpooned immediately. The wounded harpooned animal dragged through the water the inflated seal bladder float that was attached to the harpoon head by a long line. The walrus tried to escape by diving but was prevented from doing so by the bladder. It then tried to rid itself of the bladder by bursting it with its tusks. At last, exhausted by the loss of blood and energy expended in the attempt to escape, the animal would tire and could be dispatched with a bullet.

The hunters then drew the animal along the side of their boat and towed it to the nearest land mass or ice-floe.

In more recent historic times in some places the hunt was conducted in the summer and fall from whaleboats (**sivutuuq**) and Peterhead boats (**umiaraaluk**), using ten gallon steel barrel floats to replace the sealskin floats. Open whaleboats could carry three or four walruses, and a fully-decked Peterhead vessel up to 10 meters long could hold the remains of up to 20 butchered walrus.

BEAR HUNTING

A polar bear (**nanuq**) was usually hunted with dogs. After a fresh bear track was found several or even all the dogs would be let loose from the group. When a dog found a bear it would try to seize the bear from behind. More and more dogs were slipped into the fray until the pack surrounded the bear and the hunter had his opportunity for the kill. If the bear grabbed one dog, the others in the pack would pounce on it.

On smooth ice the bear might be chased directly by sled. When the sled caught up to the animal the hunter would cut the dog traces with his knife, and allow the dogs to chase and then attack the bear from behind.

A pursued bear would try to escape to the water. If there was no water close enough by, it would head to a pile of rocks or a high elevation if it was on land. On the sea, the bear would head towards the rough pack ice where the sleds could not easily follow, or the dogs could not surround it. On broken or glare ice his footing was much more sure than that of his pursuers.

Nanuq could be hunted in the late winter or spring in their snow dens. Contrary to popular

CAMP SCENE
WITH BEAR
Emily Pangnerk
Illuitok, b. 1943
Pelly Bay 1986
ivory, string
5 x 25.5 x 6.9 cm.

When the dogs found a bear they would try to seize the bear from behind at its most sensitive spot, the anus. The hunter would wait for his chance to attack the bear.

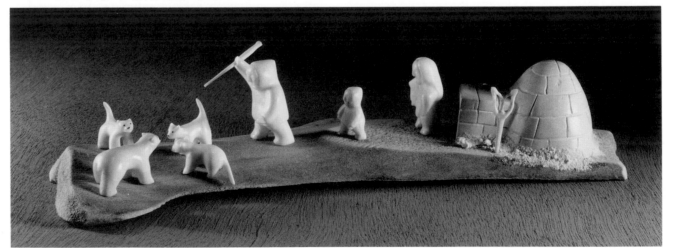

A BEAR HUNT ON SIMPSON PENINSULA

*"Bear tracks were visible all around. Fabien (***Oogaq***) started to probe the snow with his seal harpoon. Almost immediately, the steel shaft of the harpoon going through the hardened snow, and piercing through a thin layer of ice and sliding into emptiness, indicated for him a subterranean igloo. There remained now to find out whether the bear was yet at home or if, on the contrary, there were only abandoned igloos here. Fabien continued his probing, methodically. All of a sudden, the end of the harpoon hit something soft. The reaction was immediate: the bear, in a violent rage, bit at the steel shaft. "Erksinartoaluk - he's dangerous", said Fabien, drawing back his harpoon without further insistence.*

When Bernard (Irqugaqtuq) had come back, we unleashed the dogs and prepared the harpoon gun and camera. In front and slightly below the place where he had touched the bear, Fabien began to remove the snow in blocks with his knife. The blade pierced into the ceiling of the igloo at about one and a half foot from the surface - and the bear did not hesitate to apply his pulsating snout to the yawning hole. The Eskimo continued to enlarge the opening with his knife.

The bear had put his nose to the window and seemed to ask himself who these unwelcomed visitors might very well be. Brusquely, he began to scratch the snow furiously to make an opening for himself. There was not time to lose.

Fabien beset him with a violent thrust of the harpoon. A few moments later, Bernard shot a bullet through his head: the beast fell back, stone dead."

Father Guy Mary-Rousselière, o.m.i.
(Pelly Bay, 1956)

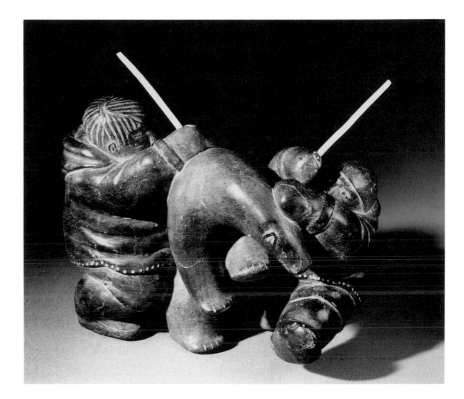

belief, both females and males can be found in dens. Very often the dens or lairs were found in the same spots each year on the south-eastern slopes of hills, sheltered from the prevailing north-westerly winds.

It has also been recorded that a bear might be hunted by stabbing it in the eye with a knife. In order to give himself more strength, the hunter would put his hands on the bear and attempt to stab the animal with his snowknife.

A charging bear might be killed with a knife, with the hunter jumping aside to face each new

TWO MEN
SPEARING A BEAR
Povungnituk 1953
stone, antler
25.2 x 26.8
x 13.8 cm.

MAN HUNTING BEAR
WITH A KNIFE
Fabien Oogaq,
1923-1992
Pelly Bay 1960
ivory
5.6 x 14.2 x 2.9 cm.

"The hunter over taken by a bear presented his forearm to the animal, because the bear with his mouth fully open could not bite through it. When the bear tried to bite his arm, the hunter would stab him with a knife on the side of the body below the shoulders, or in front of the ribs in the soft part of the gut."

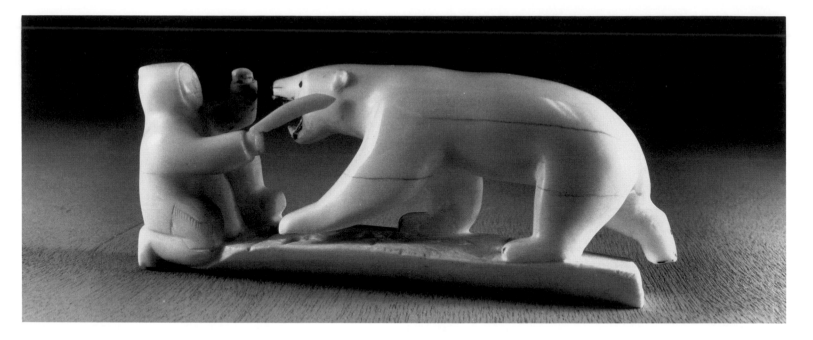

THE TRIBULATIONS OF A BEAR HUNTER

"This reminds me of my astonishment as a novice missionary when, returning from Clyde River with an Eskimo, we encountered bear tracks not too far from the open sea. However, my guide showed no undue excitement and proceeded to lecture me on the pursuit of game: how to recognize a fresh footprint from one made the previous day or from an older one, according to the firmness of the snow; how to distinguish between the footprints of a female or a male, young or old, fat or thin, depending on their length, their roundness...proceeding on our way, we reached a difficult spot strewn with ice, broken and piled up by the winds and the currents. Blood stains lead us to a veritable cache made by the lord of the country. Well-buried in the snow, under the shelter of a pile of ice, he had deposited the proceeds of his hunt, his larder against a time of want. Fat being the bear's preferred food, all that remained of the seal was the flesh and bones; not an ounce of fat on the carcass..."

Father Georges Lorson, o.m.i.
(Pond Inlet, May 1957)

HUNTING A POLAR BEAR IN ITS LAIR
Fabien Oogaq,
1923-1992
Pelly Bay 1960
ivory, caribou skull, sealskin thong
12 x 5.3 x 12.1 cm.

With a barbless harpoon or spear the hunter probed the ground to find the side of the den closest to the bear and then thinned the snow with a knife to form a hole just big enough for a bear to peer through, but not big enough for the bear to put his head or shoulders through. Then the animal could be stabbed or driven out of the lair and kept at bay by the dogs. The bear's head can be seen in the caribou skull, and a dog sits on top of the skull.

charge. Standing on its hind legs, the polar bear would try to strike the hunter with its paw. Some Inuit say that the male and female do not strike with the same paw, and that the hunter took advantage of one side of the animal being weaker than the other side.

With firearms, a well-aimed hip shot could immobilize the animal and prevent it from rearing up and attacking the hunter.

Large stone bear traps of the tower type, where the animal fell through an upper entrance, or the type where a trap door was attached to a bait inside have been observed in the Pelly Bay-Thom Bay region. Traps were built of a size that allowed little movement of the animal once entrapped.

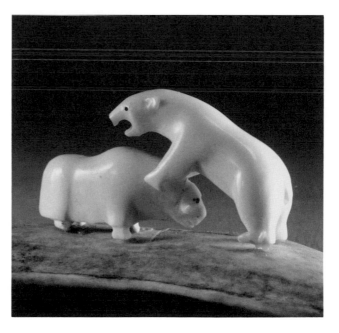

BEAR, MUSKOX, AND MAN AT COMMITTEE BAY
Fabien Oogaq,
1923-1992
Pelly Bay 1973
ivory, antler
5.6 x 10.4 x 8.2 cm.

"A man hunting at Committee Bay saw a bear stalking a muskox. The muskox didn't move, but lowered his head, inviting the bear to approach. When the bear rose up over him the muskox threw him up into the air with his horn, and killed him. The man then killed the muskox. He had a very successful hunt that day."

Nunamiutaniaqtiit...
They look for animals of the land...
Hunters of the Land

CARIBOU HUNTING

The most important land animal to the Inuit was the barren ground caribou (**tuktu**). Hunting methods for this animal were generally based on one of three techniques: stalking, attracting, or scaring the animals towards an opportune place of capture.

Using a deep knowledge of the habits of the animal, the weather, and the particular topography of the land, the hunter, hunting partners or group of hunters would decide where the animals might be found and how they could be approached. The approach would be upwind if possible because the caribou's sense of smell and hearing are better developed than its sight.

Meticulous inspection of the land was the mark of a good hunter. Every cliff, valley, coastal indentation, lake, stream, and even down to certain rocks was unique to the seasoned hunter. These landmarks were observed, named, and memorized.

On flat land, hunters may have chosen to stalk the animal, imitating the caribou's gait using bows and arrows as antlers. During mating time,

Young boy fishing at the stone weir (**saputi**) Repulse Bay, August 1951.

when the bulls fought in demonstrations of strength, a hunter might place a pair of antlers on his head and imitate the grunting of the animals to attract them closer. In winter during clear weather, hunting became more difficult because footsteps could be heard by the animal a long distance away.

A bow and arrow was the primary weapon used in the traditional stalking style of hunt, it's

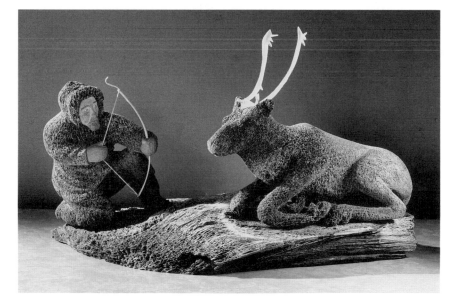

HUNTER WITH
BOW AND ARROW
Siarnak Atagootak,
b. 1938
Pond Inlet 1968
whale bone, stone,
antler
39 x 62 x 37 cm.

101

effective shooting range being only about ten to twenty meters.

A bow (**pitiksi**) could be made out of muskox horn or caribou antler and wood. It was composed of several pieces lashed together and retained its strength, tension and flexibility through a backing of caribou sinew. This backing of plaited sinew cords was held in place by cross bindings, and the bow string itself was a single plaited cord of caribou sinew.

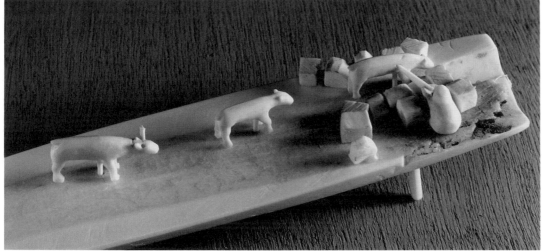

CARIBOU HUNT
IN WATER
Pelly Bay 1950.
ivory
3.5 x 24.2
x 4.4 cm.

Arrows (**qarjuk**) contained a wooden shaft, and a barbless bone point or foreshaft with a blade inserted at the end. Feathers for the arrow were commonly taken from either eider ducks, owls or ravens.

A quiver (**qarjugvik**) to hold the bow and arrows was made of depilated caribou or sealskin. A quiver was an essential piece of equip-ment, preventing the sinew on the bow backing from becoming wet and losing its holding power. Another small bag contained loose feathers and a feather twister for twisting the bow backing. The tool bag also included two marlin spikes to unfas-ten and tighten the back lashing of the bow and a feather setter for fastening the feathers to the arrows.

During the fall migrations when the caribou followed a specific route, the Inuit drove the cari-bou between single or converg-ing lines of stone cairns to a point of ambush. These cairn lines erected before the hunt, might be several kilometers long. Women or children, acting as beaters, drove the caribou into the wide entrance between the cairn lines, and some might even situate themselves between the cairns themselves to frighten the caribou by waving skins and imitating the howls of wolves.

Caribou drives might direct the animals to a point of ambush at narrow sec-tions of lakes, or slow river sections. The hunters would wait in hiding by their kayaks, set at the water edge. When a signal was made by one per-son in the group, the Inuit entered the water in pursuit of the herd. This was done as soon as the caribou had traveled a sufficient distance into the water and would be confused as to which way to

COILED BASKET
Bibiane
Ittimangnaq,
b. 1912-1979
Pelly Bay 1955
wlllow root, straw?
12.5 x 17.6 cm.

turn. A lance was then thrust into the swimming animal with a quick movement and then immediately withdrawn. The hunter would aim the point at the soft part of the animal behind the ribs trying to provoke an internal hemorrhage. As caribou are quite buoyant in the water, the hunter could pursue his next animal without fear of the loss of his previous kill. The cows and young calves were often the first victims of this kind of hunt.

In late fall when the ice was not completely frozen and the caribou crossed promontories, peninsulas and narrows, the hunters waited on the opposite side of the shore until it was time to yell and wave the herd to an area where the ice was thinnest, and the panicked animals became easy prey.

Another capture technique was the use of deep pits constructed with snow block lined walls in a manner and location where an easy slope led to the roof of the pit. The longer side of the slope was iced. More shallow pits were dug in the snow and covered with faggots and a thin layer of urine-soaked moss located nearby to attract the caribou. Stakes might be placed at the

bottom of the pit. Once trapped, the animal or animals were dispatched with a bone dagger, worn suspended from the hunter's belt or spear.

The introduction of firearms (**sirqutidjut**), binoculars (**iglututiik**) and later snowmobiles (**qamutaujaq**), resulted in increased hunting in small groups, and the winter caribou hunt became more successful.

MUSKOX HUNTING

Muskoxen (**umingmak**) live in herds that can vary from less than a dozen in summer, to larger groupings of sixty or more in winter.

The hunter took advantage of the habit of the muskoxen to move into a circular defense formation when confronted with danger, which normally came from wolf attacks.

In this defense formation the herd members line up side-by-side facing their attackers with

YOUNG HUNTER
Illustration by
Bernard Fransen

MUSKOX HUNT
SCENE
Pelly Bay 1965
ivory, muskox horn
12.7 x 21.2
x 4.9 cm.

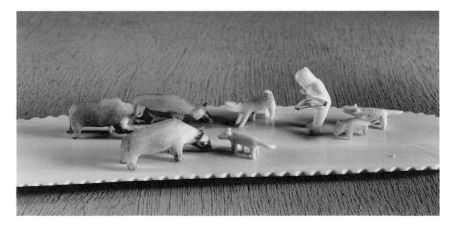

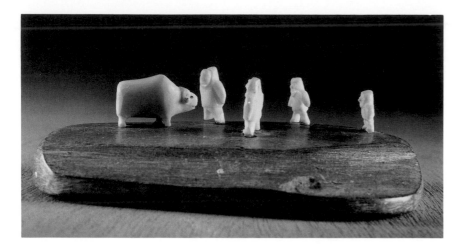

MUSKOX HUNT
Mark Tungilik,
1913-1986
Repulse Bay 1976
ivory, stone
3.4 x 10.4 x 6.2 cm.

TIRIGANIARSIUTIT
Luke Arngna'naq,
b. 1931
Baker Lake 1971
stone
10 x 18.9 x 6.8 cm.

A stone box trap
(**tiriganiarsiutit**) to
capture foxes
consisted of a
chamber of stones
and a flat sliding
stone door entrance
that was tied to bait
inside the trap.
When the bait was
touched the
cord triggered the
closure of the sliding
stone door.

hunters might shoot arrows at a bull that would leave the circle and charge the attacker. The dogs would be set on the animal, and the hunters then waited for an opportune time to attack, using their heavy spears.

TRAPPING FOX

Traditional stone traps for capturing foxes (**tiriganiarsiutit**) were generally of three kinds; the box trap with a door attached to a bait inside, a deadfall trap, or a tower or igloo trap.

In the stone box trap (**tirigannianiuti**) when the

Diagram of a stretched fox pelt. Illustrated by Fa. André Steinmann, o.m.i.

Les peaux de renard sont tendues sur des planches se terminant en pointe. La queue est tendue par une languette de bois.

bait was touched or the trap shaken the top stone would slide down causing the door to shut, containing the fox.

The deadfall trap (**kaungnattut**) had a ceiling made of a heavy stone set in an oblique position with one end resting upon another stone set vertically. When the fox went after the bait and the stone was touched, the ceiling caved in. Deadfalls could also be made with slabs of ice.

Other stone tower traps or igloo traps as recorded in Pelly Bay operated on the principle

their rumps positioned tightly together and the calves wedged between the adults. An adult might leave the formation to charge an attacker whether human or wolf, and then return to the formation.

Dogs set loose among the muskoxen might provoke an animal to leave the defense circle, or

THE OLD WHITE WOLF

"It was an old wolf, a real wolf... as white as the land of snows where it had been born. Three feet high, old age and misdeeds had worn its teeth out. It had even lost two claws in a fight and its spoor, easily detected on that account, could be found a hundred miles around.

Caribou killer, fox robber, it carried everywhere its slaughter and solitude. Many hunters had sworn to kill it but the old white wolf was cunning! It scented the traps, eluded them. Last winter, eating the foxes caught in the trappers' snares, it had waxed fat. This year saw it starting again on its rounds of misdeeds. However, it had carried its crimes too far. Its hour had come! The object of its misdeeds was going to prove the means of retribution.

A fox caught in a snare, dead and frozen, was used as bait. It was tied by a string to the trigger of a gun set nearby and cleverly concealed under a pile of snow...

It came in the dead of night, while everybody was asleep, sniffed the bait and, contentedly licking its chops, made ready to carry the fox a little farther away in order to devour it quite comfortably. The gun went off and the bullet struck Master Wolf right in the centre of the head. A spring backward and the old white wolf was dead, its blood reddening the snow.

Brought to the post, its body was viewed and weighed by everyone...the pelt of the old white wolf, duly tanned and softened, would make a magnificent pair of trousers... it will be the hunter's trophy.

Father Armand Clabaut, o.m.i.
(1960)

CHECKING THE TRAPS

"The tradition of the older people was never to allow an animal to suffer. They would always try to be orderly and kind to any living thing. They would make sure that the foxes didn't stay in the leg-hold traps too long. They would check the traps frequently....When I found a fox in a trap, if the fox was still alive I would have to kill it before removing it. An easy way to kill a fox was to tap it on the nose, using the handle of my snowknife. This would knock it unconscious or paralyze it and then I would snap its neck, upward. The fox didn't suffer."

Henry Isluanuk

that the animal could not escape after falling through a hole in the top. In this kind of trap a fox bitch in heat, or fox urine might be used to attract other foxes.

The more modern steel spring trap (**mikigiak**) was baited with fish or caribou or whatever was available. The bait would be spread around the trap but not on it because the sun would melt the snow, thereby exposing the trap.

WOLVES

Wolves (**amaruq**) could also be caught in box traps built with a flat sliding door and bait.

Before the use of firearms and modern traps wolves could be captured in pitfalls with knives pointing upwards secured at the bottom of the pit.

To position a trap (**mikigiak**) in the snow was a delicate procedure. The trapper would take a block of snow and make a pit in it for the trap. Then another block would be placed on top and slowly shaved until the trapper could see the trap by seeing a dark patch in the snow. Bait was placed near the trap but not on top of it. The trap was anchored by burying the end of the chain in the snow, packing it firmly, and adding moisture so that it froze in place. Another method was to position the trap in the snow, put bait on the spring and place a thin layer of powder-like snow on top. Then the chain was secured.

Another method used was to set a blood covered knife in the ground or frozen into the lake ice with only the edge protruding above the surface. The animal would lick the blood, cut its own tongue and spurred on by the taste and smell of blood continue to lick until it bled to death.

In some areas a piece of baleen (**surqaq**) was rolled in a loop, tied with a sinew line, set into meat or blubber, and frozen. After the wolf ate the meat and it melted, the baleen piece would spring open and tear the animal's stomach. Thin strips of muskox horn were also used for this technique in the Netsilik area.

WOLVERINE

In the Pelly Bay region a funnel-shaped trap was made with ice slabs that tapered down to about 10 cm. in diameter at the bottom. Attracted by a fish bait, the wolverine (**qavvik**) would slide down the funnel immobilizing his front paws, which prevented his escape.

Another form of trap using an igloo and small floor entrance worked by killing the animal with a triggered rifle attached to a bait that attracted the animal into the igloo.

Modern techniques include shooting and trapping. A steel trap on the top of the igloo could be set with the chain well secured to an icy section. When the wolverine was caught in the trap he would scratch furiously on the top of the igloo. As a result, he broke the ceiling of the igloo and fell through. Caught by one paw in the trap he was now left hanging. Sometimes when the trapper would recover the trapped animal he would discover the interior walls of the igloo marked all over with the scratches of the claws of the animal.

ARCTIC HARE

Arctic hares (**ukaliq**), which were not greatly valued for meat, were be caught in snares (**nigaq**) stretched between stones, with bows and arrows, or with a .22 rifle. Snares might be set across old tracks, which the animals often retraced.

OTHER SMALL ANIMALS

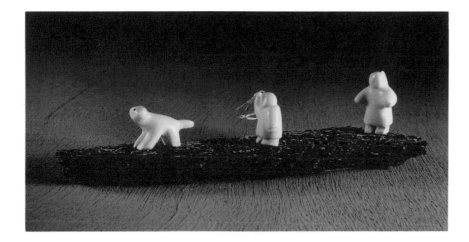

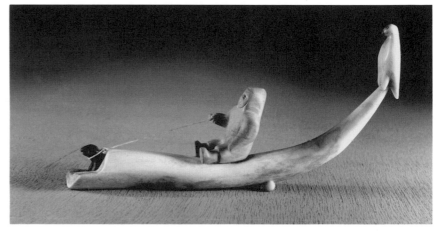

LASSOING A FOX
Sabina Qunqnirq
Anaittuq, b. 1941
Pelly Bay 1970
Ivory, whale bone
3.5 x 14.4 x 3.7 cm.

Other small animals like marmots and ground squirrels were captured with plaited sinew snares or by throwing stones. In the spring the animals could be caught with snares as they emerged into the sunlight from their winter lairs by the river banks.

BIRD HUNTING

While birds were not a major part of the regular Inuit diet, their availability on a seasonal basis was a welcome change in a diet.

Waterfowl, mainly Canada geese and various ducks, could be caught with bird darts with barbed side prongs propelled by a harpoon thrower, bola balls (**akslitaq**) attached to cords of plaited sinew thrown in the air to entangle the birds, baleen snares, or blubber encased needle-like gorges (**iiniuti**). The greatest successes occurred during the fall moulting season when the birds were unable to fly strongly or too high above the ground, or at the height of the moulting season when they were not able to fly at all. Geese could also be encouraged to fly lower in the sky by children making a noise that may have sounded like the cries of young goslings. As the geese circled lower, they finally came within range of the hunter.

In cliffs or the more mountainous areas of Baffin Island, the eggs of guillemots (**pitsiulaaq**), seagulls (**naujaq**), and murres (**akpa**) were collected by means of a long stick with a circular basket attached to the end, or by lowering the collector down the cliffs tied to a sealskin rope.

Canada goose eggs collected on the tundra were a welcome source of food in the early summer in some areas, whereas elsewhere eider duck eggs were an important food source.

Ptarmigan (**aqiggiq; nitsaartuq**) resident year round could be caught with a bow and special arrow with a rounded and blunt bone point

OWL WATCHES
A MAN CATCH A
SIKSIK WITH A
LASSO
Pelly Bay 1962
antler, clay, stone,
sinew
7.3 x 13.9
x 2.5 cm.

The man captures
the siksik with a
lasso (snare) hung
over the siksik's
burrow.

that only stunned the animal, or, more commonly, by throwing stones.

Seagulls (**naujaq**), winter residents, were caught in one region by baiting the top of a small igloo possessing a thin roof. When the gull fell through the roof, the hunter could then seize the gull by the legs. In Pelly Bay a piece of blubber with a hook on it, sometimes also containing a float, was attached to a line weighted to a rock on the tidal flats in summer. When high tide arrived the blubber floated and attracted the attention of the seagulls.

Small boys might amuse themselves by catching snow buntings and small birds in a stone and stick trap that was set in a hollow spot in the ground. The hollow would be baited with a few berries and the stick held up by a flat stone tied to a line leading to the child who by tugging on the line, dropped the stone on the unsuspecting bird.

FISHING

Throughout the Central Inuit territory, fishing for anadromous char swimming upstream in August was a major communal activity and an important source of food to be cached for the fall and early winter. Stone weirs (**saputi**) with a central basin were set at shallow rivers. Following a signal indicating sufficient fish had come through the entrance, the entrance to the weir was closed, and the families began to fish furiously using their three pronged spears.

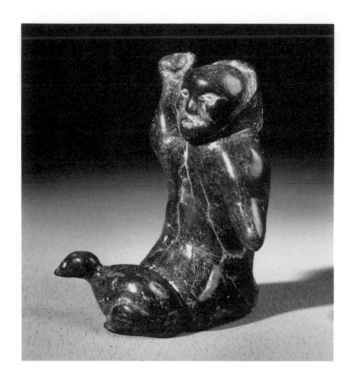

CHILD HUNTING
PTARMIGAN
Rebecca Nukallaq
Arnaqjuaq, b. 1928
Hall Beach 1971
stone
9.2 x 6.6 x 6.8 cm.

During the early part of winter or in the spring ice fishing was done through holes chiseled through the thin ice. At this time of the year, the fish, including lake trout and arctic char could still be seen through the ice holes. They would be attracted by jigging an ivory lure shaped like a fish (**iggalungoar**), often with moving parts, which was attached by a sinew line to an antler handle or reel (**imbrik**).

When the ice thickened and the fish could not be speared through the ice holes, the fish had to be caught with a hook fixed in a bone sinker, (**qajuksalik**) sometimes baited.

Other secondary fishing techniques included harpooning fish with barbed antler harpoon heads (**nauligak**) from rocky shores, or from a boat, or anywhere there was open water. This technique could be used in the annual spring and fall migrations of arctic char through swift river water.

Gill netting became more common in the North with the arrival of the traders and missionaries who needed to store meat for food and for their dog teams. In the winter nets (**matitautit**) to capture over-wintering char, lake trout and whitefish would be strung through holes made in the ice. One end of the net was pushed through the first hole with a long stick, under the ice to the second hole, from the second hole to the third, and so on, until the full length of the net was under the ice. Long lines were attached to the ends of the net so it could be lowered to any desired depth. At the time the nets were checked,

a break would be made in the new ice covering an end hole and the net pulled out of the water. As the fish left the water they froze almost instantly. The net needle was important for mending or making nets. Today most nets are made commercially.

Fishing at the Stone Weir (Saputi)

Fishing was conducted at the stone weirs (**saputi**) in August and September for a period lasting no more than three weeks when the anadromous arctic char were migrating upstream to the large lakes of the interior where they over-wintered.

Saputi would be constructed at river mouths just below the high river mark. At high water the char would enter the weir through the entrance, but could not get out at low water.

The shape of weirs could vary, but all had the end parts of the walls touching on the shores,

GOING FISHING AT THE SAPUTI
Otto Apsaktaun
b. 1932
Pelly Bay 1958
ivory, antler
5.7 x 21 x 4 cm.

During the second half of August families from the Pelly Bay region headed from the interior to the coast to situate themselves at the best fishing areas (the shallows of the Belcher, Kellett and Kuyaardjuk rivers) for the annual char migration from the sea to the inland lakes.

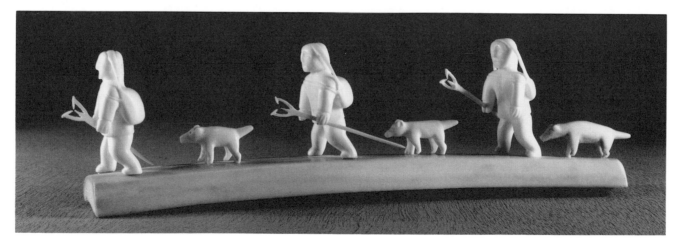

and the fish were directed to an enclosed central basin where the spearing was done. Sometimes there were secondary stone traps set within the basin.

When the char were inside the weir, the hunters (men, women, and children) would spear the fish, remove them from the **kakivak**

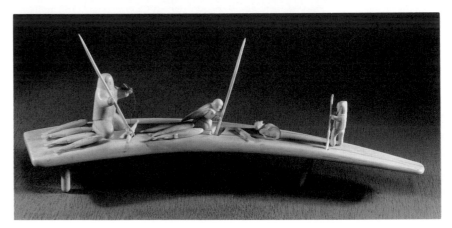

FISHING IN
THE SUMMER
Antonin Attark,
l909-1960
Pelly Bay 1949
ivory
4.2 x 45.5 x 7.9 cm.

At the beginning of
July families moved
their camp to river
mouths to fish for
char that returned
from inland lakes to
the sea. Fish that
have been split have
been hung on a skin
line to dry.

and string them with a flat bone needle and line. The spear or **kakivak** was about a meter and a half long. It had two springy barbed side prongs made with musk-ox horn or caribou antler, and a center spike of bone or iron drilled to the middle of the shaft. The whole thing was lashed together. The fish were pierced by the middle prong and held by the barbs of the more elastic side prongs. The side prongs were shaped by heating one side of the horn over the flame of the soapstone lamp while cooling the opposite side with seal oil. In more recent times hot water was used to heat the horn. While the spear was not in use, the pronged end would be placed in the water to keep the musk-ox horn flexible.

The fish stringing needle (**kopqaut**) was up to fifteen to eighteen cm long and often made from the shin bone of the caribou. It had a rope with a couple of strong knots at the end to act as a crossbar. The needle would be pushed through the fish's neck and out through the neck on the other side, not through the gills. Ten, twelve or more fish could be strung, the hunter holding the bone needle in his teeth, and dragging the fish in the water to absorb their weight.

Ice Fishing With the Kakivak

The hunter first chiseled a hole in the ice. His steady strokes caused flakes of ice to fly high in the air and as the chisel broke through the last layer there was a loud gurgling sound as the water gushed upwards. He or she would seat themselves with their back to the wind, or if fac-

FISHING
IN WINTER
Antonin Attark,
1909-1960
Pelly Bay 1944
ivory
14.6 x 36.6
x 6.2 cm.

The young boy
holds the ice chisel
while the
 man and woman
are jigging for fish.

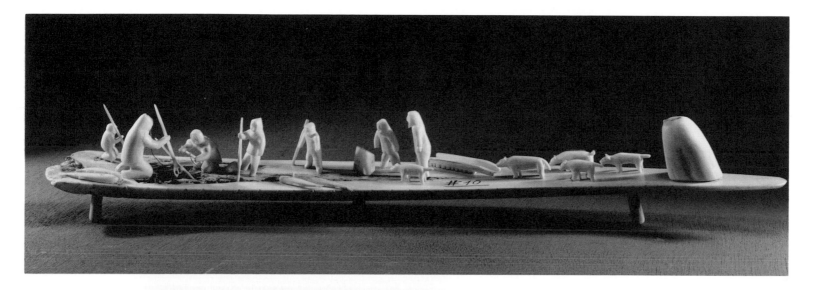

FISHING IN SPRING
WITH THE ICE
THAWING
Antonin Attark,
1909-1960
Pelly Bay 1944
ivory
7.6 x 44.9
x 6.1 cm.

The decayed
proximal end of the
walrus tusk has
been used to show
the ice thawing in
the spring.

FISHING WITH
KAKIVAK AND REEL
Hubert Amaroallk,
b. 1925
Hall Beach (Igloollk)
1978
stone, antler, sinew
35.5 x 22.5
x 23 cm.

When the ice
became thicker in
the middle of the
winter, fish could
be caught through
the holes in the ice
with an antler reel,
plaited sinew line,
and hook fixed in a
bone sinker. The
hook that was per-
haps only a bent
nail filed sharp
would be baited
with a fish-skin
section of the belly
of a fish.

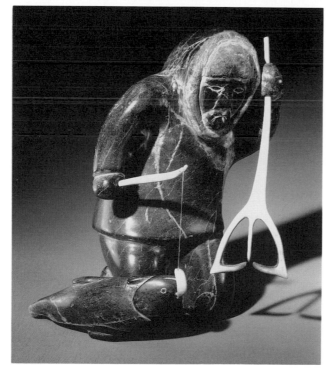

ing the wind with a shelter of a few blocks of snow. Kneeling forward with his head down, the hunter shaded the hole with both arms and his head to see more clearly through the water. The **kakivak** or spear was placed obliquely into the hole resting against the edge. The reel with the lure was held in one hand, and the line let down into the water and given a jigging motion by moving it up and down with short movements of the handle. When the fish approached, the **kaki-vak** was thrust downwards, the long central prong transfixing the fish, while the two side prongs set an angle prevented it from escaping. The fish was then shaken off the spear and killed by giving it a blow behind the head with the shaft, or cutting the spine with a snowknife, thereby paralyzing the fish.

Quaqtailijumamut…
In order not to freeze…
Warmth from the Cold

CARIBOU SKIN CLOTHING

Caribou skin was the preferred skin for clothing, and a fully dressed person carried approximately four kg of clothing or one third the weight of typical southern style clothing worn today at low temperatures. Caribou hair has an outer layer of coarse guard hairs with a honey-combed shaft of dead air space, and an inner layer of soft, light, dense hair. The hollow outer layer of hairs coupled with the air trapped between the two layers of hairs provides excellent insulating properties.

Most clothing was manufactured from animals caught in late August and early September in order to have the hair the right thickness and to have a hide suffering from the least amount of damage by parasitic warble flies. This also was the prime hunting season when many caribou were migrating in herds to the south.

Garment patterns were fashioned using eye or hand measurements, or pieces of string that were knotted. A special small ulu was used for cutting the skins. The style and design of the garment reflected the age, sex, geographic origin of

Marie Issarataitok
and Jacqueline
Utarawa,
Pelly Bay
c. 1956-58.

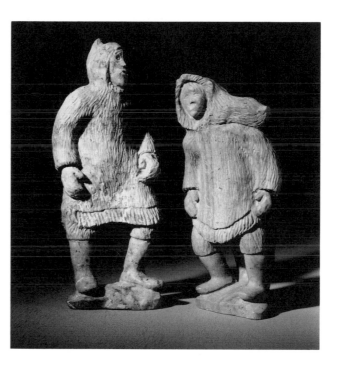

MAN AND WOMAN
Cain Irqqarqsaq,
b. 1944
Igloolik 1989
stone
26.3 x 4.2 x 8 cm.
10.5 x 9.4 x 5.3 cm.

the wearer, and often made references to animals and their spirits.

New clothing was generally meant to last a year. Some items like boots and mitts wore out more easily and more than one pair were made. The hunting parkas were designed with dropped

113

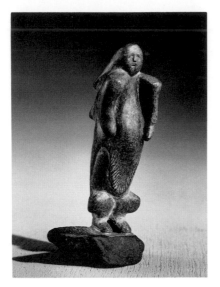

WOMAN WITH
KNEE POUCHES
Marta Qirngnuq
Ittimangnaq,
b. 1918
Pelly Bay 1954
stone
7.3 x 4.1 x 2.4 cm.

Sometimes the
ladies' stockings or
boots had a side
pouch (**avati**) to
hold mitts, fur dia-
pers, or other small
objects.

shoulders and armhole seams. This placed less stress on the stitches of the seams and allowed enough space for a person to slip his arms easily in and out of the sleeves to keep warm. This was particularly helpful when the person was relatively inactive for long periods of time, for instance when waiting at a seal's breathing hole on the ice during the winter.

The clothing was tailored to fit loosely allowing for freedom of movement and for air to enter, letting the warm air out very meagerly through the hood when it was loosened. The loose fit of the parka allowed a layer of warmed air between it and the body, while at the same time it permitted the free evaporation of perspiration. Cool air entered by the hem and side splits and reduced overheating. To reduce ventilation in extremely severe weather, a belt would be tied around the parka at the waist.

Two practical design aspects of the parka were side slits for maneuverability, and bottom fringes (**niggiit**) cut out of strips of caribou skin to hold the skin down and break the wind.

When the wearer was running or working hard the clothing flapped, increasing the air movement which kept the body cool and dry. When he was more inactive, the amount of cold air entering at the hem line and side splits was reduced by fringes at the parka sides and along the bottom hem line. These fringes also helped prevent the skin from curling up. The cuff opening for mitts was made small enough so the mitts would fill the opening.

Cut showing
positions of closed
string of the hood
when the latter is
opened and closed.
Illustrated by
Fa. Guy Mary-
Rousselière, o.m.i.

Most of the body heat escapes through the head so a specially designed hood was fashioned to fit closely to the face. The hood (**nasaq**) was an extension of the back pattern, therefore eliminating a drafty neck seam. The hood barely covered the ears and cheek bones that then allowed for better vision and a decrease of build-up of frost on the hood opening or ruff. The pointed hood was strung a special way so that when a blizzard began the person could quickly tighten the hood by pulling the tie strings over the pointed hood (**kukukpak.**)

A cold face that was in danger of being frostbitten was warmed by pulling one hand out of its mitten and holding it briefly over the cold parts.

Loose fitting caribou boots were light and warm. Traditionally there were as many as five layers of footwear in combinations of stockings, short socks, boots and short overboots. Today it is more common to see a footwear combination

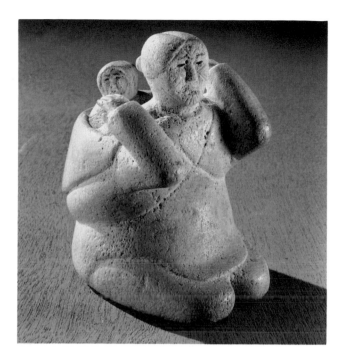

WOMAN
REMOVING CHILD
FROM AMAUT
Muckpa
Qumangapik
Arctic Bay 1984
whale bone
10.1 x 11.5
x 10.9 cm.

of a wool sock, knee length woolen duffel socks, an ankle high duffel sock, and then a sealskin boot.

The women's parka (**amaut**) differed from the men's, with a large wide hood enlarged enough to carry a child in a back pouch. The shoulders were made wide enough to move a child from the back pouch to the front for breast feeding without having to take the child out into the cold. To keep the child in the pouch the parka was bound around the waist with a skin waistband that had a large wooden or ivory button at each end. The buttons were pushed under one or two skin straps sewn on the front of the parka below the neck opening.

A MISSIONARY'S FIRST SURVIVAL LESSON

"We take a northward direction. The wind starts blowing from the east, from the sea. Chilly and damp, it numbs the fingers which we thought so well protected inside the warm caribou fur...

- "Ikkii? Are you cold?" Alphonse asks me.

- "No", I reply, with an expression on my face meaning: "Yes, I'm cold, but I'm able to stand it."
A glance at my mitts and Alphonse knows what I had not dared to admit. He takes his own mitts off and tells me: "Give me yours and try these." What a surprise to discover that his mitts are comfortably warm whilst mine were frozen."

- "Okko? Is it warm?" he asks me with a smile.

I can't but admit it. It gives him an opportunity to teach me my first survival lesson in the Arctic: the proper way to wear mitts when the hands are cold - "Imanna, like that, you see," and he shows me his closed fists, with the tip of fingers well in the bottom of the mitts. I, on the contrary, had been trying to pull my fingers in more and more. I understood that will power must inhibit the instinctive reflex of drawing in, because his way of wearing mitts was in fact protecting the tip of the fingers with two thicknesses of fur instead of one."

Father Theophile Didier, o.m.i.
(1961)

Today's woman's parka or amaut is based on traditional designs, but caribou skin has been replaced by an inner duffel parka with an outer cotton windproof shell.

When a child no longer stayed in the mother's back pouch, he was clothed for a couple years in a single combination suit (**attartaq**) before taking the clothing style of a man or woman. This one piece suit had a flap and slit at the back so that the child could relieve himself.

Boots (**kamiks**) and mitts (**pualuk**) required a tougher part of the hide so the front or hind legs of the caribou were used. Untying harnesses and chopping dog food frequently wore out the single layer mitts . Skin from the snout of the head of the caribou was good for making mitts or the soles of kamiks.

Children's clothing was made with caribou fawns or even caribou foetus.

Sewing thread (**ivalutuinnaq**) was made from the spinal sinews of the caribou which lie immediately under the skin on either side of the vertebrae, or from beluga or narwhal sinews. When caribou and whale sinew was not available seal or bird sinew was used. After the sinews were removed from the animal, they were scraped and allowed to dry or be frozen. At the time of use, the sinew was softened in water and all remaining flesh scraped from the sinew. After being spread on a board to dry, the fibers of sinew could be split off easily. A fine thread of sinew was moistened usually by passing it across

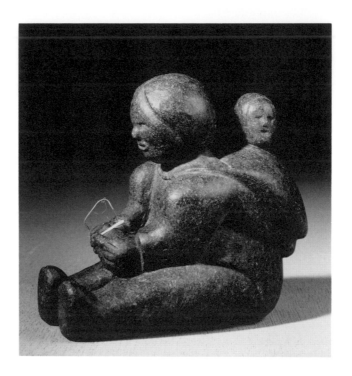

WOMAN SEWING
Repulse Bay 1959
stone
10.4 x 11.2 x 5 cm.

When sewing the seamstress moved only the wrists with a motion directed towards her. For a skin with hair, normally the overcast stitch was employed with stitches running from right to left, and the thumb nail of the left hand arranging the skin before each stitch was made. When a waterproof seam was required the needle was taken through the upper ply of the skin and half way through the under-skin and sometimes a double seam with an outer and inner one was sewn. Running stitches were only employed on unhaired skins.

the lips and then pulling it through the seamstress's fingers one or two times before threading the needle. Fat or grease from fox, goose or caribou marrow was used to make the thread more slippery.

The sewing needle (**mirquti**), today a store-bought steel needle, was previously made from the metatarsal bone of the caribou or from bird bones, such as the hard wing bone of a seagull. Cases to hold needles varied from skin needle cases fitting into elongated bone receptacles, to moss cushions in a cloth or skin bag.

A thimble (**tikiq**) for the index finger was an unhaired skin piece, oval in shape, with a curved

Eastern Arctic clothing in silhouette. Arrows show obstacles to escape of hot air at top.
Illustrated by Fa. Guy Mary-Rousselière, o.m.i.

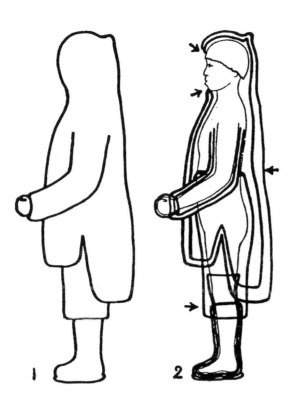

In the late summer when the winter clothing was made the hides were dried by spreading the skin out on the ground with the hair side down, and anchoring the edges with rocks. A skin used for bedding or a sled cover was spread out to be dried and stretched by being pegged to the ground.

In the winter-time, to make fine soft skins for clothing the hide was "brittle-dried" by a woman or man sleeping with the skin wrapped around her/his body with the flesh side next to the person's naked body. The skin prepared in this manner was then made more pliable with a blunt stone scraper used to break and stretch the fibers of the skin. If the skin was too dry, water would be squirted evenly over the entire hide and rubbed into the skin. The moistened skin was

Scrpapik softening a skin in the igloo. Foxe Basin, October 1947. Illustration by Fa Guy Mary-Rousselière, o.m.i.

slit near one edge. Sewing bags could be made out of skin, cloth, or even bird's feet of eider duck, loons, swans or geese.

PREPARATION OF CARIBOU SKINS

When a caribou was skinned the hide was dried, rolled up, and put away until skin preparation took place at a time when clothing or other items were made. Before this was done, the main tissues, flesh and fat were removed with a scraper made from a caribou scapula (**kiliutaq**). Care had to be taken not to cut the roots of the hair or to injure the skin.

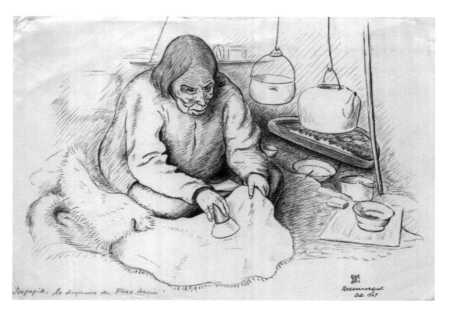

117

folded with the hair outside, rolled tightly, tied, and put outside for a day or two.

Following these activities an iron scraper, made in earlier times of bone was used to scrape the inner skin. This final scraping determined the thickness of the skin and required skill and practice to avoid cutting the skin. If the hide was not soft or pliable enough the skin might be re moistened, put away for a day, and scraped again.

Bedding and sled skins did not need a night warming process. These air dried skins were softened by rubbing them with the hands or using the blunt scraper.

An old bedding rug could be dehaired easily by placing it in water for a few days until the hair loosened, and then scraping off the hair. Other caribou skins that needed to be dehaired were dried and scraped with a knife. Before being used, the shaved skin had to be moistened.

PREPARATION OF SEAL SKINS

Treatment of seal skins varied according to the way they were to be used when the preparation was finished.

When the sewer wanted to keep the hair on the hide, the skin was first scraped with an ulu to remove the blubber and connective tissue. This was done on a scraping board, flat box, or large stone. The skin was then washed and stretched to dry by pegging it hair down a few inches above the ground to let the air circulate around it. Other more recent techniques are to stretch the pelt onto a wooden frame and secure it through slits cut in the pelt approximately every 10 cm, or by nailing the skin to a plywood board. When it was dry the flesh side might be dampened with salt water, rubbed with the hands and dried again. Then the skin was softened by using a blunt stone scraper, stomping on it, and wringing it until it was soft.

To prepare white dehaired water resistant sealskins the dark epidermis had to be removed.

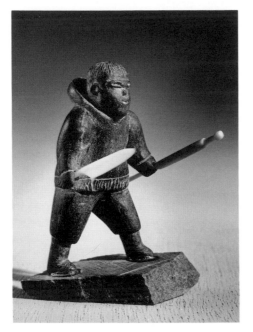

MAN WITH
SNOWGOGGLES
Bernard Irqugaqtuq,
1918-1987
Pelly Bay 1955
stone
6.1 x 3 x 5.4 cm.

Snowgoggles
(**iggak**) were worn
in the spring, usually from April to
July, to protect the
eyes against excessive ultraviolet radiation in the light
reflected by the
snow at this time of
the year.

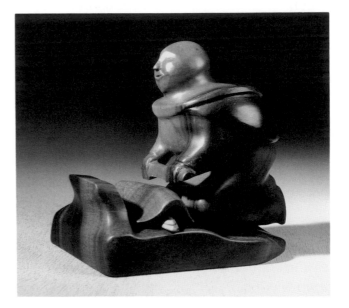

WOMAN SCRAPING
A SEAL SKIN
Johnassie Kavik,
1916-1984
Sanikiluaq 1964
stone
11.4 x 6.8
x 12.4 cm.

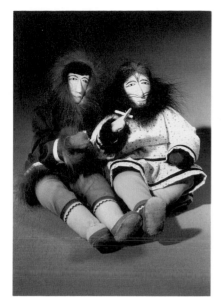

SKIN AND CLOTH DOLLS
Susie Kingolok
Evaglok, 1933-D
Coppermine 1989
1) cotton polyester, seal skin, caribou, rabbit hair, felt thread
2) cotton polyester, caribou, wolverine, wool, felt, seal skin
1) 22 x 29.3 x 11.1 cm.
2) 22 x 29.6 x 10.4 cm.

The skin was soaked in hot water after the blubber and thin layer of epidermis was removed. Once the hair was loose the skin had the excess water squeezed out. Then the hair and epidermis were scraped off and the skin stretched and softened.

To achieve a very white skin for summer boots or for use as decorative strips following the final scraping, the skin was hung in the open air in the hard frost to be bleached by the sun for about a week or longer. The prolonged sunlight and cold temperatures helped to bleach the skin. Care had to be taken not to let rain fall on the skin.

WATERPROOF BOOTS

To make the sealskin waterproof the first step was to remove the blubber. The hair was removed with an ulu first by spreading the cold wet skin over the thigh or on a scraping platform, and shaving it against the grain. The black pelt covering the skin on the outside was left on. The skin was then turned over and the connective tissue was removed. The skin was then ready to be stretched and dried either on the snow, or by pegging it to the ground, depending on the season. In more recent times the skin was lashed on a wooden frame, or nailed to a plywood board.

Before the skin could be sewn it had to be thoroughly chewed and softened.

Double seaming to waterproof boots was made possible in two steps. In the first step the sole was sewn to the instep by the needle penetrating half-way though the instep and all the way through the sole using a combination running or overcast stitch for the slightly crimped areas, and an interconnected running stitch for the heavily crimped toe and heel areas. The second seam was done with a water-tight overcast stitch taking care not to penetrate through the skin of the soles.

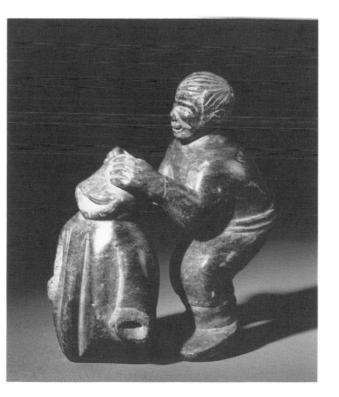

MAN HOLDING AN "ATIGI"
Inukjuaq 1958
stone
11.1 x 9.8 x 15.5 cm.

A man's winter outfit consisted of an inner parka or **atigi** with the hair facing inwards, which the man is holding, an outer parka (**qulittaq**) with hair facing outwards, inner and outer trousers, stocking, socks, boots, and mitts. Yearlings were the preferred caribou fashioned into men's clothing.

MAN
Barnabas
Arnsungaaq,
b. 1924
Baker Lake 1988
stone
31.4 x 19.2
x 9.7 cm.

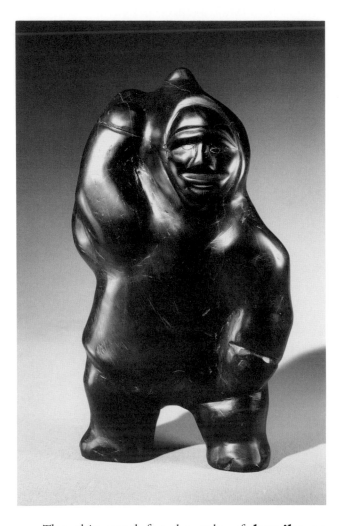

The skin used for the sole of **kamiks** or boots came from the belly of the bearded seal near the front flipper. The skin was scraped with the ulu, scalded, or allowed to ferment. In some areas it was just kept in fresh water. The hair was then scraped off and the skin was dried and chewed. This might require eight hours of chew-

ing. The soles would be easier to sew if they had been thinned down around the edges with an ulu and kept moistened around the edge at the time of sewing by wetting the skin with the mouth.

More contemporary sealskin **kamiks** are worn with a sock, calf or knee length woolen duffel sock, an ankle high duffel sock, and the sealskin boot.

SEAL SKIN THONGS

Strong ropes or thongs were necessary for many implements including dog whips, dog harness line, drying racks, tent lines, packing lines, ropes for athletic games, lashes for sleds, tools and weapons.

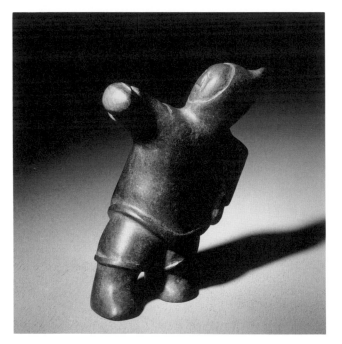

MAN IN THE WIND
Johnny Iqulik,
b. 1966
Baker Lake 1986
stone
13.9 x 10.3
x 4.6 cm.

In a storm, caribou skin clothing provides the best protection from the cold. Insulation is provided by air trapped both in the individual hairs with their honeycomb-like cells, and between densely packed guard hairs.

Most thongs were made from the skin of the **ugjuk** that was cut into a number of rings about 25 cm wide. Skin from the **ugjuk** was preferred to walrus which was heavier and harder to handle. These cuts were made through the blubber and meat with each ring loosened by passing the knife between the blubber and meat. The blubber was scraped off the thong and the ring wetted or boiled to loosen the hair and epidermis. Each ring was cut into thongs about 13 to 20 mm wide. Then the thongs were stretched between two rocks. When the skin was dry a knife was used to remove the hair and epidermis. A woman might chew or work the line to soften it before it was used for lashing, harpoon lines, or whips. A seal skin thong was more practical than modern nylon ropes because it did not make tight kinks that would have made the continual untangling of dog traces in cold weather impossible.

PREPARATION OF BEAR SKINS

Bear skins might be used as waterproof bags or coverings for belongings such as the winter clothing stored during the summer.

The skins were prepared by scraping off the fat, pegging them down for stretching and then drying. In former times the skins were scraped on a flat stone platform or on the scraper's legs.

To clean a bear or fox skin the skin might be tied hair down behind the sled in winter. After a day or two the skin would be clean.

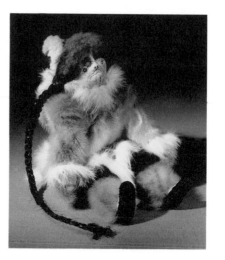

SEALSKIN DOLL
Martina Pisuyui
Anoee, b. 1933
Arviat 1990
seal skin, musk-ox hair, wolf fur
22 x27 x 19 cm.

The artisan of this sealskin doll has used muskox hair for the lady's hair.

PREPARATION OF BIRD SKINS

Bird skin clothing was considered for the most part to be a substitute, and a sign of the scarcity of caribou or seal skins. Eider ducks (**mitiq**) were the preferred skins and could be made into parkas, bonnets, underclothing, slippers, and stockings to be worn in the kayak. Bird skins were also used for napkins to clean the fingers and face after eating.

After the bird was slit at the neck, the skin preparer reached into the bird with her hand to loosen the skin from the meat. The wings were cut off and the head pulled out through a slit. The skin was cut around the beak and the whole skin pulled off the body. After being rubbed in the snow to remove blood and grease, it might be beaten with a snowbeater. Bird skins were turned inside out and dried, and then the fat sucked out until the skin felt dry.

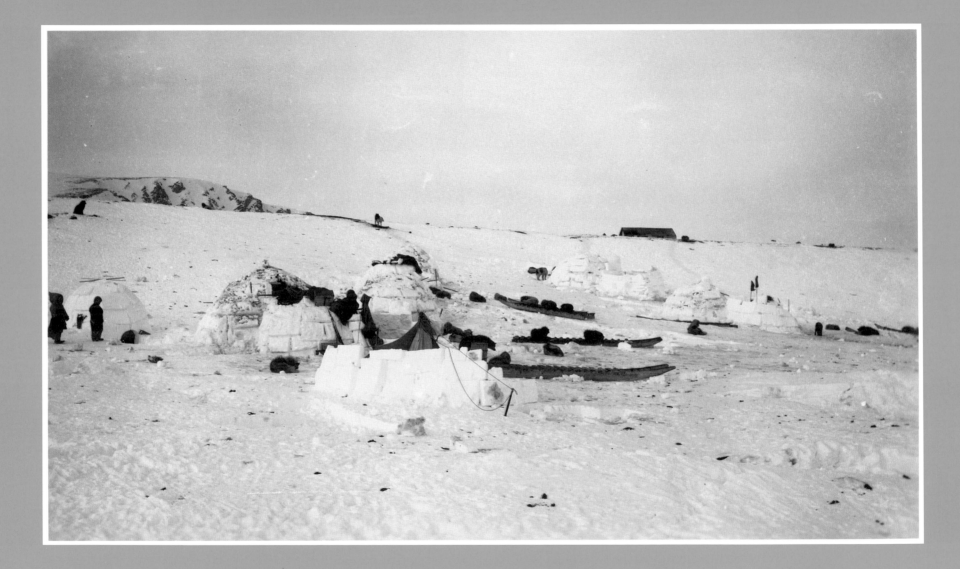

Igluillu Niqiksaillu
Housing and food...
Shelter and Food

CONSTRUCTION OF A SNOWHOUSE (IGLOO)

To construct a snowhouse the first task was to find a good building site with the right consistency and depth of snow. If the camp was on the land it was preferable to build the snowhouse on the lake ice because the snowhouse would be warmer. To find the right snow the snow was tested with a special instrument called a snow probe (**sabgut**). This long thin rod of antler had a handle at one end and a bone ferrule at the pointed end. The probe was pushed through the snow at several places to find snow with the consistency of that formed from a single storm.

The snowknife (**pannak**) was one of the most important parts of the male hunter's tool kit. Historically made with caribou antler or ivory, the blade had a downward slant. The handle ended in a squared off butt and had to be long enough to be gripped with two hands.

With only visual judgment, a large circle representing the dimensions of the igloo was drawn

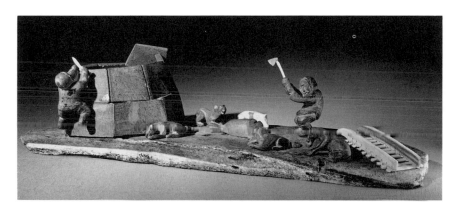

BUILDING AN IGLOO
Jimmy Muckpah
Pond Inlet, (Arviat)
1969
stone, antler, whale
bone, ivory
1.3 x 55.6 x 19 cm.

with the snowknife on the hard surface of the snow. Then the rectangular snow blocks could be cut with most of the necessary blocks cut from within the circle. The dug out hollow formed the sunken floor of the house. If possible, two builders worked together, one cutting the blocks, the other building the structure.

Rectangular blocks, preferably cut vertically from the snow, had to be cut such a size that the builder could grasp them from underneath their lower corners with his arms partially outstretched. The first row of blocks was set by laying the blocks side by side around the perimeter

Igloo camp at Button Point, Pond Inlet area, May 6, 1945.

Ice houses might be built when ideal snow conditions did not exist for building strong igloos, such as in the spring when the snow became too soft or in the fall before the snow had become sufficiently firm. These ice houses were built with slabs about 2 m high and 2.5 m wide cemented together with snow and roofed with skin tent sheets spread across the top of the walls.

of the circle. Then the top surfaces of the blocks were shaved off at a sloping angle to form the first rung of the igloo's spiral construction. A diagonal cut was made from the bottom of the first block to the top of the third block and this upper wedge of snow was removed. This left a sloping ramp so that the rest of the blocks formed a continuously climbing spiral inclining towards the centre of the snowhouse. Each block was trimmed to fit its predecessor as well as those blocks underneath. They were pushed in place with a vigorous blow of the fist. To make it fit tightly, the block was pushed sideways and downward. The placement of blocks in their correct position was more important than eliminating any spaces between the blocks that could be chinked with snow, later by the builder, or his family members.

To fit the top block in place, the edge of the opening was beveled at about 15 degrees from the vertical. The key block was lifted up through the hole in the roof, lowered down into the hole, and the edges shaved until it fit tightly.

A ventilation hole 5 to 7 cm wide was cut through the roof. At bed-time the ventilation hole was closed with a piece of skin, mitten, or snow. If it was a small igloo made while traveling, another

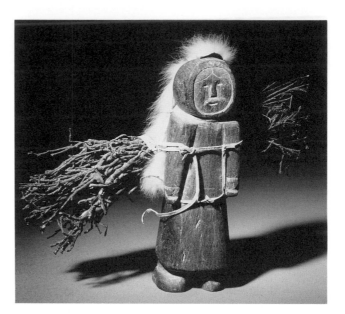

ventilation hole was cut through the wall near the primus stove to provide oxygen for the igloo.

In a more permanent igloo a window was placed in the wall above the entrance. This window might either be a large slab of fresh water ice (**igalak**) or a translucent membrane of seal gut.

A gothic style of opening was cut above 70 cm in height for an entrance. In front of this opening a smaller porch-igloo was constructed which served as a storage room. A round porch was constructed at the entrance of the igloo when the igloo was not just a temporary shelter. The floor of the porch was constructed a little lower than that of the house so that the porch acted as a "cold trap," preventing some of the cold outer air from coming directly into the house. A half

In the more southerly regions twigs were collected for fuel in the winter. This was weary back breaking work. The snow had to be scraped away, and one by one each willow twig cut. A small short-handled spade made from the shovel of an antler was used to dig moss and pull up the heather and willow branches. The branches would be tied in bundles, carried over the head and breast in a tump line, or stuffed into big bags. Back at the camp the twigs burned quickly and provided a smoky fire that had to be tended constantly.

circular windbreak made with snowblocks was built at the entrance. To enter inside, the occupant bent down, extended the right leg, entered further, and then stood up. Sometimes smaller domes or extensions on the entrance served as additional storage rooms, kennels for the pups, or cooking porches where twigs that smoked and flickered were used for fuel.

A snow shovel (**nivautaq**) was used to bank the snow against the outside walls of the igloo, or earlier in construction for clearing an area of soft snow to get at the harder more consistent snow for cutting blocks. The pulverized snow was banked about 30 to 40 cm thick at the bottom and became progressively thinner towards the top in order not to insulate too highly the upper part of the igloo where the warm air had risen up to. Traditionally, the shovel was made with a bearded sealskin stitched to a caribou antler frame with a short handle. The seal skin was replaced by several wooden pieces riveted together.

Inside, a sleeping platform 50 to 75 cm high extending two thirds of the way into the igloo, was built at the rear of the igloo. Platform skins made of caribou skin might have a mattress of heather twigs underneath them; the poorest skin was at the bottom with the hair facing downward. This platform was the center of family life, functioning as a bed by night, and table and chair by day. Smaller side platforms held the food, lamp, and other household implements. A small

block might be placed between the two platforms for the woman to rest her feet on but more normally the woman sat on her feet while tending the lamp.

The size and complexity of the igloo depended on many factors: whether it was an overnight shelter, whether one or two families were contained in a single igloo, whether adjoining igloos were erected, or if it was to be a larger dance house. A normal family igloo was 2.5 to 4.5 meters in diameter, 1.8 meters high, and could be constructed in a few hours. A more permanent camp igloo that was 2.5 m. and higher took a longer time to construct. A spring-time igloo required a higher arch so the melting snow in the igloo would glide in rivulets down the walls of the igloo rather than fall straight down on the occupants.

Eastern Arctic igloo and Baffin Island earth and moss hut.
a) front porch
b) soft ice window
d) platform bed
e) flag stoned passage
f) seal intestine window
g) skin roof.

Illustrated by Fa. Guy Mary-Rousselière, o.m.i.

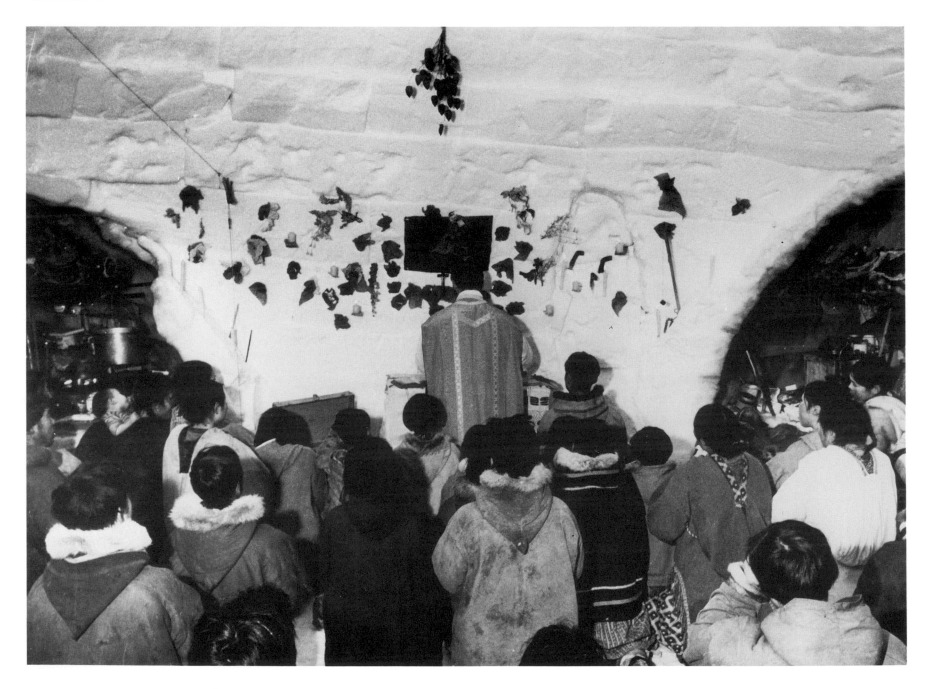

Construction of the Christmas k'aggek. Lydwina Angmadlok

Christmas Mass in the K'aggek with Fa. Franz Van de Velde presiding.

CHRISTMAS IN THE BIG IGLOO

"Once again last year the traditional snow-house or "kadget" was erected in Pelly Bay for the Yuletide festivities. The Big Igloo was built over three smaller igloos. These three snow-houses serve as temporary homes for the family group who live about twenty miles from Pelly Bay, but always come to the settlement for Christmas... Christmas Eve was highlighted by ancient Eskimo games and target shooting. Firing from about twenty-five feet with a .22 at strings from which dangled various prizes was quite a feat of marksmanship. A few of the contestants miraculously hit a string and thus claimed a prize. A special moment of Christmas Eve was the opening of presents. These gifts were sent to Father Van de Velde from his sister in Belgium. There was a gift for everyone. Such practical objects as cloth, wool, knives and even chess sets were the most frequent items. The Eskimos here are avid chess players."

Frank Gonda
(Pelly Bay, 1963)

Various factors determined what the temperature difference would be between the interior of the igloo and the outside temperature. With an outside temperature of -35° to -45°C a contemporary overnight hunting igloo 2.5 meters in diameter containing a stove and lantern might rise to 5° to 15° C.

TENT

In May or June a change was made from the snowhouse to a skin tent (**tupiq**) made from seal or caribou skin. A simple conical model supported by a single tent pole or several poles could be constructed or a more elaborate type of tent that had a ridge extending forward from the cone-shaped back portion.

The simplest **tupiq** consisted of large stones placed in a ring with a tent pole resting on a flat stone erected in the center of the ring. At the top end of the pole a number of skin thongs were attached and then fastened to the heaviest of the ring stones. The tent sheet was then stretched tightly over the pole and thongs and tucked

SUMMER CAMP
Repulse Bay
1947
ivory
7.2 x 27.4
x 4.9 cm.

Ridged canvas tents are common as they are light, quick to pitch and quite warm in summer.
A disadvantage to using canvas material is that it attracts more mosquitoes and is colder than a skin tent when used in the fall.

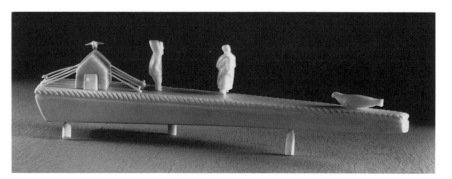

QAMMAQ
David Issigaitok,
b. 1906
Hall Beach 1985
stone, rocks, seal
skin, antler, wood
16.8 x 34
x 22.2 cm.

During the
transitional periods
of spring and
especially autumn a
variety of dwellings
with a collective
name of **qammaq**
were constructed.
The walls might be
composed of earth,
stone, whale
bones, ice, or
snow, and the roof
consisted of a skin
tent sheet
supported by tent
poles.

under the stones. It was constructed so that the entrance did not face the prevailing winds, and close by the opening there might be some large stones to be used as chairs for visitors.

Inside, the woman of the family laid a line of flat stones or poles across the floor space to separate the sleeping area from the rest of the tent space. The fireplace (**igaq**) might be placed just inside the door, but more often was located outside to avoid the build up of smoke in the tent. A fire was fueled by heather, willow branches, and dry moss. A fireplace to support the cooking pot was constructed with two or three stones. Sometimes a small kitchen tent made with a skin laid over two poles was erected to provide shelter from the wind.

HOUSEHOLD IMPLEMENTS

The inland Caribou Inuit cooked over willow or heather fires during the winter but most of the inhabitants of the Central Inuit territory relied on the lamp to cook food and provide heat. The crescent-shaped stone lamp (**qulliq**) was supported by wooden upright sticks or on two pieces of wood placed longitudinally under the lamp.

A wick made of dry moss, arctic cotton, or willow fluff was laid on the front straight edge of the **qulliq**. The bottom of the lamp sloped from the curved back part of the lamp towards the wick edge so that the fuel would be fed to the flame. Some lamps were divided into two compartments by a raised ridge with a higher compartment at the back.

The rendered-down oil from the blubber of a seal or other sea mammal, or caribou fat fueled

TENDING A LAMP
Davidee Mannumi,
b. 1919
Cape Dorset 1962
stone
14.9 x 11.8 x 13 cm.

A wick trimmer
(**tarquti**) was used to
trim the wick and
regulate the flames
after the wick was
moistened with oil
and lit. The wick
had to be placed
thinly along the rim
to keep the flame
down, to prevent
smoking and too
quick a burn. If the
wick was made with
moss and not cut
into small enough
pieces it would
smoke too much.
This smoking flame
would soot up the
interior of the igloo,
restrict lighting and
induce melting.
When the wick
became too old it
started to smoke
and had to be
replaced.

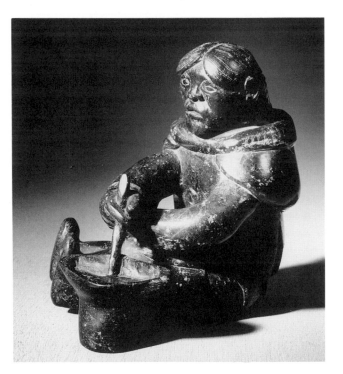

the lamp. Blubber from seals produced the most oil. Caribou fat produced a bright flame and warmed up quite easily, but it also burned out much faster than the marine animals' blubber. The fat from foxes could be used in winter in an emergency, as could putrefied fish kept since the summertime.

To produce a light, two pieces of iron pyrite could be struck together or against a piece of iron or steel such as an old file (**aggiak**). Moss could also be set alight by sparks produced by a fire drill. The sparks struck would ignite the dry, slightly oily, flammable cotton grass or moss. Then the material had to be deftly blown until it glowed with embers and the dry tuft could be ignited.

A fire drill (**niortaubvik**) that produced fire by friction consisted of a bow with a thong looped around a wooden or bone drill stem pressed on a hard surface and held in place with the aid of a mouthpiece. The stem was rotated with the bow until the tip of the stem sparked to light the dry moss.

After the camp was made, each woman tried to be the first one to start a fire. The first one to start a fire yelled, and the other women would come to get a light.

Any water that fell into the lamp could be removed from the oil with a piece of snow that would absorb the water only and not the oil. Eventually hurricane and even ordinary petroleum lamps came into use, replacing the stone lamp.

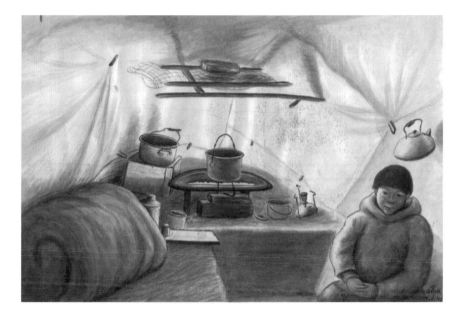

Missionary's igloo while staying at a camp at Jens Munk Island.
Illustrated by Fa. Guy Mary-Rousselière, o.m.i.

A stone pot (**ukkusik**) was used to cook meat or to heat up a soup made with water and caribou or seal's blood, or juices from the cooked meat. The pot was also used to thaw ice or fresh snow for drinking purposes. Most **ukkusik** were rectangular shaped with short straight ends and long sides that curved slightly outwards. There were holes in the upper corners for the attachment of suspension lines. When the meat was cooked it could be lifted out of the pot with a single or double pronged meat fork. A piece of the meat was placed in the first person's mouth, who cut a section off for himself, and passed the rest to the next person, and so on.

Eventually primus stoves (**supuyuk**) replaced the lamp as a heating device. In time, single burner and two burner coleman stoves

replaced the **supuyuk**, which although compact and handy, was difficult to light in cold weather.

Soup taken after the meat was passed in a ladle (**kadlut**) commonly carved from the proximal part of a muskox horn. Each person sipped from a corner and passed the ladle on to the next person. Drinking or sucking tubes could be used to drink liquid when there was ice in the container or for drinking water from flat ice-covered pools.

Serving trays to hold meat and blubber could have a variety of shapes. People ate directly from the tray, each taking a piece and taking turns eating.

A drying rack (**innitait**) was usually made with an antler or wooden frame. A network of seal or caribou skin thongs or sinews was threaded through the frame and supported over the lamp by two vertical supports at each corner and two rods that projected from the igloo walls at right angles to each other.

Wet skins, mitts, socks, clothing etc. could be hung on the **innitait** to dry. To prevent snow from melting on the clothing a snowbeater (**anautak**) made from antler, bone, or wood was used to beat the snow off the clothing. If the inner parka, or attigi was wet with perspiration,

MAN
George Arlook
b.1949
Rankin Inlet 1976
stone
16 x 10.2 x 6.5 cm.

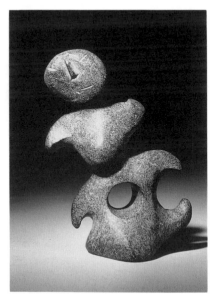

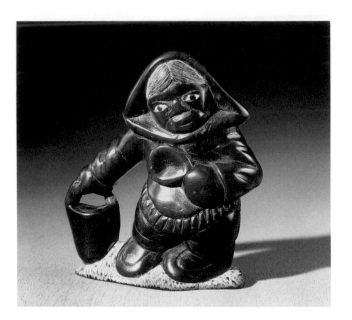

WOMAN WITH
WATER PAIL AND
LADLE
Avpaluktak, Aisa
Inukjuak 1979
stone
11.5 x 7.3
x 10.3 cm.

the skin was turned inside out and left outside to freeze, where it would become stiff like a board. The frost could then be knocked off gently with a snowbeater. When the snowbeater was iced on both sides it was scraped off and the attigi beaten again until the frost was removed and the parka was made more supple.

To insulate the caribou bedding from snow moisture, caribou ribs or waterproof kayak skins might be laid under the bedding on the snow. A mattress consisted of two or three skins. The bottom layer had the hair facing downwards and the upper one with the hair facing upwards. The top blankets were sewn together.

When water or urine was spilled on the bedding skins or clothing, it was removed with a water scraper (**qaluut**) made with a caribou scapula.

All other skins, meat, blubber, small weapons and tools were stored at the opposite end of the kitchen platform or in the porch. Harpoons and lances were stuck in the outside igloo walls near the entrance.

Female dogs with new pups might be kept on the igloo floor but normally all adult dogs were kept outside. Everything edible, meat, skin clothing, seal thongs, and harnesses had to be carefully guarded in a porch or placed high on scaffolding the dogs couldn't reach. These thongs were kept in the porch rather than the igloo to keep them frozen and dry.

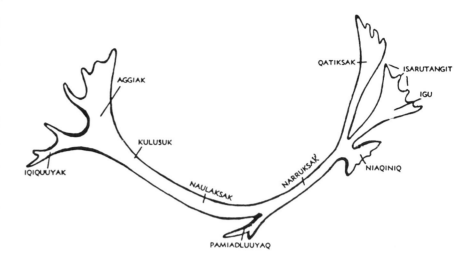

CUTTING UP
A CARIBOU
Saija Quarak Ainallk,
b. 1910
Ivujivik 1988
stone
14.4 x 18 x 9.7 cm.

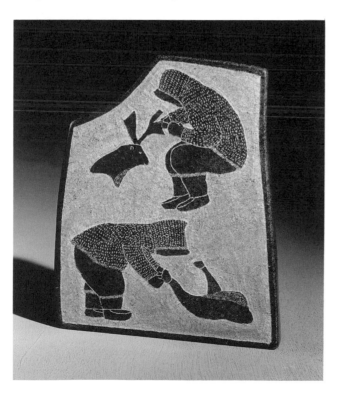

CUTTING AND FLENSING MEAT

To skin and flense animals required great anatomical knowledge of the animals and much practice. This activity was mainly conducted right at the kill site by the hunter with his flensing knife, but might also be done back at the camp by the men, or by the women, using their semi-lunar knives, called ulus.

Caribou

For caribou there were different styles of butchering and skinning depending on the season and region. In the winter the legs might be removed at the uppermost joint before cutting the hide. The skin would be cut from the throat to the tail. The hide was worked away from the belly, one side at a time, by using the hands or

Uses of the antler of the male caribou by Father Georges Lorson, o.m.i. 1966.

niaqiniq -
snow probe
igu -
snowknife, shovel
qatiksak -
breathing hole searcher
narruksak -
bow, shaft of arrows
pamiadluuyaq -
harpoon, awl
naulaksak -
fish spear
iqiquuyak -
support for the drying rack
aggiak -
device to hang kitchen utensils

131

by flaying it with a knife. With his knife, the hunter carefully cut off the skin at the head attached to the skull down to the neck-line. The skin was then pulled off the carcass starting from the head. The breast and abdominal cavities were opened and the animal gutted lying on its right side. Dark, hot blood dyed his hands crimson as

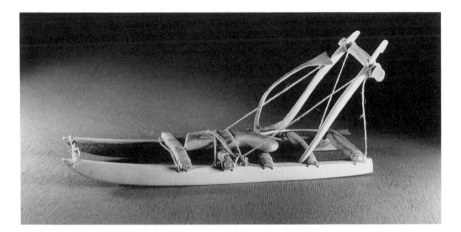

SLED WITH
CARIBOU HEAD
Repulse Bay 1970
antler, sinew
10.6 x 24.8
x 12.5 cm.

he worked. The carcass might be further butchered or just halved, and the meat wrapped in a skin to be loaded on the sled. If not completely butchered, the carcass would be brought back to the camp or settlement to complete the task.

In cutting up a frozen carcass, a shoulder with the shoulder blade was first cut from the body. Then the hind quarters were cut off in one piece. Then the breast bone and finally the flanks with the ribs were cut. Frozen meat could be thawed by placing it in a water hole. Within an hour or so the meat became soft and palatable.

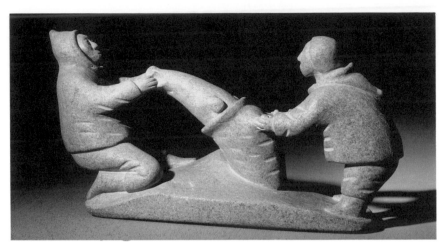

TWO MEN
SKINNING A SEAL
Kangiqsujuaq
1954
stone
12.5 x 24.6
x 6.9 cm.

Seal

When a seal was caught all the hunters circled around the kill. The one who caught it opened the belly just above the liver with a small incision cut through the skin and fat, and the liver and a piece of blubber were cut out. Then the seal was closed with long bone or wooden wound pins to prevent all the blood from escaping from the animal and it was brought back to the camp where it was cut up by the wife of the successful hunter with her ulu.

If the skin was not required to make a blubber bag, the seal was cut down the middle of the belly and the skin attached to the blubber cut off. The entrails were removed, and the body parted by being cut between the ribs.

FOOD PREPARATION

Meat could be eaten frozen, raw, cooked, or dried. Modern tests have shown that northern

country food has almost twice as much protein and considerably less fat than imported commercial meat. Seal meat contains six to ten times more iron content than beef and its liver fifteen to twenty times more iron content than beef. The main sources of Vitamin A are found in the livers of sea and land mammals and fish. Vitamin Bl can be found in the internal organs of arctic animals, as well as the meat of birds and the **mattaq** of narwhal. Internal organs of animals are rich in Vitamin C. Traditionally cooked meat was prepared in a stone cooking pot in a soup, with the juices or blood of the animal, and a piece of fat. Most meat was eaten only partially cooked so that it retained its juices.

FAT - SYMBOL OF WELL-BEING

"If the Eskimo food "par excellence" is caribou meat, what could not be said for "tunnuk," the rump fat of a healthy caribou, fat that is found at certain times of the year only!

The Eskimo who spend the summer inland in the pursuit of caribou carefully gather all the "tunnuk" and with it fill little bags fabricated from birds' skin feet sewn together. These in turn are given as small gifts upon their return to camp.

"Tunnuk", chewed simultaneously with caribou meat makes it a delicacy. Its qualities are also medicinal: it is an excellent curative remedy for children and even babies suffering from diarrhea.

The Eskimo is also very fond of the marrow. His ingenuity has even prompted him to invent an instrument that will extract the tiniest tid-bit from the bones. What a let-down when the marrow is water: "Paterluktok"! On the contrary, "pateriktok", good firm and fatty marrow makes your mouth water.

The birds, ducks, geese, owls, plungeons and others, if healthy, have a layer of yellow fat under their skins. The Eskimo who does not generally de-feather birds but skins them, delights in sucking the succulent fat once he has finished the operation.

The Eskimo would not even dream of eating seal meat and not the fat. When preparing a boiled seal dinner, numerous pieces of fat are added in addition to the fat purposely left adhering to the lean meat.

As for dry fish or "pepsi", it will often be eaten with its own oil as a form of mayonnaise.

In the spring when the season of seal hunting on ice comes to an end, it's like revealing the amount of one's bank account for Eskimos to exchange mutual information as to the number of jugs (skin bags of fat rendered into oil) they have filled with the oil produced from their hunts. "Taimanna orksotetayoguy" say the Eskimos to one another as they count on their fingers."

Father Franz Van de Velde
(Pelly Bay, 1958)

Caribou

The marrow (**patiq**) in the caribou bones that is particularly firm and fatty in the summer and early fall was extracted by breaking the bone and removing the marrow with an extractor, perhaps a long narrow chip of a caribou metatarsal bone.

Caribou fat (**tunnuk**) was considered a great delicacy and was thickest on the back and rump. In the fall the back fat was quite thick and would also be eaten raw. Other choice areas for fat were on the head and between the guts. Fat also acted as a curative remedy for diarrhea. Small bags to store fat were made in the summer. The fat would be chewed to break down its cells, heated, and poured into little bags made from the complete feet of ducks or loons that had been skinned with the bones cut off at the joints.

The contents of the caribou stomach, a greenish acidulous mass, masticated and half

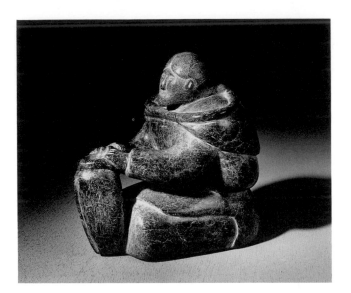

WOMAN WITH BAG
Mary Irqiquq
Sorusiluk
l897-1966
Ivujivik 1964
stone
13 x 8.7 x 14 cm.

The frozen seal blubber was kept in a special bag and had to be beaten until it became soft and the oil liquefied. The blubber pounder was made from the distal end of a muskox horn, or caribou antler, or just a stone and was used to break up the tissues in the blubber to press the oil out.

digested, was eaten either frozen with caribou meat, or covered in blubber, or mixed into a soup.

In the summer, caribou meat was dried by first being cut into strips along the grain of the meat about 2.5 cm thick. Left to dry in the sun, a hard, dark crust formed over the fresh meat inside to form **nipku**.

Seal

Seal meat was consumed cooked, raw or frozen depending on the circumstances. The liver and heart were preferred raw.

Seal meat would be cooked with pieces of fat (**urksuq**) added when available. Meat cooked in sea water was diluted with fresh water. Seal flippers were eaten cooked, or in a rotten state after fermenting in bags.

WOMAN CUTTING
A SEAL
WITH AN ULU
Irene Kataq
Angutitok, l914-1971
Repulse Bay 1967
stone
6.5 x 9.1 x 7.2 cm.

The women's knife, or **ulu**, was an all purpose knife used as a cutting instrument for meat and skins, or as a tool to chop tobacco or lamp moss.

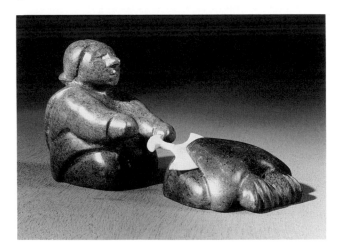

> ## MIKILAQ AND KAJUALUQ TRAVEL WITH JOHN AJARUAR TO CHESTERFIELD INLET
>
> *"The following day, April 3rd (1933), Mikilar decides to set out despite the falling snow and easterly wind; any further delay would heighten the risk of running out of dog meat. Fortunately Akkajaluk has a cache of walrus meat on an island along the way which he has agreed to let them have. Sharing, an imperative for survival, is the unwritten law of the North. John Ajaruar, one of Chesterfield's first converts and highly trusted by the missionaries, blazes the trail for the dogs, his pride and joy, eleven racers in tip-top condition. The trip, approximately three hundred kilometres, usually lasts five nights; the Inuit express the duration of a voyage in nights spent in the igloo rather than in days of travel, a normal procedure, for one easily remembers the number of snow shelters erected along the way."*
>
> *Father Charles Choque, o.m.i.*
> *(1985)*

Walrus

Walrus meat was eaten cooked, frozen or rotten, but rarely raw. The liver and heart were considered great delicacies. The hide might be eaten cooked, raw or frozen, and was cut into small pieces.

In the summer walrus meat was cached in gravel. First it was covered with a layer of blubber and then stones were placed over top of it. Sometimes it was put into a skin bag (**poktak**).

The meat would ferment and the blubber saturated it, giving the meat a desired sharp flavour.

Whale

While the meat of whales is poor, soft, and not very flavorful, the hide was much more desired and cooked along with a little blubber, or eaten raw. This **mattaq** from the beluga or narwhal that was rich in Vitamin C, was cut in 18 to 22 kg slabs with an ulu that had to slice through a 7 cm epidermal layer, and a 7 - 13 cm. layer of blubber.

Bear

Bear meat is a sweet meat and was eaten cooked or frozen. The people of Pelly Bay would not eat polar bear meat uncooked. The poisonous liver containing a toxic dose of Vitamin A known to cause trichinosis was avoided.

Muskox

Muskox meat was a food of great survival value to the inland Inuit groups. The ear cartilage was considered a great delicacy as was the **malla**, a clump of meat or fat at the lower part of the breast at the end of the neck.

Fish

Fish were most frequently eaten frozen, but could be cooked, eaten raw or dried. Fish head soup was considered very tasty and was easy to cook not having to be boiled for too long a period.

Dried fish were first gutted. A slit straight down the belly was made and the guts removed. Then the head was cut and a slit made down the back between the meat and the back bone to the tail. The back bone was cut away and the meat set out to dry with the meaty part exposed to the sun. Some horizontal cuts might be made down the length of the fish so it would dry faster. If poles were available, the fish were placed over a horizontal pole that was laid across two criss-crossed supports or across a seal skin rope tied between big stones. The fish might be soaked in salty water before being hang up. Dried fish or **pepsi** would be eaten with its own oil.

Fish bellies were cut off and cooked until the oil floated to the top. Then the oil was scooped off and stored in bladders. Fish could be cached and even after two summers could be eaten, having attained the consistency of liquid cheese.

IGLOO RESTAURANT

"I remember particularly, when I was staying in a camp in the Baker Lake region, the gift of an igloo neighbour, which I relished with extreme pleasure. Such a treat does not appear on the daily bill of fare and, for the inhabitants of the camp, its preparation is somewhat akin to a ritual feast which puts everybody in good spirits.

Half a gasoline drum and you have the kettle: fill it up with water. Place the caribou heads vertically even if you have to turn them over now and again. Stoke the fire with "iksiutark", a plant which grows plentifully in certain regions and imparts a special flavour to the meat. Take patience because the slow cooking process will last two hours or more.

It seems that the Eskimo vegetable, in the highest sense of the word, is the "nerukka", or partially digested contents of the rumen of the caribou. In an "ukkoserk" or soft stone kettle, hanging over the seal oil lamp, cook slowly - if however your sense of smell is not too sensitive - a large piece of sufficiently high caribou liver and let it cool off. Mix it with caribou fat or, better still, with seal and....serve.

Try a dried fish or "pepsi", accompanied by tiny squares of seal fat. Better still, if you ever have "nipko" or dried caribou meat, between a few mouthfuls so as to give your jaws a rest, let a few small bits of fat melt slowly in your mouth! Not any sort of fat assuredly but that fat which forms in folds around the eye of the caribou or the one which covers the kidney or coils round the intestines."

And if you think that a little salt would add just that special something it is not impossible to get some, provided you live by the seaside. The Eskimos gather, not far from the shore where sea water has evaporated on clayish spots, a yellowish white deposit which resembles it very well.

Father Georges Lorson, o.m.i.
(1963)

MEN SITTING
ON LAMP
Robert Tatty, 1927-
Rankin Inlet 1973
fired clay with glaze
11.7 x 38.5 x 22 cm.

This ceramic piece
was made at a
studio operating in
Rankin Inlet from
1963 to 1975. While
pottery was not
common in the
Canadian Arctic
there is prehistoric
evidence of this
activity at sites in
Repulse Bay and
King William Island
and in the early 19th
century Sir John Ross
encountered Inuit
engaged in this
activity. This piece
was presented as a
gift to Father Lionel
Ducharme by his
fellow missionaries
on the occasion of
his 50th anniversary
of religious life.

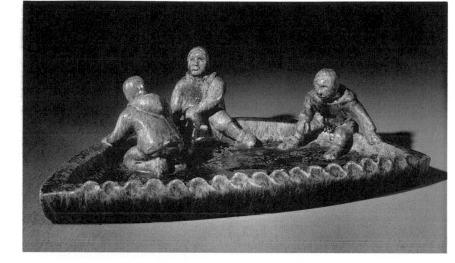

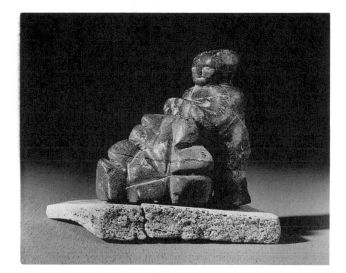

MAN AND CACHE
Repulse Bay 1974
stone
8.9 x 9.9 x 8.5 cm.

A well constructed
cache (**pirujaq**)
could not be broken
into by foxes,
wolves, or other
larger animals.
Generally speaking,
a pirujaq belonged
to an individual
hunter who kept or
distributed the
meat according to
the local custom. In
emergencies, or if
the cache was very
old, another hunter
could open it.

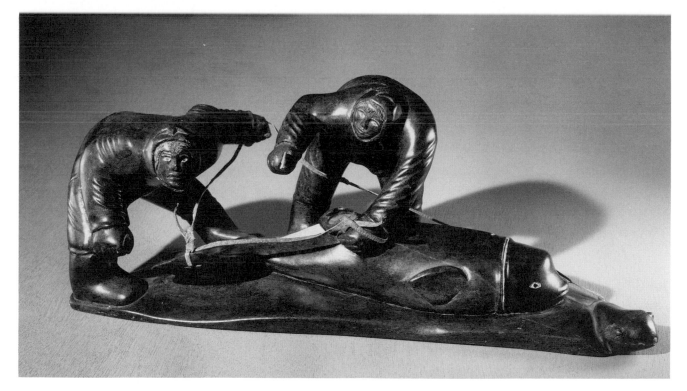

TWO MEN
FLENSING
A BELUGA WHALE
Simeonie Tukalak
Inukjuak 1988
stone
18.6 x 44 x 15.2 cm.

137

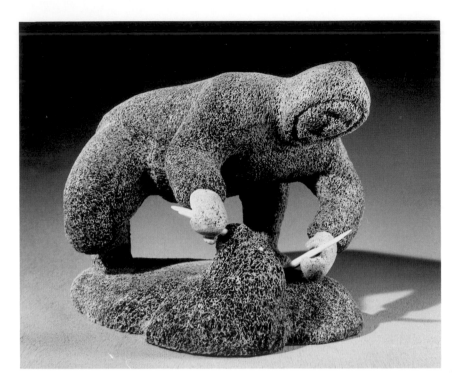

Foreign foods

The first foreign foods accepted by the Inuit were tea, sugar, molasses and flour. Tea could be prepared with a mixture of old and new leaves. In some areas a flapjack made of flour mixed with baking powder in water, was cooked in a frying pan with lard.

Smoking

Pipe smoking was an activity enjoyed by both men and women. Before the introduction of tobacco, ground-up cranberry leaves were smoked in pipes made with soapstone bowls and willow stems.

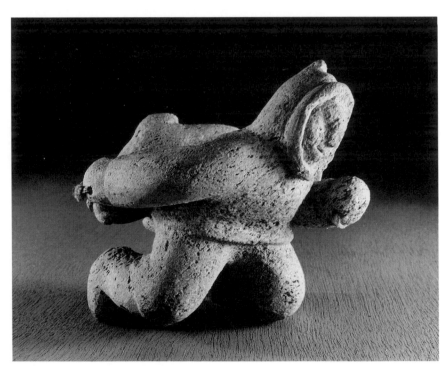

Birds

Birds such as eider ducks, gulls, geese, loons and guillemots were often cooked. Ptarmigan was often eaten raw and sometimes ptarmigan excrement in a frozen state was eaten mixed with seal oil. The birds were skinned and healthy ones had a layer of yellow fat underneath which was eaten raw.

Other animals

The meat of wolves, wolverines, and dogs was only eaten in emergencies.

Arctic hares were never eaten raw. Weasels, lemmings, shrews and ravens were not eaten.

PREPARING THE POKTAK
Ningluk Koperqualak
Salluit 1989
stone
14.4 x 18 x 9.7 cm.

"With most of the walrus hunting being done during the summer months the problem arose to keep a sufficient quantity of dog-food for the long winter months before it decomposed. The ingenious inuktitut way was to sew the boned meat and blubber into the skin of a walrus or square flipper. In this air-tight **poktak** the meat would ferment but not rot during the warmed summer months. Once frozen, the meat would not be stone-hard because of the fermentation. This allowed the poktak to be easily sliced, skin and meat together, or to be transported easily on the sled without too strong a smell.

The **poktak** was stitched air-tight using a double seam. The two sides overlapping, were sewn together once, then folded over and sewn again using walrus or seal thong and a long flat ivory needle with a curved tip. The Inuit would sometimes use white whale or caribou sinew if it was available. To make the sewing easier holes could be made using a knife to pass the needle and sinew through. Then they would pull on the thong or sinew to make sure the seam." (Father Kees Verspeek , o.m.i., 1992)

SENSE OF TIME

Dear Parents,

* With a little bit of flour, given by Kattolik, I was able to make some pancakes. There was even some eggs from ducks in my dough. As you can see I'm not unhappy. I fried my pancakes on the "cadlok", that is to say a rock lamp of seal oil. After four hours I was lucky enough to have made 20 pancakes. You do not need to be in a haste because the Eskimo never are. They ignore all notions of time..."*

Father Etienne Bazin, o.m.i.
(Igloolik, July 13, l931)

MAN WITH
BOW DRILL
Pelly Bay 1950
ivory
4.6 x 21.7
x 5.7 cm.

The bow drill (**niurtuut**) operated similarly to a fire drill. It consisted a bow with a thong looped around a wooden or bone drill stem pressed on a hard surface and held in place with the aid of a mouthpiece. The point on the stem made in stone was later made from iron. The stem was rotated with the bow to drill a hole in hard materials.

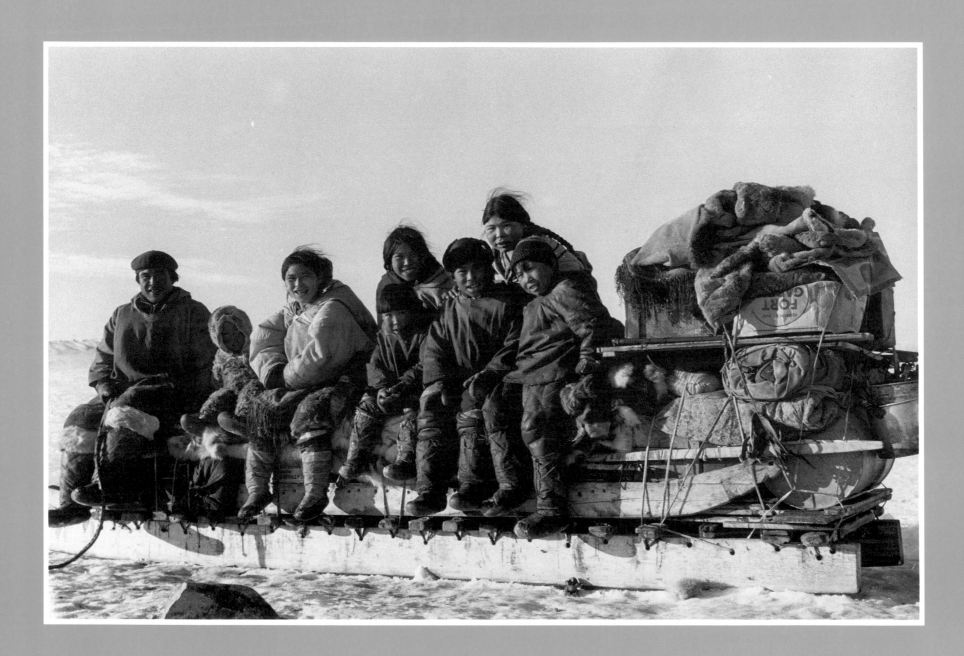

Aullat...
The people who leave...
From Place to Place

WINTER TRANSPORTATION

As there are very few months without ice and snow in the Arctic, the predominant form of transportation was by sleds pulled by dog teams.

The size and style of sleds or **qamutiiks**, and the number of dogs pulling the sled differed from region to region. The most common and simplest type of sled consisted of two parallel runners held together by crosspieces of driftwood, ivory or antler lashed with skin thongs.

The Inuit were experienced sea-ice travelers. From the vantage point of a high ridge of piled ice they scanned the vast expanse of tumbled ice blocks and found the least difficult trail to be followed. They read the ice conditions, currents, and weather signs. One characteristic of unsafe ice was its dark color, the ice being saturated with water sufficiently translucent to reveal the darker color of the sea below. Powerful storms might cover open holes, cracks or areas of thin ice with snow and create dangerous traveling conditions. Accidents resulted. Traveling in the spring was tedious work. Snow on the ice that was hard in the winter became soft. Both dogs

Family of Guy Mamatsiaq Igloolik, spring 1954.

and man tired quickly from wading through drifts, and dragging their loads over the ridges. As the snow became thin and meltwater flooded the

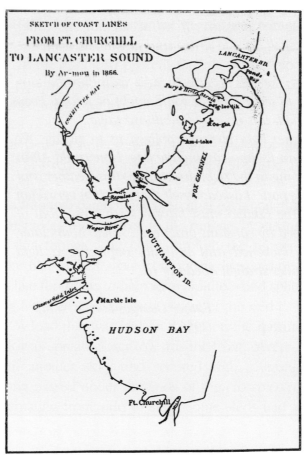

Figure 5b. Eskimo map of coasts from Churchill to Lancaster Sound
Source: Hall, *Narrative of the second Arctic Expedition,* p. 225.

Map drawn by an Aivilik Inuk for Capt. Charles Frances Hall, 1866, showing his knowledge of the area from Churchill to Lancaster Sound. Ref. (Hall, Narrative of the second Arctic expedition, p.225)

141

rope with hooks on it passing along the length of the runner to string the thong to secure the load. The sled might be furnished with an anchor or iron grapnel with two hooks to keep the dogs from starting out too soon. This anchor, originally a caribou antler with hooked tines, was attached

to a rope on the side of the sled. A rolled line of walrus or seal skin held under the runners served as a break for going downhill.

The driver sat at the front of the qamutiik with his legs hanging over the right side and his whip hanging down with the lash trailing on the snow. More often, the driver would walk alongside the sled. When the driver had to give a good push to change the direction of the sled he would wait until the sled was hanging in equilibrium over the uneven snow, and then give it a little push.

The dogs were hitched in a fan arrangement with traces of various lengths. The "lead" dog (**isurartuniq**) had the longest trace, perhaps 10 to 20 meters long. Pups, hitched behind their mothers the first winter and poor dogs requiring more frequent use of the whip might be given the shortest traces. Except for the lead dog who kept a constant position during the journey, the dogs eventually crossed from side to side, entangling the traces. It required great patience to unravel the lines and steer the team while sledding through pack ice.

A thick thong or draught strap looped across the front of the sled held the trace lines. Each dog trace was attached to the draught strap by a dog trace eye button. The other end of the trace was attached to the harness of the dog with a toggle that could quickly be unhooked should a bear hunting opportunity present itself.

The **isurartuniq** and the "boss or king" dog (**angayukaaqtaq**) were not necessarily the same

THE WORSE PART OF THE TRIP

"The worse part of the trip lies just ahead (Ukkuanguarq; around Cape Bowen): no more sitting at ease for more than a quarter of an hour at a time. Facing wind we reach the shore hillocks, close together and sometimes fifteen yards high. The sea is always agitated in this section and when the fall comes with formation of ice, the tide joins with the wind to break up the new ice into huge chunks that are pushed shoreward and piled up in an indescribable helter-skelter. A path has to be found through this dangerous labyrinth as well as possible; the sled rolls and lurches, up here, down there, balancing on top of a heap of broken ice, sticking between two blocks, smashing against another, going from one crisis to another. The guide holds back, pushes, snaps the whip, yells, stops to survey the lay of the land, slashes a wandering dog, chops away at upthrusts of ice, rights the overturned sled, etc.

The dogs crawl, jump, howl, look for the way, disappear in a cloud of snow, catch their traces in the ice. How do they manage to come out of it alive? I don't know. They do this over and over again, for three days, for long and short periods."

Father Georges Lorson, o.m.i.
(Trip from Pond Inlet to Clyde River, 1956)

dog. The boss or king dog was the master who ruled the team with a kind of terrorism attained through fights. The lead dog who sometimes might be the boss dog was chosen by the driver due to his skill in following a track and remaining obedient to his master.

CANADIAN ESKIMO HUSKY DOG

The Canadian Eskimo husky dog (*Canis familiaris borealis*) is a distinct breed of dog not to be confused with the Alaska Malemute or Maleumute crossed with the blue-eyed Siberian husky introduced to the North by the R.C.M.P. Some R.C.M.P. dogs also had green and white eyes. The Eskimo husky dog (**qimmiq**) weighs about 29 to 38 kg, or slightly less for the females. The average height at the shoulder for females extends about 50 cm, and up to 70 cm for large malcs. The dog is not shaped for speed but rather for strength and stamina in relation to its weight. It has a thick neck, broad chest, strong muscular legs and a dense fur with a thick coat and shorter under fur.

A DOG'S LIFE

"In every team there is a leader, strongest and bravest of the pack. He is quite a spectacle in their midst, with his lofty airs, giving a bite here and there for no reason whatsoever to the others or holding them down between his paws, while they gently try to get away, with a low whine intended to arouse the benevolent sentiments of the boss. Even on the road, he is not bashful in keeping order amongst his followers. His privileges are well earned because the Eskimo expects a lot of him and will not excuse the slightest imperfection on his part.

The affection of the dogs for their master or the one who feeds them has been often described. They never keep the smallest grudge for the frequent lashes they receive, probably because they know they deserve such treatment. As soon as it is finished, a beating is forgotten and the victim will frolic around licking the hand of the master. Little children, two years old, no taller than the dogs, will play with them hour after hour, to the great delight of the animals who will kill each other for a piece of seal. The babies pull their tails and ears, put hands in their mouths, torment them in many ways, and are treated with great patience. Tired of playing, the little imp will throw a stone at them, almost too heavy to lift; they trop a few yards away, stretch out and wait for the next session of play, soon resumed.

Their endurance is unbelievable. This winter the police, en route for Clyde River, ran out of food for the dogs, who kept going on empty stomachs, over bad ice, for nine days. The expression: a dog's life, must have been coined up North."

Father Georges Lorson, o.m.i.
(Northern Baffin Island, 1956)

A litter averaged about 7 or 8 animals and could be up to 13 pups. The younger pups were placed in a skin bag lashed to the sled and the bitch knew instinctively when to come and feed her pups.

TWO DOGS
FIGHTING
Sivuarapik
Povungnituk 1953
stone
6.4 x 15.1
x 11.5 cm.

Fighting dogs had to be quickly scattered because of the tendency of the whole pack to eventually go after the weakling. A young dog starting to mature often challenged the "boss" dog, creating a real fight where the animals could become badly mutilated or killed. It is said that ordinarily the male dogs avoid fighting females, but when the males were fighting, the females provoked the male dogs by biting their legs from behind.

Feeding patterns and type of food fed to the dogs varied from one area to the next. Seal, walrus, whale skin, meat and blubber were fed to the dogs as well as fish. Walrus meat was considered to be the best food. Caribou flesh was considered poor for dogs as it is too light and easily digestible, although it does contain bones that can be eaten. Refuse such as the entrails of seal or stomach contents of the caribou might be fed to the dogs.

The dog's ration varied with availability and the philosophy of the owner. Daily water rations were necessary in the summer, and thirsty dogs might dig up to 50 cm. into the ground to find water. The best time to feed was in the evening after a day's work. The team seemed to sense feeding time immediately and the howling began and grew in volume until the owner brought the chopped up rations right to the dogs. Then the fighting and noise would be tremendous. Certain items such as thongs or lashings, meat or skin clothing had to be kept out of the reach of dogs by being hidden in the house or placed high on scaffoldings.

Before the dogs slept they would scratch the snow a little and turn in a spot a few times before lying down. They would then curl up, each dog placing its muzzle under its tail and if a storm appeared the dogs would allow themselves to be snowed in. The hunter had to check his dogs at least once a day, especially if they had a chain which through freezing and thawing might get frozen to some ice. During the summer the dogs panted outstretched on the ground or rested in deep, cool hollows they had dug for themselves after the snow disappeared. The nearby ground was littered with gnawed bones and excrement, as well as tufts of hair that the animals had shed. When the mosquito season arrived the dogs' fur become black with clustering mosquitoes and their noses' bug-ridden and bleeding.

It is said that the Eskimo dog does not bark but has a monotonous, melancholy howl all it's own. If one dog begins, the rest will rise on their haunches, noses raised, and howl into the night. Newly arrived sleds are announced by the howling of dogs who could detect their approach kilometers away.

THE DOGS HAVE EATEN THE ROOF

"June 2, 1941...Fr. Didier has returned from the southern point of Igloolik island where he noticed that a great part of the walrus skin roof put on the mission last summer, has been eaten by the dogs. The problem from now on is to find a roofing material capable of keeping out the rain while not attracting the dogs. The same fate befell the cabin that served as a warehouse which was built at Abadjak after the fire of 1933: there is not a scrap of the walrus hide roof left. When the dogs are hungry nothing resists their long teeth!"

(1941)

THE DOGS EAT MY WHIP

"At nightfall, after a long day's trip, we stopped to camp and my companion had chopped a seal into small pieces to feed the dogs. Armed with a long whip made of sea lion (walrus) skin, I tried to keep order amongst the dogs, the strongest of whom were grabbing the better pieces from the weak. With the handle of the whip, I was landing blows on the backs of the battlers to separate them in the twilight. But while I was busy at this task, the other ones took advantage of the situation to bite off the other end of the whip. By the time I noticed what was going on, the whip was practically all gone; all that was left was the handle."

Father Ernest Trinel, o.m.i.
(Cape Dorset, 1940s)

SNOWMOBILE
Saklassie
Povungnituk 1972
stone, wood, antler
8.2 x 20.1
x 5.5 cm.

SNOWMOBILES

Snowmobiles (**qamutaujaq**) came to the North around 1962. The main advantages of snowmobiles for travel are their speed that increases the daily range of travel, and the freeing of the owner from the burden of caring for and feeding the dogs. The disadvantages lie in the snowmobile's inability to sense or smell the presence of game animals and find the breathing holes of seals as dogs can. The snowmobile's inability to find its way home in a storm as an animal can, its high cost, and frequent breakdowns are further disadvantages.

As a result of the change from dogs to snowmobiles, the contemporary nylon shod sleds are not designed with as much curve on the bottom runners as the traditional runners. Sometimes the long tow rope attached to the sled is tied to the snowmobile in such a way that one sled runner

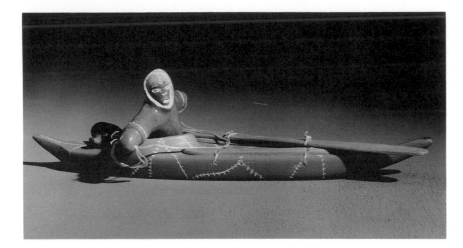

QAJAK
Isaac Sala, b. 1969
Sanikiluaq 1989
stone
7.5 x 27.7
x 10.9 cm.

When dismounting
from the **qajak** the
Inuit walked out
over the front of it,
stepping lightly on
the concealed
crossbar. If he
stepped on any
other place the skin
would break
through.

is pulled slightly ahead of the other making the sled veer to one side. This prevents the driver of the snowmobile from being run over if he has to make a quick stop on the machine.

SUMMER TRANSPORTATION

In the summer the means of transportation changed to foot and water craft. One form of watercraft, the kayak (**qajak**), varied in size and design from region to region, but the basic design in all regions was a slim, fast enclosed boat propelled by double-bladed paddles. Average length ranges of the craft were from five to eight meters, with a width of approximately 60 to 70 cm. The **qajak** was designed primarily as a hunting boat to capture sea mammals, or caribou on inland lakes and rivers. Sea-going kayaks were usually larger and heavier than those designed for inland travel where portages frequently had to be undertaken.

One Arctic phenomenon that the kayaker might have seen in the sky above the sea was the "ice mirage", a shimmering haze of white standing out above the icy horizon of the sea like a sheet of fog. This mirage was caused by an upward reflection of light waves in the clear warm air.

Among the Copper and Netsilik Inuit the **qajak** was only used inland for caribou hunting. In the Netsilik culture area the Inuit stored their kayaks in stone frames in the late autumn after the fall caribou hunt had been completed. They were fetched to the early summer camps in spring to be repaired and have new skins placed on them in preparation for the summer and fall caribou hunt.

SUMMER AND
FALL TRAVEL
Pond Inlet 1969
whalebone
19.7 x 22.2
x 14 cm.

Dogs were used to
pack meat, tents,
or other supplies.
Each dog could be
equipped with a
pack saddle (**nam-
magaq**) with two
large pockets on
each side and
could carry items in
the pack or tied on
its back with the
sled traces. Straps
would have to be
tightly secured
around the dog and
in under the fore
legs so that the
load was balanced.
Once the dogs
were accustomed
to carrying a load
they could easily
carry 25-30 kg
from morning until
evening.

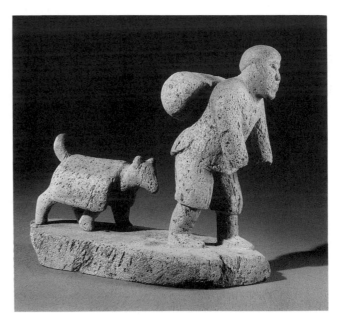

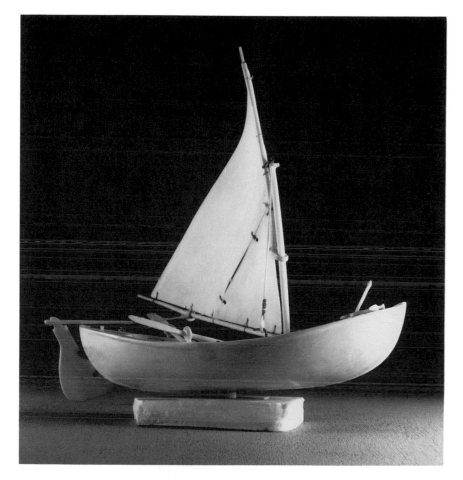

SIVUTUUQ
Quviq
Repulse Bay 1962
ivory, metal, sinew
21.4 x 21.1 x 9 cm.

Whaleboats (**sivutuuq**) introduced in the Hudson Bay region by Scottish and American whalers had several advantages over the native kayak. They were higher, therefore providing better visibility, and had a more stable base for shooting and harpooning sea mammals. They were much more secure against the attack of a wounded sea mammal, especially the walrus. Hunting trips could be extended because more gear and food provisions could be carried.

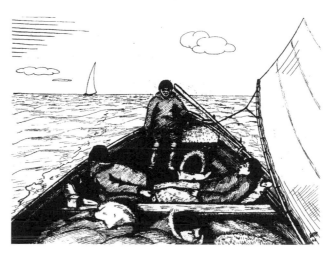

Homeward bound from a walrus hunt offshore at Pingerkalik, Igloolik. Illustration by Fa. Guy Mary-Rousselière, o.m.i.

When the people had to move inland to the stone fishing weirs at the beginning of August some of the men proceeded ahead of the group paddling the newly outfitted kayaks upstream in readiness for the crucial fall caribou hunt. The rest of the group slowly moved by foot to the stone fishing weirs, walking through all sorts of terrain including marshy tundra. They carried their possessions in bundles held on their backs secured with straps running across the chest and forehead. Heavily laden with all sorts of gear, dogs would be saddled with a pack with a large pocket on each side. The dogs also carried the tents and soapstone lamp belonging to the family.

Umiaks, a much larger open skin boat used more exclusively for transporting goods and families between hunting locations than kayaks, were more common in the Labrador, Baffinland and Mackenzie areas.

While the introduction of whaleboats (**sivu-tuuq**) and Peterhead boats (**umiaraaluk**) to the Arctic in the late 19th and early 20th centuries helped contribute to the demise of the kayaks, in most areas these larger vessels were never commonly available to the main population.

In the 1950s' freighter canoes and outboard motors became the common mode of water travel in the Arctic. These new water craft brought great speed, increasing the daily range of travel of hunters as well as the possibility of more river navigation, and the extension of the boating season on the sea. This enabled more individual hunting families or pairs of men to operate as economic units.

In the late 1960s three wheel all-terrain vehicles (**h-aanta**) made their appearance. Today the four wheel version is the predominant means of summer and fall ground transport within the settlements and adjacent area.

KAYAK
Annie Komek
Kigiuna, b. 1947
Coppermine 1991
stone, copper
7 x 23 x 3 cm

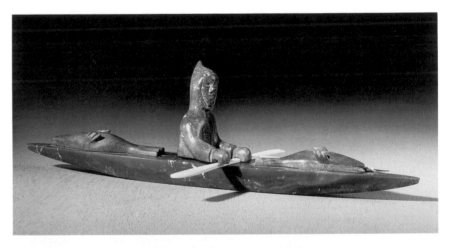

MAN RELIEVING HIMSELF
Victor Anernelik,
1903-1982
Pelly Bay 1955
ivory
6.8 x 8.5 x 5.5 cm.

The appetite of dogs was voracious. When relieving oneself, a whip or snowknife or stick held in the hand was useful to keep the dogs away from the human feces that they would readily eat. Sometimes a few blocks of snow would be constructed behind the person as an additional protection.

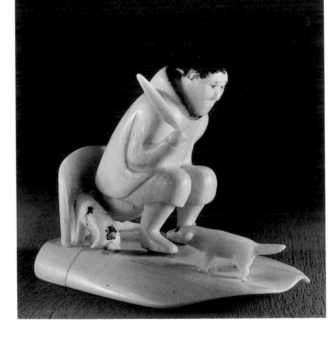

MAN CARRIES CHILD
Bernard Irqugaqtuq,
1918-1987
Pelly Bay 1954
stone
7.3 x 3 x 3.5 cm.

During summer and fall travel both people and their dogs carried packs (**nammagaq**). The adults could carry loads on their back with a tumpline (**ikajuut**) strapped over the forehead. A child is carried on the back of the man's load.

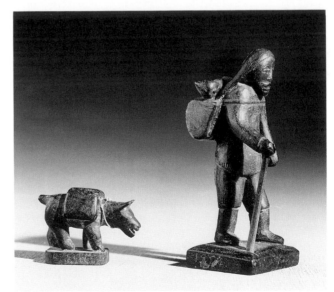

WHAT TO DO WHILE TRAVELING

"As far as I am concerned - and since I am not a unique specimen, others probably share my feelings - a strange emotion arises when one leaves the post. Ahead lies adventure and the unknown, a route never before explored, a chain of little incidents and accidents that will crop up one after another, calling forth from the experienced guide the proper solutions. Every time a new world seems to open and a new kind of adaptation. Only on the second day does composure return.

On the first night, out, of course, I slept badly, but that is merely incidental. All day I remain seated like a Buddha on a thick bear skin, with occasional sprints of a hundred yards to get the blood circulating. Tomorrow I will be comfortable and will not regret at all the relatively easy life at the mission. On the road, life simplifies itself, circumstances simply cut out a lot of the objects with which a civilized man surrounds himself. To be relieved of them gives a feeling of wonderful liberation.

You must think that time hangs heavy, sitting all day and running a bit alongside the sled. But I have rarely felt that way and I never thought of asking the guide to halt because I was fed up. When I travel I make my best meditations. Distractions come, naturally, but the Good Lord understands that, I get back into His company in short order."

Father Georges Lorson, o.m.i.
(Trip from Arctic Bay to Pond Inlet, 1957)

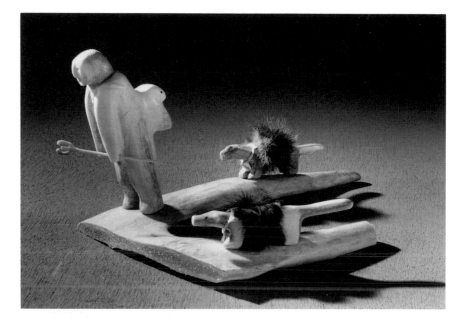

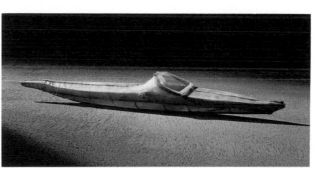

MAN AND TWO
PACK DOGS
Sabina Qunqnirq
Anaittuq, b. 1941
Pelly Bay 1972
antler, sealskin
10.4 x 12.5
x 20.6 cm

QAJAK
Repulse Bay 1965
seal intestine, ivory,
string
2.3 x 19 x 2.1 cm

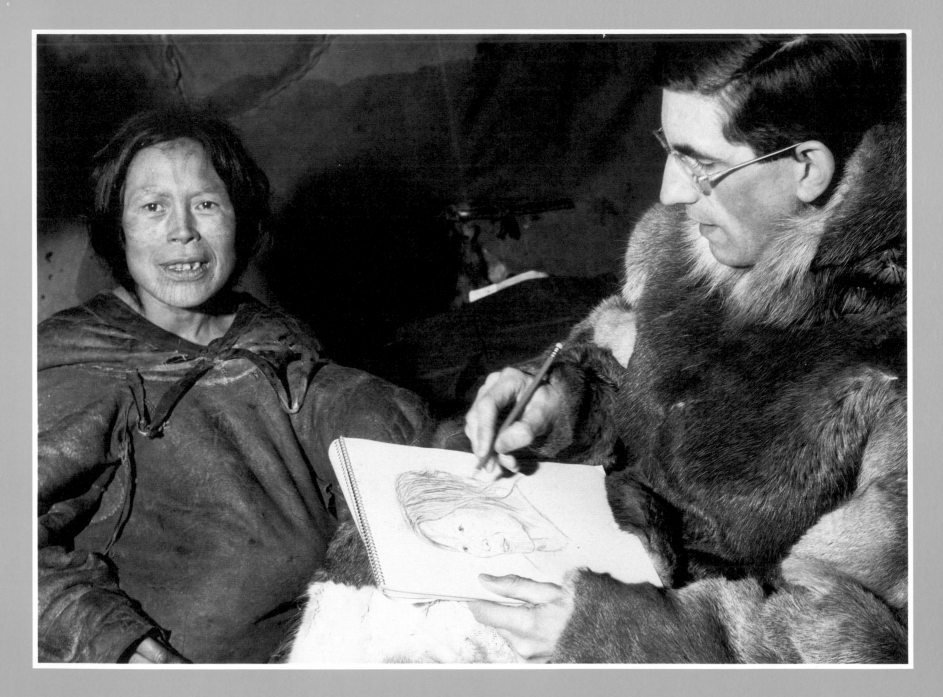

Inuusiq...
The Life...
Personal Life Cycle

The name (**atiq**) in traditional Inuit society was considered sacred. At the time of childbirth, which took place in a separate tent or igloo, the mother or an elderly woman attending the birth might utter a series of names of deceased relatives and when the child was actually born the last spoken relative's name would be given to the child. It was believed that all who had died had a desire to live again on earth, and to express gratitude for life in a new body through the child receiving its name, the deceased person's soul gave the child special powers and protection.

People often had more than one name given to them in their lifetime. Someone might receive a new name as a consequence of some physical defect or accident, a personal trait, or when ill a person may have been given a new name to ward off bad spirits.

A child might be nursed for three to five years. New children were eagerly awaited and welcomed. Infant and child mortality rates were high before the advent of regular medical services.

Children were quickly enculturated into their future adult roles. They grew up in close association with the adult world and were free to observe and imitate their parents. At 7 or 8 years of age the girls began to look after their younger brothers and sisters. The girl learned the art of scraping and softening skins, and sewing clothes for dolls. She fetched ice for water, and helped hammer the blubber for the lamp. She pretended to cook outside on a large stone. She played with her brothers and sisters for hours with a small sled, sliding up and down large snowbanks near the igloos.

NURSING MOTHER
Irene Kataq
Angutitok,
1914-1971
Repulse Bay 1959
stone
20.8 x 7.2 x 6.4 cm.

Young Inuk
Abadjak, Igloolik
February 1948
Illustration by
Fa. Guy Mary-Rousselière, o.m.i.

practiced infrequently in others. Polyandry was rare. A number of marriages failed to last, with divorce being more frequent at the beginning of a marriage at which time the girl simply left the groom with her belongings. The arrival of children tended to stabilize most marriages.

Remarriage was the rule following a failed marriage.

Adoption was widely practiced and there existed a kinship obligation especially towards grandparents, parents or older siblings desiring additional children.

DISAPPOINTMENT
IN FEMALE CHILD
Rosa Arnarudluk
Kanayok,
1914-1984
Repulse Bay 1964
stone
11 x 11.5 x 10.8 cm.

"When a woman was about to give birth the father left. They both had hoped for a boy and man has bought a touque from the trading post for his new son. His face on the carving shows his disappoint-ment...He has a daughter!"

CHILDREN
WITH SLED
Repulse Bay 1959
ivory
7.5 x 27.4
x 5.6 cm.

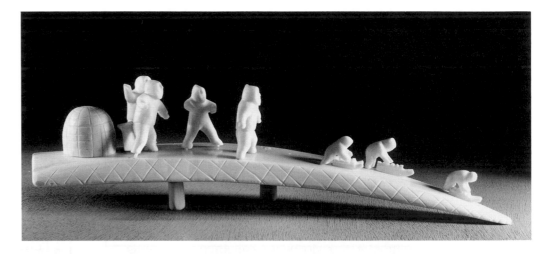

STORY OF THE ORPHAN
(AMAJORJUK)
Martha Kutsiutikku, b. 1913
Pelly Bay 1974
stone
8.4 x 11.4 x 8 cm.

"Once upon a time there was a little orphan who lived with Amajorjuk. Having decided to abandon the child, she placed it on a large rock. When she returned later to fetch the child and to place it in her amaut (woman's parka), the child threatened to eat her up. Amajorjuk was frightened and ran away....on a bear." (as told by Bernard Irqugaqtuq)

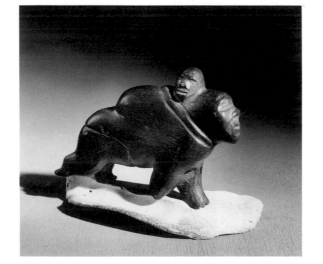

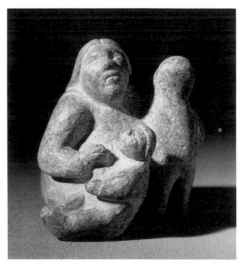

WOMAN AND
CHILDREN
Irene Kataq
Angutitok,
l914-1971
Repulse Bay 1968
stone
10.7 x 11.5
x 10.9 cm.

The older people played an active role in society. They carried influence in decisions made about hunting, or seasonal shifts of the camps. They were valued for their wisdom and knowledge of customs and taboos. They passed on the traditions and ancestral knowledge of their people to the young children through storytelling. These stories were intermingled with practical advice and concrete examples, providing a powerful means of instruction. Both parents and grandparents impressed upon the child the theme of the good hunter and the poor hunter.

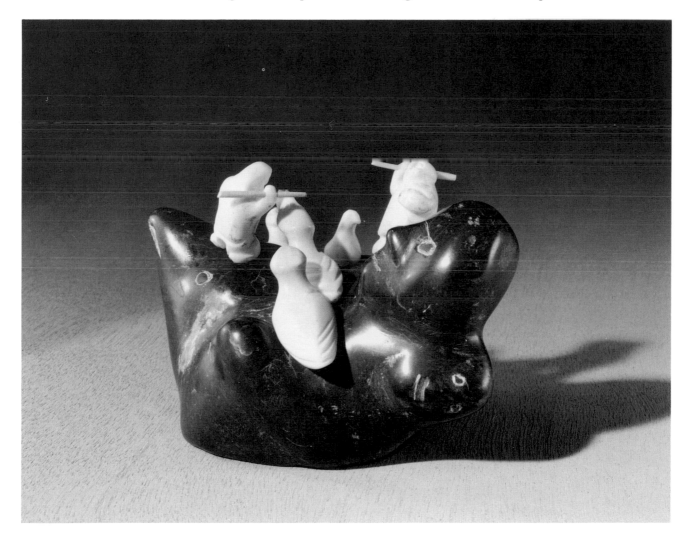

BIRTH RITUAL
David Issigaitok,
b. 1936
Hall Beach 1975
stone, ivory
8.9 x 9.8 x 12 cm.

"This group of ivory carvings on the stone base represents a ritual of the ancient Inuit at the birth of a child. It is a boy and all the family and neighbours come to wish that he will be a great hunter. One ivory carving in the center and one to the side have a human head and are the body of a swimming bird. These are talismen or good luck charms. The two birds represent all the different animals and the two men represent the hunters. This ancient custom of our ancestors to educate by use of small carvings part animal and part human inspired me to make this group."

The life span in the traditional society was not long. When someone died the person's tools and possessions might be left with the body if they had not been given away before death. The body was wrapped in a skin and the body was lain in a circle of rocks if these were present in the vicinity. In some locales more stones were placed over the whole body; in sandy regions the person might be buried in the ground. The Inuit believed that life did not end here on earth. For a period of 3 or 4 days after death various taboos relating to the cutting up of meat and feeding of dogs were observed so that the soul of the dead did not return and strike the offenders with sickness.

UJAUTARPOQ
Repulse Bay 1963
stone
21.5 x 23.3
x 12.8 cm.

Gymnastic exercises (**ujautarpoq**) were performed on a thick sealskin thong stretched tightly across the igloo and passing through the walls, where it might be tied to sleds that were braced against the exterior. The thong was seized with the right hand palm facing upwards and the left palm downwards, with the performer raising himself to roll himself over the thong. Another exercise was to swing around the thong with arms extended.

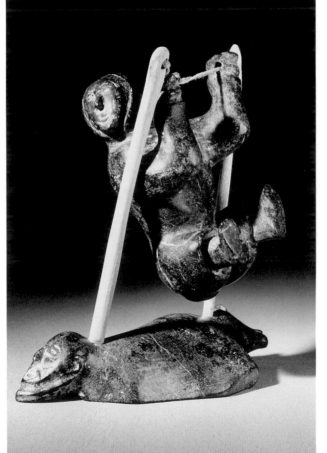

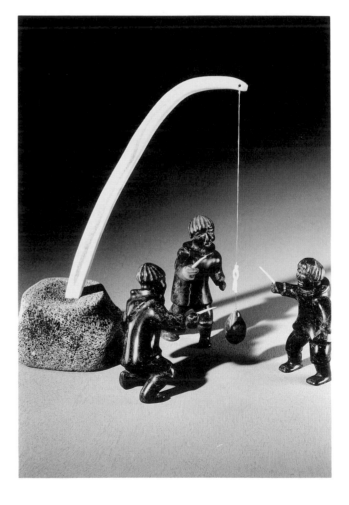

NUGLUKAKTOK
Pond Inlet 1971
stone, whale bone,
antler, sinew
30.7 x 25.5
x 10.4 cm

Nuglukaktok was a game played by both men and women with a ivory or bone target drilled with a hole(s) which was suspended from the ceiling, or a tripod of tent poles. The line was adjusted to the height of the players and weighted below the target. Each player, equipped with a short pointed stick, formed part of a circle around the target. The weight was wound to start the line and target rotating at great speed. When the signal was given, all began to jab at the target causing it it to bobble and sway back and forth. The one who succeeded at keeping his spear in the hole and moving it out of the center was the winner. Each game lasted but a few minutes, and the winner picked up what had been gambled by the previous winner.

WOMAN AND
CHILDREN
Yvonne Kanajuq
Arnakyuinak,
b. 1920
Baker Lake 1986
stone
7.5 x 7.7 x 6.3 cm.

MOTHER NURSING
YOUNG CHILD
Fabien Oogaq,
1923-1992
Pelly Bay 1954
stone
9.6 x 1.8 x 5.5 cm.

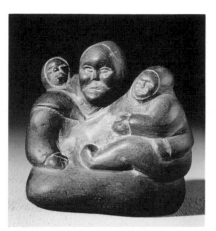

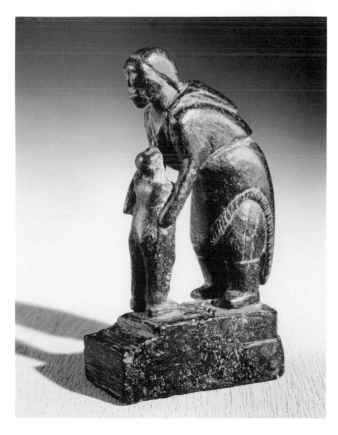

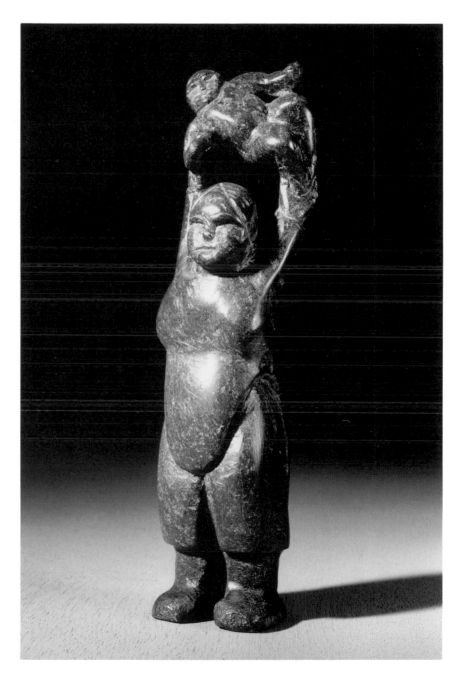

PLACING CHILD
IN AMAUT
Rosa Arnarudluk
Kanayok,
1914-1984
Repulse Bay 1968
stone
17.9 x 4.5 x 3.9 cm.

Atagurtaalukutsuk
Kapiuvik 1947
Illustrated by
Fa. Guy Mary-
Rousselière, o.m.i.

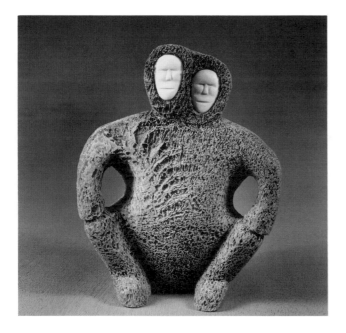

WOMAN AND CHILD
Noah Siakoluk
b.1924
Hall Beach 1969
whale bone, antler 18.3 x 15 x 10.7 cm.

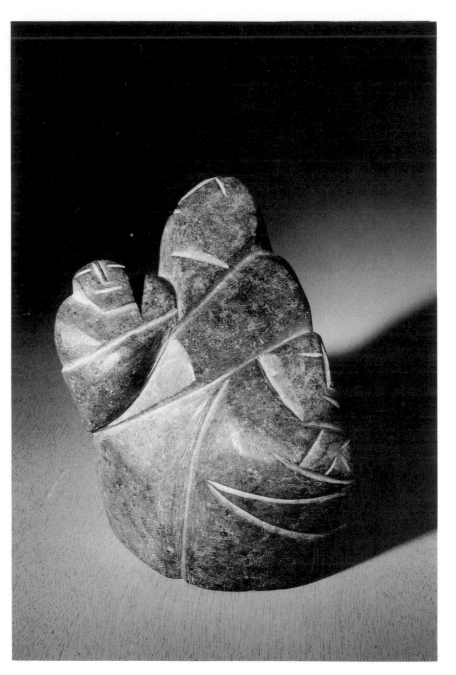

FAMILY GROUP
Matthew Okutark
b.1937
Arviat 1974
stone
14.5 x 2.7
x 15.9 cm.

TWO LADIES
TALKING
Alice Utakralak
Nanorak, b. 1939
Repulse Bay 1970
stone
11.3 x 11.1
x 7.3 cm.

CERAMIC POT
Donat Anawak,
1920-1990
Rankin Inlet 1981
clay
22.2 x 25
x 22.2 cm.

The stoneware clay
originally used in
the Rankin Inlet
ceramic project
was dug up from
the shores of Baker
Lake, thanks to
Pissuk, the hunter
who discovered it.

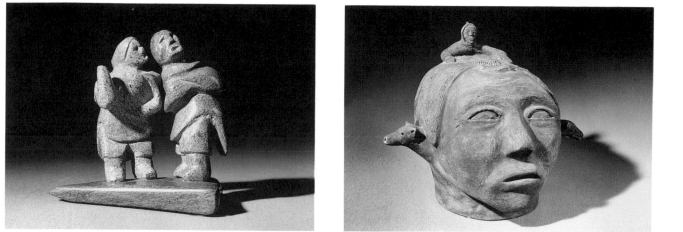

A YOUNG MAN'S FIRST SEAL

"The young man has just killed his first seal at the breathing hole. What an occasion for public rejoicing since it means that a new purveyor is born in this country where the struggle for food is first and foremost! However, success must not be allowed to ruin his head; on the contrary, he must become thoroughly imbued with traditions and customs and aware of his duties towards the whole group. A hunter who is too independent, too boastful, would be a danger to the rest of his fellow beings.

So, the new hunter is ordered to hitch himself to his seal and to pull it behind him, running as fast as he can. Then, at a given signal, all the women set off in pursuit of the fleeing man, armed with their "ulu" or half-moon shaped knives. The fastest ones gain ground rapidly. The first one to catch up with him, while on the run, cuts straight out of the seal the piece to which she is entitled, that is to say the hind part underneath the pelvis...if she succeeds in cutting it before another rival can knock her aside and hinder her from claiming her prize. As the other women catch up to the hunter, they join in the carving of the carcass and it is a wonder that, in such a tussle, they don't seriously gash each other's hands. Gradually, the seal vanishes and, finally, there is nothing left for the young hunter of the product of his hunt.

An Eskimo woman who is still living had the reputation of being a fast runner. Arriving first in a chase of that kind, she found nothing better than to get astride the seal and allow herself to be dragged along while she was cutting her prize piece before the others could catch up to her."

Father Franz Van de Velde, o.m.i.
(Pelly Bay, 1960)

THE WOMAN AND THE POLAR BEAR
Pond Inlet 1972
whale bone, stone, wood
10 x 31 x 14.2 cm.

"A man has been abandoned in an old snow-house so that he may die. His sister would come once in a while and give him food through the breathing hole, but nobody from the Inuit camp knew about this. This man told his sister,"When our people will be moving away from the camp, do go ahead of them and bring with you the pegs used to stretch the skins." And so she did...quite often looking behind her. Then she saw a polar bear attacking and killing the Inuit who were traveling with the sleds. When she saw the polar bear coming towards her, she went down on all fours, drove the pegs in the snow around her; the pegs started to grow longer forming a cage-like structure all around her thus preventing the bear from killing her."

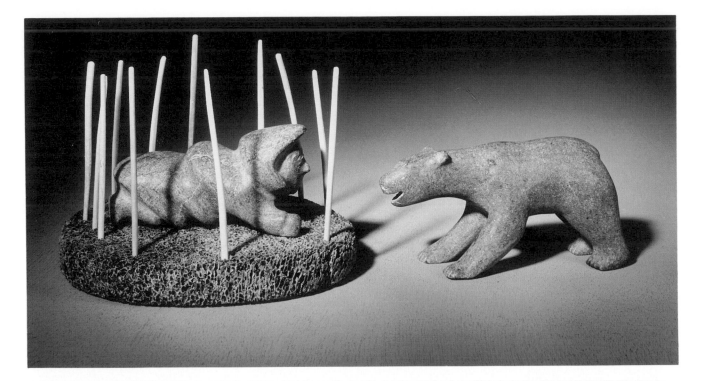

AJUTTAQ
Antonin Attark,
l909-1960
Pelly Bay 1954
ivory
5.2 x 25.7
x 5.6 cm.

Soccer or football (**ajuttaq**) was a popular sport in the winter when there were large open spaces on the sea ice for kicking a skin ball filled with moss.

162

FAMILY
Victor Sammurtok,
1903-1980
Chesterfield Inlet
1965
stone
17.2 x 23.5
x 6.9 cm.

"This sculpture
symbolizes the
feelings of a
formerly great
hunter that his
powers are failing
and that the
prestige and
capabilities of his
son, a carver are
increasing. The
carver was crippled
by polio and taught
his son to carve."

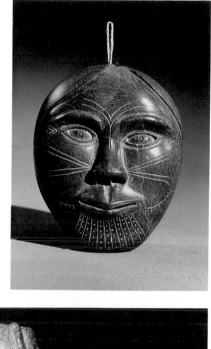

MASK-TATTOOED
LADY
Louis Oksokiktok,
b. 1926
Repulse Bay 1965
stone
15.3 x 12.9
x 6.5 cm.

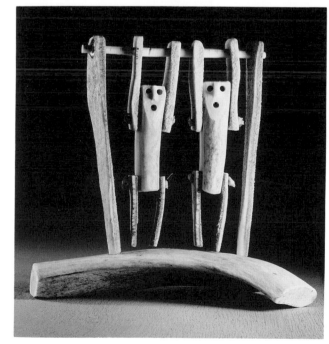

GYMNAST P26
John Angasaq,
b.1945
Arviat 1975
antler
13.3 x 14.6
x 9.7 cm.

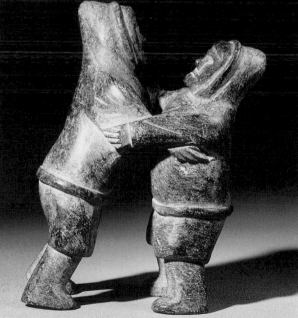

WRESTLING
Repulse Bay 1960
stone
16.5 x 12.8
x 7.7 cm.

163

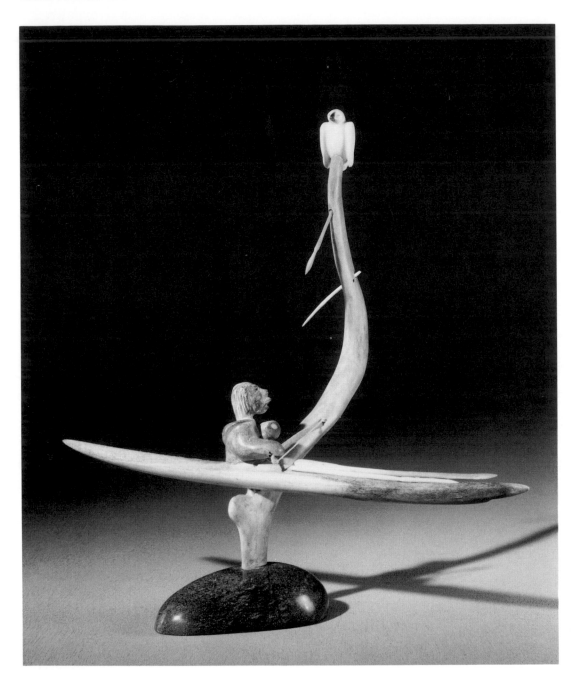

MAN SHOOTING BIRD FROM A KAYAK
Mariano Aupillardjuk, b. 1923
Repulse Bay 1978
stone, antler
27 x 30.5 x 18 cm.

"A man wanted to shoot a bird with his bow and arrow but the arrow deviated from its mark by the wind, and it missed. He tried again, shooting an arrow at it, but the arrow again fell short. He was sorry for it, and unhappy because of his sorrow, so he composed a song. (The meaning of the song relates about how the man was not taught as a child to use a bow and arrow so he was unable to catch anything.)"

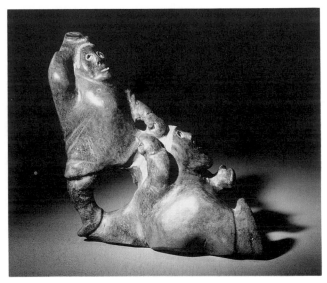

FIST FIGHT
Isaac Nangmalik,
b. 1939
Hall Beach 1975
stone
20.9 x 21.5 x 11 cm.

DID THE INUIT LIVE TO BE VERY OLD?

"(Ublorear), baptized under the name of Helen, at Pond Inlet where she died, recalled having seen Parry when she was just about to be married (As we know, formerly the Eskimo girls used to get married when they were 12 or 13 years old). Therefore, she must have been born around 1810, making her 130 years old at her death....Father Cochard remembers also having heard Ublorear say that she had known Parry. She used to recall that when the white man's boat arrived at Iglulik, the Eskimos received biscuits and tobacco; how they would make the biscuits skip on the water and make them roll on the ground. As for the tobacco, they did not like its odor - how they have changed since! - so they simply threw it away."

Father Guy Mary-Rousselière, o.m.i.
(Pond Inlet, 1957)

TUG OF WAR
Annie Tallrak
Arqviq, b. 1937
Gjoa Haven 1981
caribou back sinew
5.8 x 11.4
x 9.6 cm.

This piece is made from the braided sinew of the back muscles of the caribou.

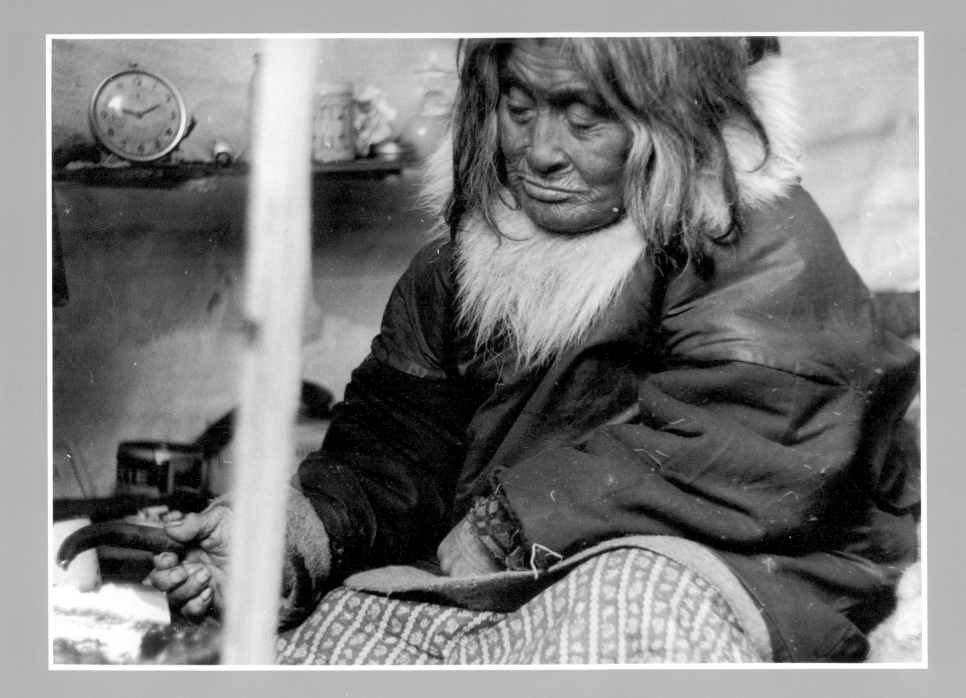

Silatuniq...
The wise way of understanding things...
View of the World

RELIGIOUS BELIEFS

Religious beliefs provided the main source of knowledge for understanding and accepting the world. There was no need to rationalize or explain all beliefs or events for conditions were held to be different at differing times. The Inuit believed traditional narratives were true accounts of real events, and had almost unlimited faith in what they saw, in what they dreamed, and in what they had been told had happened by their fellow countrymen. They did not distinguish between legends, stories and fables, but termed all traditional narratives as "**unipkaatuat**".

The supernatural was very much as real and tangible as the natural and the seen. They knew their surrounding country in minute detail and were familiar with every lake, valley, hill, and animal that inhabited the area. Yet, such astute practical observations did not render impossible or illogical belief in all kinds of beings such as giants, monsters, and dwarfs.

Father Georges Lorson, o.m.i. recorded one such story of the Inogaruligardjuit, the dwarfs of the inland.

Rosa Kangatalark tends the lamp in the igloo.
Pelly Bay,
c 1956-1958

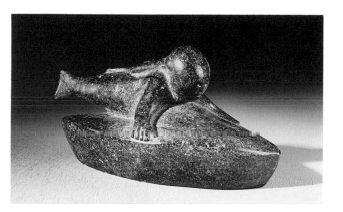

SEA MONSTER-GIRL SWALLOWED BY A WHALE
Qavavoark Tunnillie, b. 1928
Cape Dorset 1954
stone
9.4 x 18.6 x 10 cm.

"A girl fell into the water and was swallowed by a whale. When she was released she had the tail of a fish. She is frequently seen by the Inuit lying atop of a kayak using her hands as paddles."

"A long time ago, as an Eskimo ventured into an unknown by-place, he noticed, far away, a small black spot on the lake. Being naturally curious, he came closer and found himself face to face with one of these dwarfs half bent over a hole dug in the ice, and waiting patiently for an obliging fish to bite on his line. At his feet rested a small bow and a few arrows. "What a strange little man", thought the Eskimo. However, the dwarf did not seem surprised. They entered into a conversation, but for some reason unknown to the Eskimo, the little man got angry, and as his wrath gradually took hold of him, his body became taller and taller. Now the Eskimo

GIANT
IN THE KAYAK
Repulse Bay 1965
seal skin, stone
11.7 x 18.5 x 41 cm.

"A very long time
ago there lived a big
giant. As he was very
mean, the
people of the village
tried to get rid of him
by various means
and ways but had
no success. Finally
they made a kayak
and challenged him
to sit in it. As soon as
he accepted the chal-
lenge they
pulled him far away
with their kayaks
and abandoned him.
That's where he still
is, in his kayak, not
daring to stop for
fear that he might
capsize."

appeared as a dwarf besides him, and frantic with fear, he turned around to grasp his whip and run away as fast as he could. He looked back, his eyes wide open, searched closely right, left, and behind him, nothing was to be seen; the object of his fright had suddenly vanished. Only small footprints were visible in the snow.

.....The latter (Eskimo) as I was told by my informant from Pond Inlet have often seen car- casses of hares and foxes killed by inogaruli- gardjuit; many also have seen some of their graves over which were laid part of their world- ly possessions, piously placed there by their rel- atives. Sometimes one still sees their footprints in the snow, when hunger urges them to come clos- er to the sea in search of food."

The Inuit believed in a moral sanction, in both this life and the afterlife. Bishop Arsène Turquetil wrote "The Eskimo thinks of his future life as a material paradise, abounding in the choicest game, and one where success in hunting is assured without work... His hell too, is a mate- rial one, a land of desolation and of famine, with- out food or raiment or lamp, where he is forever engaged in the Tantalus-like pursuit of game which he can never take or overtake."

Heaven would be a land of plenty for who among them had not known the hunger and despair caused by the lack of game animals? To view from earth the dead playing football back and forth across the skies in the form of the northern lights was quite consistent with their views on the afterlife.

What was the basic nature of their concept of the surrounding world? First, most objects in the world were living and had a living "owner". Yet, man and animals were distinct or different for each also possessed a soul, an invisible, but immortal force.

A person's name (**atiq**) was also associated with his soul (**tarniq**) or had a special force

NARWHAL
AND MAN
Suzanne Tupitnerk
Mablik, b. 1942
Repulse Bay 1974
stone, ivory
5.2 x 18.6
x 13.l cm.

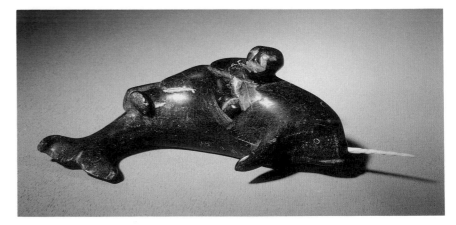

which protected him against evil external influences. The name could be changed, and more than once during a person's lifetime especially if it was thought that an evil spirit had invaded the person's being. At death the name stayed with the person until a child was named after him.

Father Turquetil wrote "The name! For the Eskimo this means everything. If the infant dies

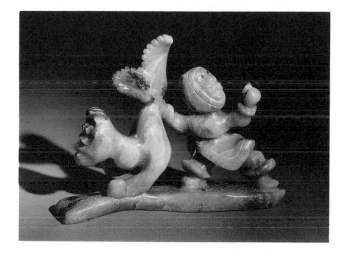

before it is given a name, there is no mourning. If it is a girl of which they wish to rid themselves, they smother it before the eighth day, but to smother it after it has received its name would be looked upon as a real murder which would call for vengeance. The name given an infant is that of a deceased relative. If a small boy receives the name of his grandmother, his father will address him as mother, his mother will address him as mother-in-law, his brothers and sisters will call him grandmother, and he himself so soon as he

begins to talk will at four or five years of age address them as my son, my daughter, and so forth... The Eskimo does not, however believe in metempsychosis, in a real reincarnation of the soul. But, he says, the dead person lives again through his name."

Why did mysterious and unexplained events happen in the world? What caused sickness? What kept the game away from the small band who knew so well their habits and methods in order to hunt them so successfully?

For the Inuit, unseen powers or personification of natural forces affected their lives in various ways. These spirits, although not all inherently evil, were dangerous nevertheless because if man did not follow their rules of conduct or taboos their actions towards man could be severe and unmerciful

In the Inuit mythology three powerful controlling spirits, the Sea Spirit, the Moon Spirit, and the Spirit of the Air and Weather were known in some form. Of the three spirits the Sea Spirit was the predominant one, being the most powerful and feared of all the spirits.

The story of the Sea Spirit, called **Nuliayuk** or by various other names is known throughout the circumpolar region in differing versions.

In one version of the Nuliayuk story, a young

NULIAYUK
Joachim Kavik,
b. 1945
Rankin Inlet 1973
stone
6.2 x 12.5
x 8.6 cm.

NULIAYUK
Susie Najaqit
Kunnaq
Gjoa Haven 1973
stone
12 x 15.3 x 8 cm.

"This carving is a story about a little orphan girl. After her parents died she was adopted at the age of ten or twelve. In the spring time or summer time the family went kayaking to reach a new camp. On their way the little girl slipped off the kayak. She was only holding on by her fingers. The father of the step-daughter cut off her fingers so he would be relieved of her. The story tells of how each finger turned into a seal and the little girl turned into a mermaid. This carving is of the father and the mermaid. The people of Gjoa Haven call her Nuliajuk and the story took place at Nektillik, near Spence Bay."

169

orphan girl was courted by a sea-bird. To escape the bird the orphan had her father and brothers row her to an offshore island. A storm raised the seas and in order to save the boat she was tossed off the craft. Her fingers were cut off when she tried to come back on board and these fingers became the animals who went to the bottom of the sea to live with her. From the bottom of the sea she reigned over the animals allowing them to be killed at her will. Some Inuit groups considered her to be in control of all the animals, and others considered her to be only in control of the sea animals. Nuliayuk was a powerful spirit. If there was an infraction of the taboos, the people were punished by Nuliayuk keeping away the game animals, causing hunger or starvation, or allowing sickness and death.

Another myth about a girl who did not want to marry who became the mother of different peoples in the world through a union with a dog

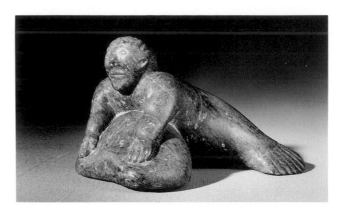

SEAL SPIRIT
Tunilee Samyuallie,
b. 1918-
Cape Dorset 1954
stone
11.5 x 20.2
x 11.8 cm.

"Each time a seal is killed, the hunter makes an offering of a portion of the meat to the seal spirit."

is sometimes integrated into the Nuliayuk myth. In these narratives the girl who married the dog is identified as Nuliayuk.

It was believed that it was only by obeying numerous taboos or rules of conduct (**tiregusuktok**) that the Inuit could prevent the spirits such as Nuliayuk from affecting their lives in a negative way. Other more personal methods were used to ensure success in life. Magic words (**erenaliut**) properly inherited from a child's mother or father would be sung or recited to the souls or spirits of deceased relatives to achieve a certain aim such as success in the hunt. Amulets (**arnguaq**) worn on the clothing, that were usually parts of an animal's body, could be used to protect oneself against evil spirits. The amulet's power was derived from the spirits that inhabited the object and would also have homeopathic powers, granting its bearer the special attribute of the particular animal it came from, such as a fox's metatarsal bone making its bearer a fast and enduring runner.

WALRUS-MAN
James Kukkik,
b. 1949
Hall Beach 1970
stone
5.5 x 17.5 x 8 cm.

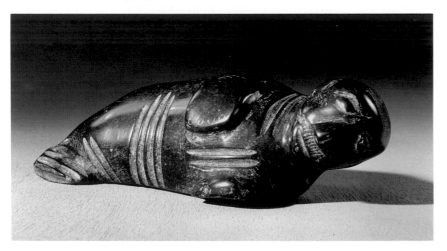

The Inuit had a special relationship to the animals that also had souls. At death the animal's soul left its body and was born again in another animal if the taboos regarding the hunt and other precautionary rules relating to the handling of game and camp life were observed. Some of the taboos observed were to make offerings of fresh water to marine animals after the kill, to observe rules where marine and land products were not to be mixed, to engage in specific ways to flense game animals, and the separation of menstruating women from game animals. Customary taboos meant to engender respect for the slain animal might not be too difficult to follow if a person was aware of all of them. Others, such as the prevention of the mixing of land and marine animals might be more difficult to follow, even causing great hardship such as when a taboo might prevent the preparation and sewing of caribou clothing at a critical season because the

men were hunting sea mammals, or when work on walrus skins and ivory was impossible because the summer caribou hunt was taking place. Careful adherence to all the rules resulted in the soul of the animal conveying its good treatment to other animals who would allow themselves to be killed.

These innumerable rules of conduct were learned in the camp. Bishop Turquetil related that "Usually the old grandmother is the teacher. Every night she tells the children bedtime stories, part of the interminable folklore of the Arctic. She plays on the children's acute imaginative powers. For example, she will describe a herd of fat walrus in a way to make their young mouths water. At once their hunting instincts are aroused. Then the grandmother goes on to tell about the hunter who killed one of the walrus against the will of the gods.

The grandmother (**aana**) craftily elaborates on this part of the story, giving accurate details as to who the hunter was, how many there were in his family, and so on. Gradually her young charges, tucked away in their

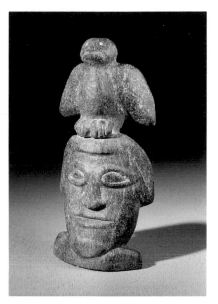

MAN WHO MARRIED
AN OWL
Bernadette
Ivaluardjuk Saumik,
b. 1938
Repulse Bay,
(Rankin Inlet) 1958
stone
16.4 x 7.8 x 5.2 cm.

"A man married an owl. After a time she became too proud and lazy. He chased her away and then married a weasel. She behaved like the owl so she shared the same fate. The man married all the other females of wildlife. All of them assumed the form of a woman at the time of marriage."

POLAR BEAR
AND MAN
Pond Inlet 1956
whale bone, ivory,
wood, plastic
13.5 x 45.7
x 20.2 cm.

"A man bends over a seal hole watching the alert device. He is surprised by a bear which grasping him by the head causes him to fall backwards. The two dogs attack the bear which turns upon them and the man kills the bear with his knife. At death the bear changes into the man's mother-in-law. She has assumed the form of a bear to frighten him. He has killed the bear not knowing it was his mother-in-law"

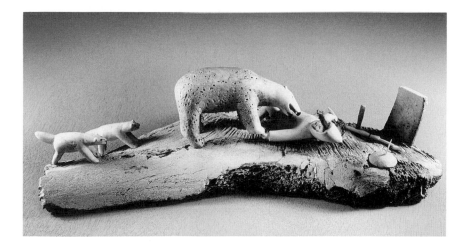

BEAR-MAN
David Issigaitok,
b. 1936
Hall Beach 1970
stone
10 x 5.6 x 9.2 cm.

OWL-MAN
David Issigaitok, b.
1936
Hall Beach 1970
stone
11 x 8.4 x 5.5 cm.

It was believed that
the separation of
the human and ani-
mal world was not
so distinct, and that
men and animals
could pass quite
freely from one
species to another.

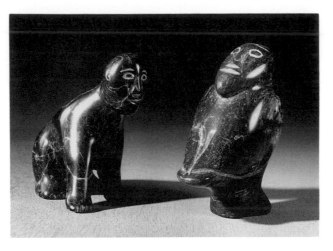

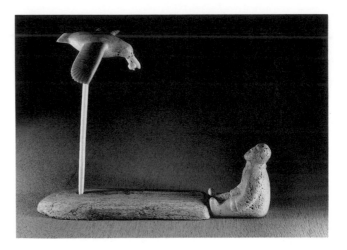

MAN AND RAVEN
Peter Ahlooloo,
b. 1908
Arctic Bay 1956
whale bone, antler
16.4 x 20
x 11.7 cm.

"A man was
starving. He came
out in the morning
to look for remains
of food. He saw a
raven doing like-
wise and followed
her. Eventually she
found a bone. He
praised her for her
beauty. She
became overcome
with joy, opened
her beak and the
man took the
bone."(similar to
Aesop's Fable
"The Fox and the
Crow")

caribou sleeping bags, begin to nod...they soon fall asleep. The grandmother smiles. She knows that their first question in the morning will be "What happened to the hunter?" It is then, when their minds are fresh, that she will tell them about the taboo (that the hunter has broken and what happened to him as a result).

One time the answer will be that he was swallowed by the angry spirit, or that his family was put under a spell and starved to death. Or perhaps the criminal was swept out to sea on an ice floe and perished of cold and hunger. These punishments are very vivid to the Eskimo child, for he knows what it is to be cold and hungry."

In the traditional mythology which is manifest in many of the carvings produced by contemporary Inuit artists, animals acted and talked. Transformations took place from animals into human beings, and vice versa. Legends and stories related many aspects of the Inuit world view explaining how the animals got their physical characteristics. Stories also instructed the listener about proper moral behaviour. Somewhat like Aesop's Fables, some legends demonstrated that to be successful or triumphant was not dependent on size or physical characteristics, but on cunning and observation.

Greed was portrayed negatively in a society where the common good was important. One legend as told to Father Papion by Felix Kopak from Repulse Bay aptly demonstrated that the common good or survival of the whole group comes before the individual good.

"A raven had two ducks for wives. In the autumn he wanted to accompany them south. They tried to dissuade him, telling him that the distance to be covered was great and that they would have to fly over the sea. But he swept away all objections replying: "It seems you come

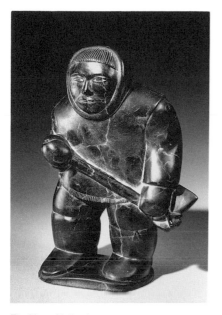

The Man with the Axe
28.1 x 19 x 13 cm.

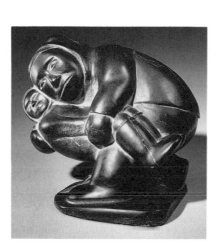

The Giant Listening for Breath
19.5 x 21.2 x 18 cm.

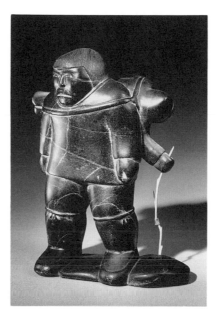

The Giant Carrying the Man
30.7 x 12 x 21.7 cm.

Charlie Sivuarapik
Illustrated by
Father André
Steinmann, o.m.i.

LEGEND OF THE GIANT AND THE FOG
Charlie Sivuarapik, 1911-1968
Povnungnituk c.1958-60
stone

A man that was fishing saw a giant coming, so he pretended to be dead, and held his breath. The giant thought that he was frozen, and tied him up to carry him home. As the giant walked, the man kept grabbing willow bushes, and would suddenly let go, so that the giant would almost fall down. When the tired giant reached home, he propped the man at the entrance to the thaw and went to sleep. The man opened his eyes and the children called. "Father, his eyes are opening!" but the giant answered that the man was dead. When the giant was asleep, the man picked up an axe, killed the giant and ran out. The giant's wife chased him so the man chopped the ground and a river flowed between them. She said, "How did you get across?" "By drinking it." She drank so much that she burst and formed mist. That's how fog came to be everywhere. When the wind blew the fog away the man returned home.

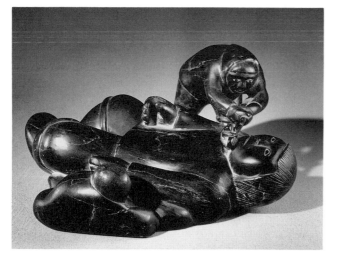

The Man Axing the Giant
28.4 x 15 cm.

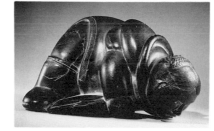

The Giantess Drinking the River
13.3 x 22.4 x 18.3 cm.

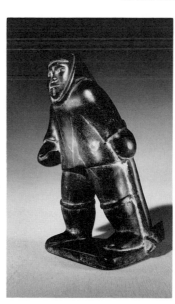

The Man Taking the Axe
19.2 x 10.5 x 11 cm.

here in a day!" Therefore they all left together. At first the raven led the little group, but he was soon passed and left behind. At his request his two wives landed side by side on the water so that he could land on their backs. Once rested, they left again, but the raven was soon tired again and the operation had to be repeated several times before the end of the day. When the water was a bit rough the raven had to hang onto

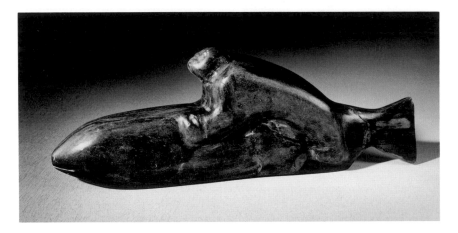

KIVIOQ AND THE CHAR
Leo Napayuk, b. 1927
Rankin Inlet, (Coral Harbour) 1975
stone
15.2 x 39.5 x 7.2 cm.

"Kivioq once married a young woman who really was a wild goose in human form. They had two sons. Eventually she became restless to return home and she struck feathers on her sons and herself, thus turning into wild geese. Then they flew away.

Kivioq became very distressed and started to look for them. He came to Erketiliyoq who carved chars out of driftwood. Erketliyoq told Kivioq that he had seen the goose wife with her two goslings flying over the lake. Since Kivioq had no boat, Erketliyoq, who had power over the fish, summoned a giant char which then carried Kivioq across the lake of the wild geese."

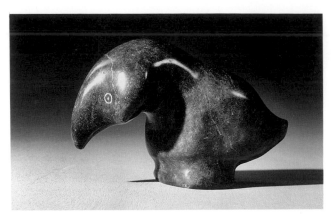

MYTHICAL BIRD THAT HELPED MAN
Therese Arnasivik Tabo, 1927-1985
Repulse Bay 1969
stone
10.2 x 7.6 x 17.2 cm.

"This mythical bird was so large and strong that it could carry a man. Once a man was running away from people trying to kill him. He came to a river that he could not cross but the bird carried him across it and he escaped."

his wives whose backs were soon plucked bare. Fearing they would never come to the end of their trip, the father-in-law decided to take matters in hand and ordered his two daughters to separate when the raven came to land, which they did. The raven fell in the water crying: "Evil father-in-law! I'm sinking!" " Right up to where, my son-in-law?"... the raven answering his father-in-law as he sank...right up to the final glug, glug."

THE SHAMAN

All crises such as continued bad hunting, or sickness and death were attributed to the activities of spirits that had been angered by the breaking of taboos, or in some cases by witchcraft. A special person, the shaman (**angakkuq**) acted as a mediator to try to find out what had caused the misfortune.

One technique the **angakkuq** used was to enter into a trance allowing for his soul to travel

outside his body on a mystical journey to the spirit world, oftentimes aided by a benevolent guardian spirit such as the bear spirit. There he could discover the reasons for the crisis and ascertain which rules of life had been broken. Upon his return to the community he elicited a public confession by the transgressor of the taboo. This was done in order to loosen the transgression attached to the soul of the transgressor which might have also become attached to others in the group. An individual who did not follow the rules that were pleasing to the spirits

MUSKOX GIVES
HIMSELF TO MAN
Mariano
Aupillardjuk,
b. 1923
Repulse Bay 1976
stone
3.4 x 6.2
x 10.4 cm.

This story relates to how the muskox was not afraid of being caught and knew it was his destiny to be caught by man's bow and arrow.

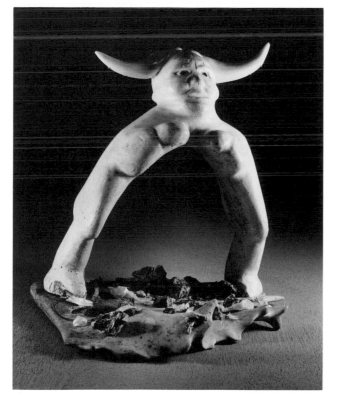

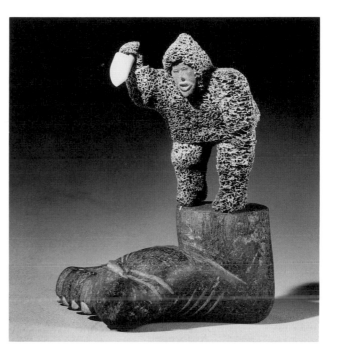

OOTOOK'S DREAM
Thomas Ootook,
b. 1944
Pond Inlet 1968
stone, whale bone
22.9 x 19.5
x 10.5 cm.

"The sculptor dreamed that he stood on the foot of a giant whose big toe was wriggling."

caused hardship and suffering affecting the welfare of the whole group. Therefore an individual's action could not be considered a private matter.

An **angakkuq** could be a man or a woman. He was called upon by his society to perform many functions including curing the sick, locating game, predicting and controlling weather, and locating lost objects or people. While heredity might play a role in becoming a shaman candidate, an Inuk did not become a shaman only because of hereditary reasons or of his own free will. The person was usually recognized later in life when a spirit or spirits made his future vocation known to him through dreams or visions, or in some other manner.

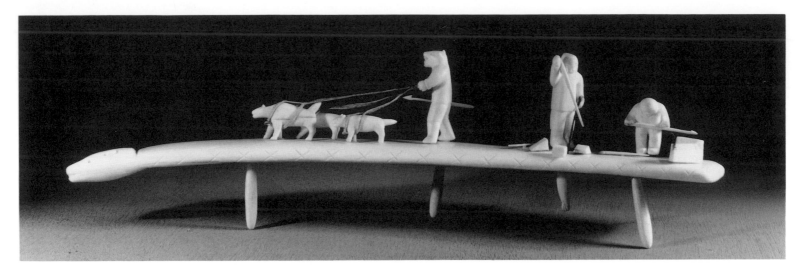

Training might proceed under the guidance of another **angakkuq**. During the initiation, the apprentice would have to learn about the spirits and primary powers, and be instructed in the taboos and religious observances. He also learned the sacred words and songs used only by shamans, and shamanic techniques, especially those used in healing where he might have to remove evil spirits from a person, recover a stolen or lost soul, or treat a physical ailment. Periods of solitude were required during initiation and throughout his life. These times of fasting and privation and perhaps intense exposure to the cold, resulted in psychic and physical suffering which promoted states of altered consciousness. At times the shamans' altered mode of perception resulted in them being able to experience dismemberment where they could see their own skeleton, the zenith of inner change towards a spiritual being.

The **angakkuq** exhibited special abilities, or performed feats such as inflicting self-bodily harm which he miraculously recovered from in order to demonstrate his supernatural abilities and to distinguish himself from ordinary mortals.

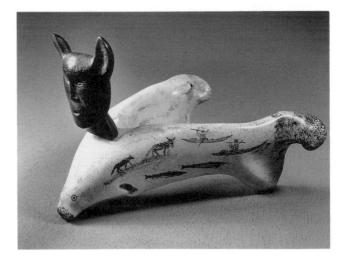

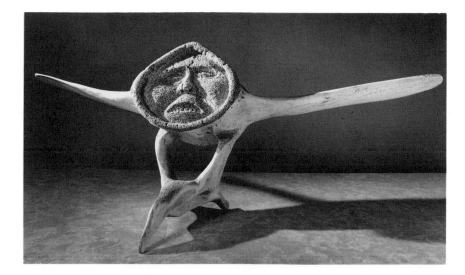

MAN AND WOMAN
FLYING TO
THE MOON
Terry Irqittuq,
b. 1930
Hall Beach 1973
whale bone
38 x 102 x 30 cm

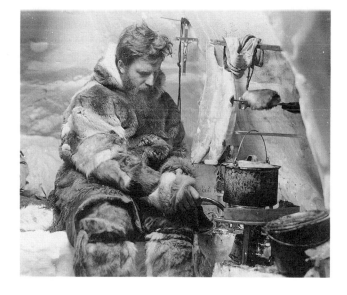

Fa. Pierre Henry (Kajaluk), pioneer missionary in the Kitikmeot region.
Pelly Bay, 1937.

Seances conducted by the shaman where he was transformed to assume the voice and language of a helping animal spirit reconfirmed for his fellow Inuit a state of the world where animals and man were still one. Contemporary Inuit art is rich in imagery of human/animal beings where human figures may have animal extremities or the animal figures may have human features.

INTRODUCTION OF CHRISTIANITY

With the introduction of Western technology, especially firearms and mechanized transport and other new influences, the religious life of the Inuit changed. Over a period of time many of the traditional religious beliefs and functionaries were challenged in the face of new ideas, goods, and services introduced by traders, missionaries, policemen, doctors, nurses, schools, and even meteorologists.

Christian missionaries moved into the Central and Eastern Canadian Arctic in the later 19th and early 20th century. The first Anglican mission was established in 1894 by the Rev. E.J. Peck, at Blacklead Island in Cumberland Sound, Baffin Island. The first Roman Catholic mission was established in 1912 at Chesterfield Inlet on the west coast of Hudson Bay by Father Arsène Turquetil, o.m.i. Various Evangelical or Pentecostal Christian denominations have established churches in the Central and Eastern Arctic since the 1940s. The largest number of adherents to

WHAT IS A MISSIONARY?

"A missionary who cannot quickly become a master of many skills isn't worth much. In fact he is completely useless in the Arctic where people may need him at any hour of the day or night. We had to become what the English call "Jack of all trades but master of none."

If I had to speak of all the trades we had to practise when we lived with the Inuit, I'd never end. We were dentists, doctors, surgeons, psychiatrists, carpenters, electricians, hunters, fisher-men, navigators, teachers.....the works! We learned from books as much as possible and then did the best we could. In some emergencies you have to pretend you are the best person to handle the situation, you have to forget your fears and doubts, you have to trust yourself and have faith to take the plunge. Most times you come to realize that it really does work."

Father André Steinmann, o.m.i
(1977)

Christianity in the region belong to the Anglican and Roman Catholic denominations.

Without minimizing some of the initial resistance to Christianity, it was accepted by the Inuit within a relatively short period of time after its introduction. While missionaries from Great Britain, France, Belgium, and southern Canada as well as other places became the first people to spread Christianity it should be noted that the Inuit also played a role in spreading the early faith.

Father Robert Lechat reports "... In Igloolik, I can tell you what I heard from very old people about the spreading of Christianity amongst them. Anglicanism and Roman Catholicism were first brought here, not by white missionaries, but by two Inuit, namely Maktar (for the Catholics) and Umik, father of the well know Nuqadlak (for the Anglicans) around the 1920s. They had had, directly or not, some rapid contacts with white missionaries, and they started spreading the new faith amongst the Iglulingmiut."

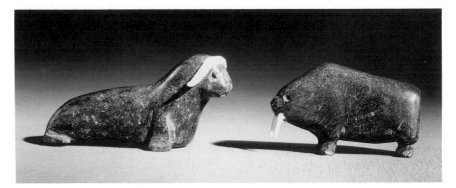

THE WALRUS AND THE MUSKOX
Kayotak
Repulse Bay 1982
stone
a) 3.8 x 8.9 x 5.2 cm. b) 3.8 x 6.5 x 2 cm.

"It is said that at one time the muskox (umingmak) had tusks and they bothered him, mostly in the winter because they would crack and make noises keeping the muskox awake.

The walrus (aiviq) had a horn but because he was in the water most of the time it would become soft and was not useful for digging shellfish.

The two animals exchanged the tusks and horn, both to their mutual satisfaction."
(This story has been recorded in similar versions from the Netsilik Inuit (Rasmussen 1931:408) and the Iglulik Inuit (Rasmussen 1930:32)

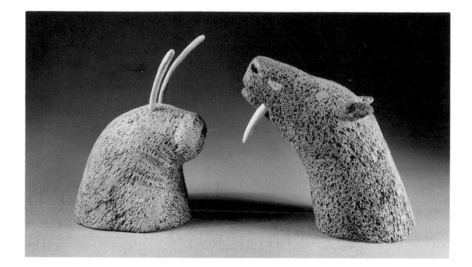

THE CARIBOU AND
THE WALRUS
Charlie Inuarak,
b. 1947
Pond Inlet, (Arctic Bay)
1968
whale bone, ivory,
antler, stone
a) 14.3 x 8.7 x 15 cm
b) 15.5 x 10.1
x 21.3 cm.

"In the beginning, the caribou (**tuktu**) had tusks and the walrus (**aiviq**) had antlers. It happened that the walrus after having become good friends with the caribou exchanged the antlers for the tusks. After acquiring these tusks the walrus headed straight for the sea. Since then walrus have tusks."

Later in 1930, some Iglulingmiut who had already learned from Maktar and from some of their fellow Inuit, the Aiviliit, a few Roman Catholic prayers and hymns copied by hand by themselves, went in a delegation to Pond Inlet in order to ask to have a priest stay amongst them. The Roman Catholic mission had settled in Pond Inlet in 1929. In 1930 it had been impossible to realize this project. It was only in June 1931 that Father Bazin, o.m.i. accompanied Ittusardjuaq back to his camp."

Many Christian concepts were not alien to a people who strongly believed in a spiritualistic world, a world which strongly influenced the course of events here on earth.

Both traditional beliefs and Christianity spoke of an afterlife and the immortality of the soul. Where the Inuit's traditional primary controlling spirits were communicated with mainly out of a state of fear according to many Inuit testimonies, the Inuit were now introduced to a loving God, a Provider and Creator. This presentation and emphasis on a singular loving God (**Anirnialuk**) that was to be primarily worshipped rather than feared liberated them from following the numerous and exacting taboos which permeated their life from birth to death. Yet, the Inuit were also introduced to the God of the Old Testament, a God who punished those who disobeyed his laws, a concept they were more familiar with in their traditional beliefs.

The traditional concept of the public confession of transgressions was replaced by the general confessional liturgy of Christian worship services, and the sacrament of private confession of the Roman Catholic faith. Christian ministers

TABOOS

"How often these natives suffered a loss of time, of money, of health, or of opportunities for good hunting. For instance, when a hunter died, all his implements and belongings had to be left at the side of his grave: brand new canoes, rifles, blankets, spoiled and made useless when so many needed them badly and lacked the money to buy new ones; because of a death the natives had to remain for days and days without hunting or doing anything...."

Father Arthur Thibert, o.mi.
(1954)

became the new intermediaries with the "spirits", and especially in the beginning were called upon to assist the sick, one of the shaman's traditional functions.

Not all traditional religious practices had an affinity with Christian beliefs or were upheld by the new religious functionaries in the North. Traditional practices such as infanticide or the abandonment of the elderly who could no longer follow the group, practices oftentimes associated with the existing harsh conditions, were actively condemned.

Christianity's belief in the magic power of words through prayers, and the acceptance of miraculous unexplained happenings, had natural affinities to traditional religious beliefs as did the concept of the "communion of saints" or helping spirits. The uniqueness of a name, and the powers inherited with a given name being associated with a saint while not directly analogous with the concept or significance of the traditional naming process, did show an important value associated with names.

Christian churches (**tutsiavik**) exist in all the hamlets and settlements in the Central Arctic today. More and more, the Inuit are exercising leadership in the church as ordained ministers, catechist couples (**tuksiartiit**), and in many other forms of leadership.

TERESIKULUK NIAKROGLUK

I also am a Little Theresa
(young Inuk who died tragically young at
the age of 20 north of Chesterfield Inlet;
by her great example she was attributed with many
conversions to Christianity
before and after her death)

"The visitors, more and more numerous, enjoyed Teresikuluk's smile and all of them made the same reflection, "Kuvianartok najurtanga - her igloo is a place of happiness." People earnestly gathered around her for the morning and evening prayers. She continued to preach by her words, her joy and her love in suffering."

Father Eugene Fafard, o.m.i. (1934)

Teresiluluk Niakrogluk
"I also am a little Theresa".
Young girl from Chesterfield Inlet who through her inspired life and tragic death was attributed with many conversions to Christianity.

Walter Porter and his family- a great leader and catechist.
Gjoa Haven, c.1968

Romani, Sarakalu, and Sidonie prepare the altar made by Anthony Manernaaluk.
Pelly Bay, 1901.

RESPECT FOR POLAR BEARS

"Coming back to polar bears, I recall that our elders taught us never to make fun of them; polar bears understand us, they used to say, and whoever makes fun or speaks ill of "Nanook" will always suffer the consequences. Should you not believe me, listen to the story of Igalialuk. (Igalialuk, meaning "He who wears glasses" or, in this case, Father Prime Girard, o.m.i. 1883-1949). One night, at Chesterfield, Igalialuk was smoking his pipe and joking about polar bears. "Never yet have I seen a bear," said he; "I would really like to have a close look at one, ah! how I would enjoy seeing a polar bear!" As it happened, the next morning, just as the Mass which I was attending was about to start, the dogs outside started to howl, but to howl in such an unusual way that Igalialuk wanted to know what was going on. He opened the door only to find himself face to face with an enormous polar bear standing on his hind legs, who brought his paws down on Igalialuk's shoulders. Throwing himself back, Igalialuk slammed the door shut: he had seen his bear! He ran toward Bishop Turquetil who was about to proceed to the Altar; Bishop Turquetil turned around and grabbed a rifle which he quickly passed on to an Eskimo who cautiously slipped outside and shot the bear. It seems our forefathers were right in their claim that polar bears know what we say about them.

*Jean Ayaruar
(Chesterfield Inlet, 1965)*

THE OWL
AND THE HARES
Pelly Bay 1956
antler
5 x 9.7 x 6.8 cm.

"An owl saw two hares. Being a greedy owl he grasped each of them by a paw. In the struggle that followed, the owl was torn apart. The lesson is to be content with enough. This story was overheard by an Inuk passing closed by an owl's house. The owl spoke the same language as the Inuk." (Similar versions of this story were recorded from the Netsilik Inuit (Rasmussen 1931:401) and from the Caribou Inuit (Rasmussen 1930:88)

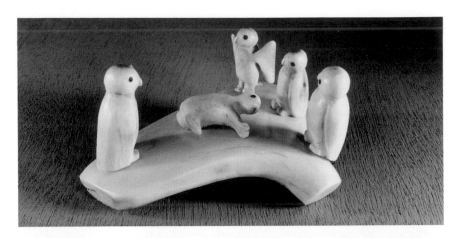

POLAR BEAR KILLING THE WALRUS
Lazaroosee Akpaliapik, b. 1921
Arctic Bay 1965
whale bone
19.2 x 23 x 22.5 cm.

"The bear surprises the sleeping walrus on the ice. Picking up a piece of ice he crushes the head of the walrus. If the piece of ice is too light to kill the walrus the bear will dip it in and out of the water until the size is increased." (Similar versions of this story were recorded from the Igloolik Inuit by Captain G.F. Lyon (Lyon 1824:375) and from the Caribou Inuit by Rev. Donald Marsh (Marsh 1987:76)

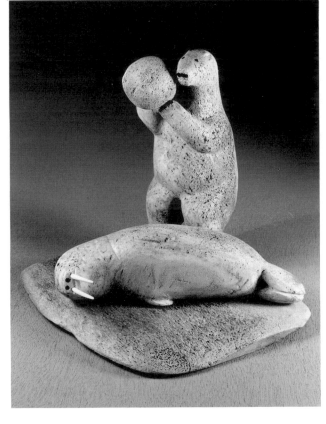

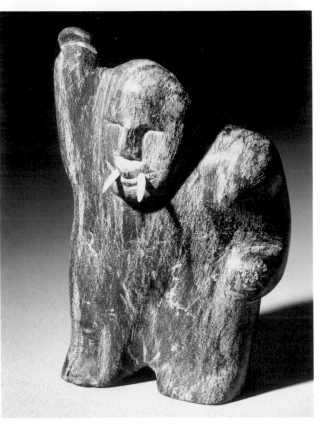

SHAMAN WITH TUSKS
Therese Arnasivik Tabo, 1927-1985
Repulse Bay 1968
stone, ivory
17.6 x11.7 x 9 cm.

"The shaman reportedly grew tusks during incantations when he was possessed by the spirit of the walrus."

THE WEASEL
AND THE MUSKOX
Vital Makpaaq,
1922-1978
Baker Lake 1973
stone, ivory
10.4 x 14 x 9.1 cm.

"There was a time of famine when there were no caribou on the land. A group of hungry animals spotted a muskox and asked the wolf to kill him. But the wolf was afraid and said, "I am too weak." Then the weasel offered to go, and all the animals laughed at him. But the weasel crawled under the muskox's tail, dug into his rectum and the muskox bled to death. The moral of the story is that with cunning even the smallest can triumph."

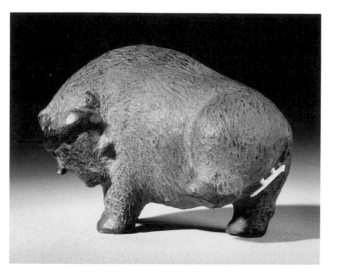

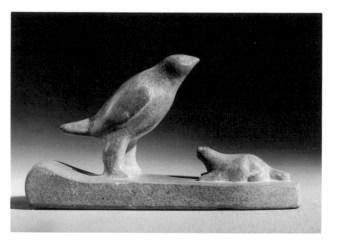

THE OWL
AND THE SIKSIK
Evalak, b. 1900
Hall Beach 1974
stone
8.4 x 15 x 4.9 cm.

"Once upon a time there was an owl (uppik) who went out hunting because he was hungry. He noticed a little ground squirrel (siksik) which turned out to be too smart for him. The Uppik attempted to position himself without a sound between the siksik and its ground hole. He also asked some relatives who flew by to help him catch his meal.

Meanwhile little Siksik started to speak. "Oh my dear great grandfather, there is no doubt in my mind that you will feast on me, that the tender fat of my kidneys will be delicious and so will the succulent fat of my belly. Enjoy yourself therefore and dance! Swing your arms! Roll your head! And I shall follow you. Watch the drum stick! Follow it closely! Dance, dance, dance! Roll your head! Swing your feet and spread your legs! And don't lose sight of the drum stick!"

And here the siksik sang in rhythm with the dance. Then suddenly he cried out, "TSI, TSI, TSI, TSI" (the alarm by ground squirrels) and with a leap went through the spread legs of the uppik, and jumped into his hole, and disappeared.

The uupik cried out disappointedly, "YAAAAA..A...", blaming himself for his great stupidity. Then he stationed himself in front of the hole and said, "Come back, little great-grandfather. I won't partake of you. Simply come out!"

Inside his home, Siksik's wife wanted to know all about what was going on outside. Her husband answered, "Uppik says that you are no good and that he won't do anything bad to you. So why don't you go out and see for yourself! Your privates smell a bit strong! Go out and hug him.

But she too did not leave the den."
(This story has been recorded both for ground squirrels and lemmings in various Inuit groups including the Netsilik (Rasmussen 1931:398; Papion 1955:7) and the Caribou Inuit (Rasmussen 1930:83-84)

FEMALE SHAMAN AND NOVICE IN TENT
Davidealuk Alasua Amittu, 19l0-1976
Povungnituk 1968
stone
23.9 x 34.8 x 10 cm.

A female shaman (**angakkuq**) is teaching her apprentice an invocation to the walrus spirit.

AUPILLARDJUK'S DREAM
Mariano Aupillardjuk, b. 1923
Repulse Bay 1971
stone 31.5 x 24.3 x 26 cm.

"This carving is an interpretation of a story about a person, known to the artist, who was afraid of a shaman who tried to harm him.

One night Aupillardjuk dreamed about a bull-dozer coming to roll over him but he was unable to move. The bulldozer came closer and closer, and then it suddenly stopped. The following is Aupillardjuk's interpretation of this dream. The bulldozer was the shaman. "It stopped" means the shaman can't harm the man anymore. The shaman was just a great bully who wanted to frighten the man but, in fact, was not able to do so."

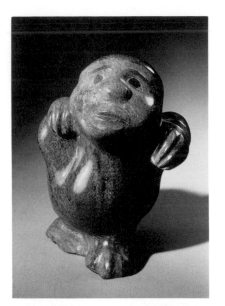

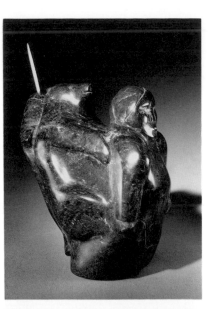

FIRST NARWHAL
Rosa Arnarudluk Kanayok,
1914-1984
Repulse Bay 1972
stone, antler
33.4 x 16.5 x 26.7 cm.

"Tutigak was blinded by his wicked mother's trick. He shot a fine bear but his mother lied and denied it. Later when he regained his sight, she complained that he should catch larger whales. He tied the hunting line to her waist and when he harpooned the largest white whale it pulled her into the sea. She changed into a narwhal and her plaited hair became the long spiraling horn."
(Similar versions were recorded from the Baffin Island Inuit by Franz Boas (Boas 1888:625-626) and the Northern Quebec Inuit (Hawkes 1916 :157-158)

SHAMAN
WITH TUSKS
Luke Iksiktaaryuk,
1909-1977
Baker Lake 1968
antler
25.9 x ll.6 x 19 cm.

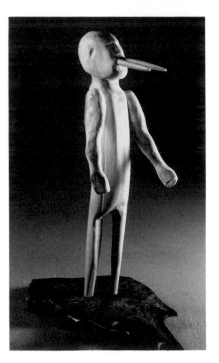

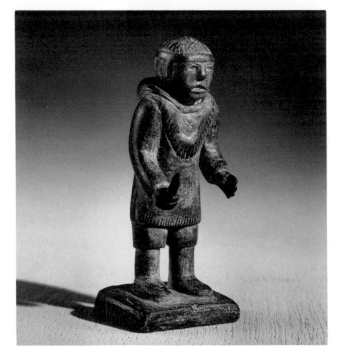

SHAMAN
WITH BELT
Bernard Irqugaqtuq,
1911-1987
Pelly Bay 1955
stone
7.2 x 2.5 x 3.4 cm.

"The shaman (**angakkuq**) distin-guished himself from his fellow country men by wearing a shaman's belt. Sometimes the items on the belt were gifts from people he had helped."

MARY
Irene Kataq
Angutitok,
1914-1971
Repulse Bay 1959
stone
20.8 x 8.7 x 5.2 cm.

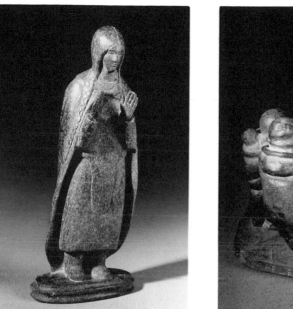

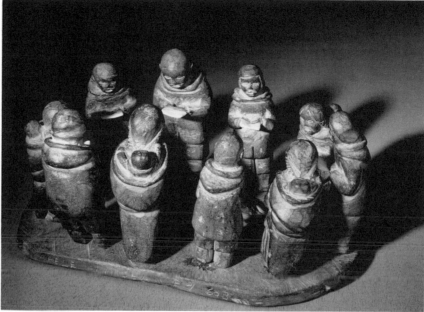

NIRISIUTIT
Pudloo Inuqtaqau,
b. 1932
Iqaluit 1969
stone
12.5 x 24.6
x 14.3 cm.

"A group of Inuit
thank God for their
food, a seal."

MY BEST FRIENDS WERE SORCERERS

"When I visited the Eskimo camps, I was always accommodated in the biggest igloo. It was that of the sorcerer's family. They were always my best friends. Moreover, my first conversion was that of the wife of the good old sorcerer. It was she who, completely paralyzed, except for her tongue, was my best Inuktitut teacher.

I think I've presented the person of Jesus Savior, without timidity, to my Eskimo nomads...I have gone to live with them; I went to them since they didn't come to me. I shared their lot: hunter, cold, solitude and much more. Alone at first, in my corner, each time a person came to visit me, I knelt down to thank God."

Father Marcel Rio, o.m.i.
(Cap-de-la-Madeleine, 1992)

A MISSIONARY'S LIFE

"His life (Father Joseph Buliard) can be summed up in a few words: " I do what I can, I pray, I set a good example, I am kind to everybody; I visit often, on occasion I say a word about religion, I try to lessen the effects of calumnies circulating against us. As for the rest, let the grace of God prevail; as He wants and when He wants!"

Father Joseph Buliard, o.m.i. in a book written by his confrère Father Charles Choque, o.m.i. (Churchill-Hudson Bay Diocese historian, and veteran missionary)

JESUS
Mark Tungilik,
1913-1986
Repulse Bay 1952
ivory
9.4 x 4.4 x 2.4 cm.

Mark Tungilik first began carving in Pelly Bay in the mid 1940s with the encouragement of Fa. F. Van de Velde, o.m.i.. At the request of Fa. Van de Velde he created his first bust of Christ, with a crown of thorns.

TAMUASULIURVIK
Antonin Attark,
1909-1960
Pelly Bay 1954
ivory
6.1 x 42.8 x 5.4 cm.

"This mass **(tamuasuliurvik)** is being led by Father Pierre Henry **(Kajualuk)**. At the back a blind man is being led by his son. There is tent and shelter for the fire. A dog is howling at the back.

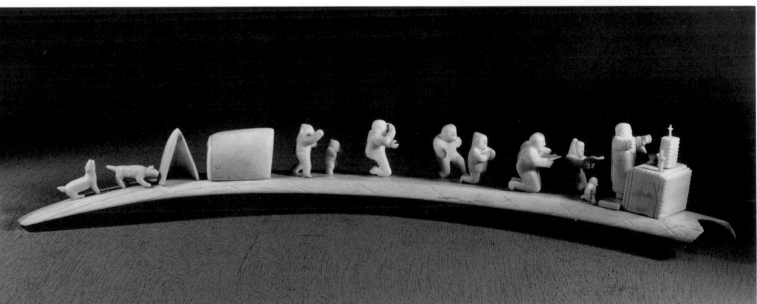

SNAKE FROM THE
GARDEN OF EDEN
John Audlak
Arviat 1969
antler
2.7 x 12.2 x 16.9 cm.

POPE PIUS XII
Repulse Bay 1952
ivory, plastic
7.3 x 5 x 3 cm.

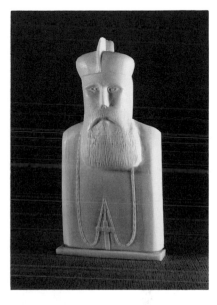

BISHOP ARSENE TURQUETIL, O.M.I.
Repulse Bay 1952
ivory
12 x 5.9 x 2 cm.

Father Turquetil, the first Roman Catholic
Bishop in the Central and Eastern was known
to the Inuit as Ataatatsiaraluk (grandfather).

ON THE PULLING OF FA. COCHARD'S TOOTH

"I installed myself in a chair, biting energetically the handle of my shaving brush, while Bernadette, Alain's wife, bound a piece of caribou sinew around my tooth and tied this thread to a strong string. Alain, lacking the courage of his wife, closed his eyes... and I did the same...Ouch! Bernadette gave a good sharp blow "Nauk" (nothing), the tooth refused to leave its bed.

The Eskimos held a war counsel..."Takiyoaloungmat-k'ai..." (the tooth is probably too long). The thread was not tight enough, etc...My dentist proposed the following solution; to replace the caribou sinew by a whale sinew the results will undoubtedly be better. And the operation was renewed, with alas! the same negative results. I decided I had enough. Useless to add that I did not sleep that night.

Two days later, James Nilaolak offered his good services which I unhesitatingly accepted, as my tooth was aching terribly. This time, he used forceps and guaranteed that all would soon be over. The chair, the shaving brush... and I was ready. The forceps grabbed my tooth, pulled and tugged, while sweat covered my face. Ouch! Ouch! Luckily the operation was soon ended and James Nilaolak proudly held up the tooth he had just extracted."

Father Joseph Cochard, o.m.i. (1961)

UJAMMIK
Repulse Bay
1962
ivory
70 cm.

A Catholic rosary
(**ujammik**) with
beads made from
ivory.

MARY AND CHILD
Irene Kataq
Angutitok,
1914-1971
Repulse Bay 1952
ivory
18.5 x 5.5
x 4.8 cm.

The artist was
inspired by Father
Bernard Fransen to
create this delicate
carving.

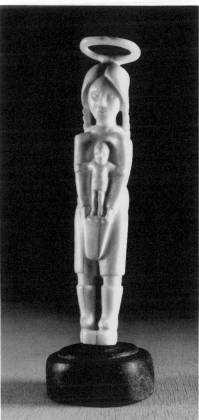

T'AIMANE

*"T'aimane has a rather
definite meaning:
a long time ago....
In that time
It will usually be the first
word said by Eskimo
storyteller"*

*Father Maurice Metayer,
o.m.i. (1973)
A different word was
used in different areas.
In the Keewatin District
Taipsomane meant "a
long time ago".*

THE INUIT - A CONSTANT EXAMPLE TO US

*"The Inuit were a constant example to us. When we felt at the end of our
tether we would often be inspired by their indomitable courage, their boundless
endurance. Their good humour was so communicative that there was no way you
could resist them when you felt low."*

Father André Steinmann, o.m.i. (1977)

Sidonie Nirlungayuk
feeding her son
Gabriel.

NAKINGAQTUT
SELECTED REFERENCES

The American Review of Canadian Studies
1987

Inuit Art: Contemporary Perspectives. Vol XVII, Spring, 1987. *The American Review of Canadian Studies*. Association for Canadian Studies in the United States.

Amundsen, Roald F.G.
1908

Roald Amundsen's "The Northwest Passage," Being the Record of a Voyage of Exploration of the Ship "Gjoa", 1903-1907. 2 vols. New York: E.P. Dutton.

Anoee, Eric
1988

Traditional Ways of Preparing Meat. *ISUMASI* Vol. 1(3):15-19.

Anoee, Martina
1979

Remembered Childhood. *Ajurnarmat* 1-7 (Education Collection)

Arima, Eugene
1984

Caribou Eskimos. In *Handbook of North American Indians*. gen. ed. W. Sturtevant Vol. 5 vol. ed. David Damas pp. 447-462 Washington: Smithsonian.

Arnadjuak, John
1987

Building a Snowhouse: how to choose the right snow and cut blocks. *ISUMASI*, Vol. 1(2):15-19

artscanada
1971-72

The Eskimo World. Vol. 27, No. 6, *artscanada*, (December 1971-January 1972).

Atuat, Joan
1989

Traditional Clothing. Interviewed by Mark Kalluak. *ISUMASI* Vol. 2(1):4-12.

Atagutsiaq, Isaija
1991

A Word about Qamutit. *Inuktitut*, vol. 73:52-58.

Ayaruaq, John
1965

Eskimo Hunters of Yore. *ESKIMO*, Spring, Vol. 69:9-11.

1968

The Autobiography of John Ayaruaq. (Ottawa: Department of Indian and Northern Affairs).

Balikci, Asen
1970

The Netsilik Eskimo. Garden City, N.Y. : Natural History Press.

Barz, Sandra
1981

Inuit Artists Print Workbook. New York: Arts and Culture of the North.

Bazin, Etienne
1974

Les Lettres d'Oncle Etienne Bazin 1903-1972. (Paris): Eric-Marie-Etienne Bazin.

The Beaver
1967

Eskimo Art Issue. *The Beaver*, Autumn, 1967.

Berton, Pierre
1988

The Arctic Grail: the Quest for the North West Passage and the North Pole 1818-1909. Toronto: McClelland and Stewart.

Birket-Smith, Kaj
1922

Correspondence to Fa. A. Turquetil from Repulse Bay, August 28, 1922. Montreal: O.M.I. Archives.

1929

The Caribou Eskimos. Material and Social Life and Their Cultural Position. Report of the Fifth Thule Expedition, 1921-24, Vol. V(1-2). Copenhagen.

1940

Anthropological Observations on the Central Eskimos. Report of the Fifth Thule Expedition 1921-24. Vol 3(2). Copenhagen.

1945

Ethnographical Collections from the Northwest Passage. Report of the Fifth Thule Expedition, 1921-24. Vol. VI(2). Copenhagen.

1959

The Eskimos. London: Metheun.

Bissett, Don
1967

Northern Baffin Island. An Area Economic Survey. 2 vols. Ottawa: Department of Indian Affairs and Northern Development.

Blodgett, Jean
1978

The Coming and Going of the Shaman: Eskimo Shamanism and Arts. Winnipeg: The Winnipeg Art Gallery.

1979

The Historic Period in Canadian Eskimo Art, *The Beaver*, Summer 1979, pp. 17-27.

Boas, Franz
1900

Religious Beliefs of the Central Eskimo. *Popular Science Monthly*, New York, October, Vol. LVII:624-631.

1964 *The Central Eskimo (1888)*. Lincoln: University of Nebraska Press.

1901-07 The Eskimo of Baffin Land and Hudson Bay. *Bulletin of the American Museum of Natural History*, Vol. XV. New York.

Brack, D.M.
1962 *Southampton Island Area Economic Survey; with Notes on Repulse Bay and Wager Bay.* Ottawa: Department of Northern Affairs and National Resources, Industrial Division, Area and Community Planning Section.

Bruemmer, Fred
1985 *The Arctic World.* Toronto: Key Porter.

1986 *Arctic Animals.* Toronto: McClelland and Stewart.

Burch, Ernest S. Jr.
1979 Ethnography of Northern North America: A Guide to Recent Research. Arctic *Anthropology* 16(1).62 146.

Canada Dept. of Indian and Northern Affairs
1992 *Inuit art bibliography = Bibliographie de l'Art Inuit.* Ottawa: Inuit Art Section, Dept. of Indian and Northern Affairs.

Canadian Eskimo
1971 *Sculpture/inuit. Sculpture of the Arts Council Inuit Masterworks of the Canadian Arctic/La Sculpture chez les Inuit: chefs-d'oeuvre de l'Arctique canadien.* Toronto : University of Toronto Press.

Choque, Charles
1981 *Hopital Ste-Thérèse, Chesterfield, T.N.O.* Churchill: R.C. Mission.

1982 *Kayoaluk: Pierre Henry, o.m.i. Missionary Oblate of Mary Immaculate, Apostle of the Inuit 1904-1979.* Churchill: R.C. Mission.

1985a *Joseph Buliard: Pecheur d'Hommes.* Longueil: Editions le Preambule.

1985b *Kajualuk: Pierre Henry, o.m.i.* Churchill: R.C. Mission

1987a *Joseph Buliard: Fisher of Men.* Churchill: R.C. Episcopal Corporation.

1987b *75th Anniversary of the First Catholic mission to the Hudson Bay Inuit.* (English and Inuktitut). Churchill: Diocese of Churchill Hudson Bay.

1987c *75me Anniversaire de la première mission Catholique chez les Inuit de la Baie d'Hudson* (French). Churchill: Diocese of Churchill Hudson Bay.

1987d *In Memory of Piku: Brother Jacques Marie Volant, Oblate of Mary Immaculate 1900-1987.* (Churchill: Diocese of Churchill Hudson Bay).

Clabaut, Armand
1960 The Old White Wolf. *ESKIMO*, June, Vol. 55:3-4.

Cochard, Joseph
1961 On the Pulling of a Tooth. *ESKIMO*, December, Vol. 60:7,12.

Comer, George
1984 *An Arctic Whaling Diary: the Journal of Captain George Comer in Hudson Bay 1903-1905.* ed. by W. Gillies Ross, Toronto: U. of Toronto Press.

Condon, Richard G.
1983 Modern Inuit Culture and Society in *Arctic Life: Challege to Survive.* Margaret Mageneau Jacobs and James B. Richardson III eds., Pittsburgh: Board of Trustees, Carnegie Inst.

Cooke, Alan, and Clive Holland
1978 *The Exploration of Northern Canada. 500 to 1920: A Chronology.* Toronto: Arctic History Press.

Copland, A. Dudley
1985 *Copalook: Chief Trader Hudson's Bay Company 1923-39.* Winnipeg: Watson and Dwyer.

Crowe, Keith J.
1970 *A Cultural Geography of Northern Foxe Basin, N.W.T. (N.S.R.G. 69-2)* Ottawa: Department of Indian Affairs and Northern Development, Northern Science Research Group.

Damas, David
1969 Environment, History, and Central Eskimo Society. Pp. 40-64 in *Ecological Essays.* David Damas, ed. Anthropological Series 86, National Museums of Canada Bulletin 228. Ottawa.

1984 Copper Eskimo. In *Handbook of North American Indians*. Vol. 5, gen. ed. W. Sturtevant, vol. ed. David Damas, pp. 397-414, Washington: Smithsonian.

1988 The Contact-traditional Horizon of the Central Arctic: reassessment of a concept and reexamination of an era. *Arctic Anthropology*, Vol. 25(2):101-138.

Danielo, Etienne
1949 Ke-na-o-wet? (What is your name?). *ESKIMO*, September, Vol. 14:13-15.

Degerbol, Magnus
Freuchen, Peter
1935 *Mammals*. Report of the Fifth Thule Expedition, 1921-24. Vol. II(4-5).

Didier, Theophile
1961 My first Funeral in Eskimo land. *ESKIMO*, December, Vol. 60:3-11.

Driscoll, Bernadette
1985 *Uumajut: Animal Imagery in Inuit Art*. Winnipeg: The Winnipeg Art Gallery.

Ducharme, Lionel
1977-78 Knud Rasmussen and his visit to Chesterfield Inlet. *ESKIMO*, N.S. 14:3-10.

Eber, Dorothy Harley
1989 *When the Whalers were up North: Inuit Memories from the Eastern Arctic*. Kingston: McGill-Queen's U. Press.

Fafard, Eugene
1978 *Flower from an Icy Midst: a little Eskimo Therese, Theresakuluk, Niakrogluk*. (translated from French by Sister Mary Olive Sarrasin, s.g.m.) (Churchill) : (Diocese of Churchill Hudson Bay).

Fleming, Ven. A.L.
1929 *Brief History of Missions to the Canadian Eskimo*. Given at the summer school for the Diocese of Niagara and Toronto at the Bishop Strachan School, Toronto, July 3rd, 1919, Toronto: Missionary Society, Church of England in Canada.

Fox, Audrey
1974 "Franz Van de Velde" Polar Priest". *Arctic in Color*, Autumn, Vol 3(2):9-17.

Freeman, Milton M.R.
1976 *Report: Inuit Land Use and Occupancy Project*. 3 vols. Ottawa: Department of Indian and Northern Affairs.

Georgia
1982 *Georgia: an Arctic diary*. Edmonton: Hurtig.

Gonda, Frank
1963 "Christmas in the Big Igloo". *North/Nord*, November/December, Vol. X(6):28.

Graves, Jonquil and
Ed Hall
1985 *Arctic Animals*. Yellowknife: Department of Renewable Resources, Government of the Northwest Territories.

Hall, Charles F.
1865 *Arctic Researches and Life Among the Esquimaux: Being the Narrative of an Expedition in Search of Sir John Franklin, in the Years 1860, 1861, and 1862*. New York: Harper.

1879 *Narrative of the Second Arctic Expedition Made by Charles F. Hall: His Voyage to Repulse Bay, Sledge Journeys to the Straits of Fury and Hecla and to King William's Land, and Residence Among the Eskimos During the Years 1864-69*. J.E. Nourse, ed. Washington: U.S. Government Printing Office.

Hall, R.H.
1912 Correspondence from the Hudson's Bay Company to Bishop Charleboix, October 29, 1912.

Harington, Lyn
1956 *Ootook: young Eskimo girl*. Photographs by Richard Harrington, Toronto: Thomas Nelson.

Harper, Kenn
1983 Writing in Inuktitut: an historical perspective. *Inuktitut* No. 53:3-35.

Hawkes, Ernest W.
1916 *The Labrador Eskimo*. Geological Survey Memoir 91, Anthropological Series 14. Ottawa: Dept. of Mines.

Hessel, Ingo
1986a Contemporary Inuit Art : Living Memories of the Past. Part I. *Canada Journal* 1(2):38-40.

1986b Contemporary Inuit Art : Living Memories of the Past. Part II. *Canada Journal* 1(3):34-37

Houston, Alma (intro)
1988 *Inuit Art : an Anthology*. Winnipeg: Watson and Dwyer.

Hofmann, Charles
1974
Drum Dance: Legends, Ceremonies, Dances, and Songs of the Eskimos. (New York): n.p.

Hunter, Archie
1983
Northern Traders: Caribou Hair in the Stew. Victoria: Sono Nis Press.

Iglauer, Edith
1966
The New People: The Eskimo's Journey into our Time. New York: Doubleday.

Inuit Art Gallerie
1979-
Exhibition brochures. Mannheim, IGM

Inuit Art Quarterly
1990/1991
Special Issue. Inuit Art: a Dynamic Art Form. *Inuit Art Quarterly,* Ottawa: Inuit Art Foundation, Vol. 5, NO. 4, Fall/Winter 1990/1991.

Inuit Cultural Institute
1986
Recollections of Inuit Elders. In the Day of the Whalers and other Stories = Iqqaittarningit Inutuqait. ICI Autobiography Series No. 2. Eskimo Point: Inuit Cultural Institute.

1987
ICI Inuktitut Glossary. Eskimo Point: Inuit Cultural Institute.

1988
Recollections of Levi Iqalujjuaq: The Life of a Baffin island Hunter = Iqqaumajangit Levi Iqalujjuup. ICI Autobiography Series No. 3. Eskimo Point: Inuit Cultural Institute.

Inuktitut
1983
Inuktitut. Special Issue: Language. September, Vol. 53.

Irwin, Colin
1989
Future Imperfect. *Northern perspectives,* Jan-March, Vol. 17(1)2-20.

The Isaacs/Innuit
Art Gallery
1972-
Exhibition brochures. (formerly called Innuit Gallery of Eskimo Art).

Issenman, Elizabeth
1985
Inuit Skin Clothing. *Etudes/Inuit/ Studies,* Vol. 9(2):101-119.

IIsluanik, Henry
1987
Trapping by Dogteam. *ISUMASI.* October, Vol. I(2): 37-40.

Jackson, Marion
Brother Jacques Volant, o.m.i. - Guardians

1983
of Legends and Dreams. *Arts and Culture of the North.* Vol. 6(3):438-439.

Jenness, Diamond
1922
The Life of the Copper Eskimos. Report of the Canadian Arctic Expedition 1913-1918. Vol 12(A). Ottawa.

1928
The People of the Twilight. New York: Macmillan.

1946
Material Culture of the Copper Eskimos. Report of the Canadian Arctic Expedition 1913-18. Vol. 16. Ottawa.

Kalluak, Mark
1988
The Ways of our Elders still work: Preserving and Caching Country Food. *ISUMASI* Vol. 1(3): 7-14.

Karetak, Rhoda
1982
Preparing Wildlife for Use. *Inuktitut* No. 50:54-61.

Keenleyside, Anne
1990
Euro-Canadian Whaling in the Canadian Arctic: its effects on Eskimo Health". *Arctic Anthropology,* Vol. 27(1):1-19.

Keewatin Inuit Ass.
1989
Inuit games. Dept. of Education Regional Resource Centre. Rankin Inlet: Govt. of the Northwest Territories.

Kemp, William B.
1984
Baffinland Eskimo. In *Handbook of North American Indians,* Vol. 5, gen. ed. W. Sturtevant, vol. ed. David Damas, pp. 463-475, Washington: Smithsonian.

Klutschak, Heinrich
1987
Overland to Starvation Cove with the Inuit in Search of Franklin 1878-1880. Transcribed and edited by William Barr, Toronto: University of Toronto Press.

Lacroix, Marc
1959
Integration or Disintegration. *The Beaver,* Spring, Outfit 289:37-40.

Lechat, Robert
1977
Letter to the editor. *Inuit Today,* October: 9.

1979-80
Biblical Experience relived by the Inuit". *ESKIMO,* Fall/Winter, N.S. No. 18:12-15

1980
"Biblical Experience relived by the Inuit. *ESKIMO,* Spring/Summer, N.S. No. 19:3-7.

1974 Christianization of the Inuit.
ESKIMO, Spring/Summer, N.S. No. 6:15-17.

1974-75 Christianizaton of the Inuit.
ESKIMO, Fall/Winter, N.S. No. 8:14-21.

Ledyard, Gleason
1958 *And to the Eskimos.* Chicago: Moody
Press.

Lorson, Georges
1956 North of '72. *ESKIMO*, September, Vol. 41: 12-19

1963 Igloo Restaurant: Recipes for Eskimo
dishes. *ESKIMO*, September, Vol. 65:
16-17.

1966 The Tribulations of a Bear Hunter.
ESKIMO, Autumn, Vol. 72:9-11.

Lyall, Ernie
1979 *An Arctic Man.* Edmonton: Hurtig.

Lyon, G.F.
1824 *Private journal of Captain G.F. Lyon
of H.M.S. Hecla during the Recent
Voyage of Discovery under Captain
Parry.* London: John Murray.

McCartney, Allen P.
1979 (ed) Thule Eskimo Culture: an
Anthropological Retrospective. ed. by
Allen P. McCartney. Archaeological
Survey of Canada Paper #88. Ottawa:
National Museums of Canada.

McGhee, Robert
1978 *Canadian Arctic Prehistory.*
Toronto: Van Nostrand Reinhold.

1980 Eastern Arctic Prehistory: the
Reality of a Myth? Special Issue:
Arctic Archaeology. *The Musk-Ox.*
No. 33:21-25.

1984 Thule Prehistory of Canada. In
Handbook of North American Indians.
gen. ed. W. Sturtevant, Vol. 5
vol. ed. David Damas pp. 369-376.

1987 Prehistoric Arctic peoples and
their art". *The American Review of
Canadian Studies*, Vol. SVII(I)5-14.

1988 Material as Metaphor in prehistoric
Inuit Art. *Inuit Art Quarterly*,
Summer, Vol. 3 (3): 9-11.

McGrath, Robin
1984 *Canadian Inuit Literature: the
Development of a Tradition.*
Canadian Ethnology Service Paper No.
94. Ottawa: National Museums of
Canada.

1990 Reassessing Traditional Inuit
Poetry. *Canadian Literature*,
Spring-Summer, No. 124-125:19-28.

Marsh, Donald B.
1987 *Echoes from a Frozen Land.* ed. by
Winifred Marsh. Edmonton: Hurtig.

Martiijn, Charles A.
1964 Canadian Eskimo carving in historical
perspective. *Anthropos* 59(3-4):
545-596.

Mary-Rousselière, Guy
1955 The "Tunit" According to Igloolik
traditions. *ESKIMO* March, Vol. 35:
14-20.

1956a Mythical and Prehistoric Animals in
Arviligjuarmiut folklore.
ESKIMO, December, Vol. 42:10-12.

1956b This and That: the Eskimo and the
principle of conserving hot air.
ESKIMO, December, Vol. 42:18-20.

1957a A bear hunt on Simpson Peninsula.
ESKIMO, September, Vol. 45:16-19.

1957b Longevity among the Eskimos.
ESKIMO, March, Vol. 43:13-15.

1962 Inukkat: Eskimo game. *ESKIMO*,
March-June, Vol. 61:3-9,17-19.

1965 The Death of Okamalok. *ESKIMO*,
Spring, Vol. 69:13-14.

1969 *Les Jeux de ficelle des
Arvilgjuarmiut.* Bulletin 233, Ottawa:
National Museum of Canada.

1970 Eskimo Voyages in the Waters north of
Canada." *Etudes d'Histoire Maritime
prehistoric.* XII e Congres
International des Sciences
Historiques, Moscow.

1980 — *Qitdlarssuq: l'histoire d'une migration polaire.* Montreal: Les Presses de l'Universite de Montreal.

1983 — Merqusaq (ca. 1850-1916). Arctic Profiles, *Arctic*, Vol.36 (3):292-293.

1984a — Iglulik Eskimo. In *Handbook of North American Indians.* gen. ed. W. Sturtevant, Vol. 5 vol. ed. David Damas, pp. 431-446, Washington: Smithsonian.

1984b — Exploration and Evangelization of the Great Canadian North: Vikings, Coureurs de Bois, and Missionaries. *Arctic*, Vol. 37(2):596-602.

1987 — How Old Monica Ataguttaaluk introduced me to Arctic Archaeology. *Inuktitut* Spring #66:6-24.

1991 — *Qitdlarssuaq: the story of a Polar migration.* Winnipeg: Wuerz Publishing.

Mathiassen, T.
1927 — *Archaeology of the Central Eskimo.* Report of the Fifth Thule Expedition, 1921-24, Vol. IV(1-2). Copenhagen.

1928 — *Material Culture of the Iglulik Eskimos.* Report of the Fifth Thule Expedition, 1921-24, Vol. VI(1). Copenhagen.

Maxwell, Moreau S.
1984 — Pre-Dorset and Dorset History in Canada. In *Handbook of North American Indians.* gen. ed. W. Sturtevant, Vol. 5, vol. ed. David Damas pp. 359-368.

Metayer, Maurice
1972 — *Tales from the Igloo.* illus. by Agnes Nanogak, ed. and trans. by Maurice Metayer, Edmonton: Hurtig.

Morice, Adrian G.
1943 — *Thawing out the Eskimo.* Boston : The Society for the Propagation of the Faith.

Morrison, William R.
1986 — Canadian Sovereignty and the Inuit of the Central and Eastern Arctic.

Muehlen, Maria
1990/91 — Government activity in Inuit arts and crafts: for the Canadian government handicrafts was an obvious answer. *Inuit Art Quarterly.* Fall/Winter Vol. 5(4):38-39.

Muller-Wille, Luger
1978 — Cost Analysis of Modern Hunting among the Inuit of the Canadian Central Arctic. *Kanada und das Nordpolargebiet. (Canada and the Polar Regions.* H. Schroder-Lenz and L. Muller-Wille (eds). Trier Geographische Studen, Sanderheft 2, 1978.

Myers, Marybelle
1984 — Inuit Arts and Crafts Co-operatives in the Canadian Arctic. *Canadian Ethnic Studies* 1693):132-53.

Nanogak, Agnes
1986 — *More tales from the Igloo.* as told by Agnes Nanogak, ed. and trans. by Maurice Metayer, Edmonton: Hurtig.

Neatby, Leslie H
1984 — Exploration and History of the Canadian Arctic. In *Handbook of North American Indians*, Vol. 5, gen. ed. W. Sturtevant, vol. ed. David Damas, pp. 377-390, Washington: Smithsonian.

Nuligak — *I, Nuligak.* ed. and trans. by Maurice 1966 Metayer, Toronto: Peter Martin.

Nunasi Corporation
1986 — *Our Way of Life.* Ottawa: Nunasi Corporation.

Nungak, Zebedee
Arima, Eugene
1969 — *Eskimo Stories: Unikkaatuat.* National Museums of Canada, Bull. No. 235, Anthropogical Series No. 90. Ottawa: National Museums of Canada.

Oakes, Jillian
1991 — *Copper and Caribou Inuit skin clothing production.* Canadian Ethnology Service Mercury Series Paper No. 118, Ottawa: Canadian Museum of Civilization.

Owingayak, David
1986 — *Arctic Survival Book: Safety on Land, Sea and Ice.* Eskimo Point: Inuit Cultural Institute.

Talerok, Martha
1989
Preparation of Skins. *ISUMASI* Vol. 2(1):13-18.

Taylor, J.G.
1974
The Netsilik Material Culture: the Roald Amundsen Collection from King William Island. Oslo : Universitetsforlaget.

Taylor, William E., Jr.
Swinton, George
Prehistoric Dorset art. *The Beaver* 298 (Autumn):32-47.

Thibert, Arthur
1954
Enter....the Roman Catholic Missionaries. *The Beaver*, Outfit 285, Winter: 34-35.

1970
English-Eskimo dictionary: Eskimo-English. Canadian Research Centre for Anthropology. Ottawa: Saint Paul University.

Trinel, Ernest
1958
A few Examples that show the voracity of Eskimo dogs. *ESKIMO*, March-June, Vol. 47:14.

Turquetil, Arsène
1929
Religious Rituals and Beliefs. In *Eskimo of the Canadian Arctic.* ed. by Victor F. Valentine, Frank G. Vallee, pp. 43-48, The Carleton Library, Toronto: McClelland and Stewart, 1968.

1936
Have the Eskimo the Concept of a Supreme Being?, July, Vol. IX(3): 33-38.

1944
Taboo: why children obey. *The Oblate World*, December:7-8.

Usher, Peter J.
1971
Fur Trade Posts of the Northwest Territories, 1870-1970. (NSRG 71-4) Ottawa: Department of Indian Affairs and Northern Development, Northern Science Research Group.

Vallee, Frank G.
1962
Kabloona and Eskimo in the Central; Keewatin. (NCRC 62-2) Ottawa: Department of Northern Affairs and National Resources, Northern Co-ordination and Research Centre.

Van de Velde, Franz
1956
Rules Governing the Sharing of Seal after the "Aglus" Hunt amongst the Arviligjuarmiut. *ESKIMO*, September, Vol. 41:3-7.

1958
Fat - Symbol of Eskimo well being and prosperity. September, *ESKIMO*, Vol. 48:16-17.

1960
Quaint Customs and Unusual Stories of the Arviligjuarmiut: Seal chase. *ESKIMO*, March, Vol. 54:7-8.

1970
Canadian Eskimo Artifacts. with Eric Mitchell. Ottawa: Canadian Arctic Producers.

1970
Canadian Eskimo Artists: a Biographical Dictionary: Pelly Bay. Yellowknife: Govt. of the Northwest Territories.

1985
Counting on One's Fingers in Inuktitut. *ESKIMO*, Spring/Summer N.S. 29:10-12.

1985
Eskimo Containers. ms. 8 p.

Van Stone, James W.
Oswalt, Wendell
1959
The Caribou Eskimos of Eskimo Point. (NCRC 59-2) Ottawa: Department of Northern Affairs and National Resources, Northern Co-ordination and Research Centre.

Viesse, Jeannine
1979
The Churchill Eskimo Museum / Le Musée Eskimo de Churchill. Churchill: The Diocese of Churchill Hudson Bay.

Villiers, D.
1968
The Central Arctic, an area economic survey. Ottawa: Department of Indian Affairs and Northern Development, Industrial Division.

Volant, Jacques
1979
Speech to the Senate at the occasion of receiving an Honorary Doctorate at the University of Manitoba, Winnipeg, May 24, 1979.

Wenzel, George
1991
Animal Rights, Human Rights: Ecology, Economy and Ideology in the Canadian Arctic. Toronto: University of Toronto Press.

Wilkinson, Douglas
1970

The Arctic Coast. The Illustrated
Natural History of Canada. Toronto:
Natural Science of Canada Limited.

Winnipeg Art Gallery
1974 -

Exhibition catalogues including a settlement
series on Arctic communities. (some are
listed under the curator/author)

Woodman, David C.
1991

*Unraveling the Franklin mystery:
Inuit Testimony.* Montreal:
McGill-Queen's U. Press.

1983

Arctic Life: Challenge to Survive.
eds. Martina Magenau, Jacobs and
James B. Richardson III. Pittsburgh:
Carnegie Insitute.

Zepp, Norman
1986

*Pure Vision: the Keewatin Spirit =
Une Vision Pure: L'Esprit du
Keewatin.* Regina: Mackenzie Art
Gallery.

PERIODICALS

ABOUT ARTS AND CRAFTS = L'ART ET L'ARTISANAT
(Canada. Dept. of Indian Affairs and Northern Development)
1974-1982, succeeded by *INUIT ARTS AND CRAFTS =
L'ART ET L'ARTISANAT INUIT*

ARCTIC
(Arctic Institute of North America)
1948 -

ARCTIC ANTHROPOLOGY
(U. of Wisconsin Press)
1964-

ARTS AND CULTURE OF THE NORTH
(Arts and Culture of the North)
1976 - 1984)

ESKIMO
(Diocese of Churchill Hudson Bay)
1944

ETUDE / INUIT / STUDIES
(Inuksiutiit Katimajiit Association,Inc.)
1977-

INUIT ART QUARTERLY
(Inuit Art Foundation) (Kingait Press)
1986-

INUIT MONTHLY / INUIT TODAY
(Inuit Tapirisat of Canada)
1971 - (1983)

INUKTITUT / INUTTITUUT
(Inuit Tapirisat of Canada ; formerly published by Canada. Dept. of Indian
Affairs and Northern Development)
1959-

INUMMARIT
(Inummarit Association - Igloolik)
1972-1977

ISUMASI
(Inuit Cultural Institute)
1987-1989

UQAQTA
(Inuit Cultural Institute)
1985-1988

SANAGUAQTIIT
INDEX OF ARTISTS

Note: In the artist index the artists have their current residence listed first and their previous communities of residence in brackets (). This is opposite to the designations with the sculptures that list the place of residence where the sculpture was made first and current community of residence in brackets ().